# BLOOD
## ON THE
# LENS

## Potomac Books of Related Interest

*Fragments of Grace:*
*My Search for Meaning in the Strife of South Asia*
by Pamela Constable

*"My Heart Became Attached":*
*The Strange Odyssey of John Walker Lindh*
by Mark Kukis

*Enduring the Freedom:*
*A Rogue Historian in Afghanistan*
by Sean M. Maloney

*Imperial Hubris:*
*Why the West Is Losing the War on Terror*
by Michael Scheuer

*Through Our Enemies' Eyes:*
*Osama bin Laden, Radical Islam, and the Future of America*
by Michael Scheuer

*Al Qaeda's Great Escape:*
*The Military and the Media on Terror's Trail*
by Philip Smucker

# BLOOD
## ON THE
## LENS

A Filmmaker's
Quest for
Truth in
Afghanistan

## JIM BURROUGHS

POTOMAC BOOKS, INC.
WASHINGTON, D.C.

**Library of Congress Cataloging-in-Publication Data**
Burroughs, Jim.
  Blood on the lens : a filmmaker's quest for truth in Afghanistan / Jim Burroughs. —
1st ed.
       p. cm.
  Includes bibliographical references and index.
  ISBN 978-1-59797-124-9 (alk. paper)
  1. Afghanistan—History—Soviet occupation, 1979–1989. 2. Afghanistan—History—1989–2001. 3. Afghanistan—History—2001– 4. Documentary films—Afghanistan. 5. Burroughs, Jim—Travel—Afghanistan. I. Title. II. Title: Filmmaker's quest for truth in Afghanistan.
  DS371.2.B87 2007
  958.104—dc22

                                                                    2007007816

Printed in the United States of America on acid-free paper that meets the American National Standards Institute Z39-48 Standard.

Potomac Books, Inc.
22841 Quicksilver Drive
Dulles, Virginia 20166

First Edition

10  9  8  7  6  5  4  3  2  1

# Contents

# Preface

**The story of Afghanistan's struggle for liberation** during the last quarter century resembles a drama of Greek proportions. Beginning with the 1978 Cold War deliberations of Zbigniew Brzezinski, who sought to undermine Soviet political efforts in that country during the Carter administration, it features the Afghans' war with the Soviets (1979–89); the ongoing machinations of Pakistan's secret intelligence, intent on controlling Kabul; the Saudis' religious proselytizing; America's suspension of its support for Afghanistan so that it could instead fight the Gulf War with Iraq (1990–92); the grim Afghan civil war (1992–96); the Taliban's gradual rise in the early 1990s (first in Pakistan); those same proselytizing Saudis subsequently hijacking the Taliban after 1996; the U.S.-led intervention after September 11, 2001 (9/11); the turn of U.S. attention once again to Iraq in 2002; and now a resurgence of the Taliban in southwestern Afghanistan. The story cannot be told on a CNN "crawl" or in a nightly news report. Making sense of events from the past twenty-five years or even of the U.S. involvement with the country requires constant attention to multiple layers of fact, fiction, and disinformation, as well as understanding of the turmoil within Islam itself.

Sadly, until recently people on the front lines or in Western academia have not investigated these matters. Moreover, little from the world of documentary film and video attempts to tackle the whole story, because those few journalists who were brave or foolish enough to continue following this ever-changing epic were forced to dig into their own pockets to finance their work. Between 1987, when CBS was embarrassed by a bogus hour-long special documenting a faked engagement between Soviet troops and the mujahedin, and the great fallout after 9/11, few networks covered events in Afghanistan. Most U.S. broadcasters decided to follow the dollars instead of the story,

and aside from the BBC and a few independent journalists, few covered the ferment building within this remote land that would have enormous repercussions in the West.

There are many types of journalists: print reporter, print analyst, radio reporter, radio analyst, photojournalist, television news producer and newscaster, and documentary filmmaker, to name a few. For more than twenty-five years, I have been a documentary producer. During that time I've been afforded the marvelous opportunity of plying my craft with projects that have taken me around the world. Some of my films have tended toward exploration and adventure, some toward historical portraiture, and others have placed me in complex cultural or political situations. In many cases, especially in the last category, I have found myself working alongside my brethren in news divisions. We have frequently arrived at the same scenes at the same times, shooting or probing the same events. We've frequently shared the same camera angles, though the newsman's crew tended to aim the camera at a subject's face rather than choose perspectives that might have better served his or her purposes. And we have often spent evenings together in local watering holes around the world, sharing strong drink and swapping war stories.

But the news producer-gatherer's job usually ends when he or she turns the material over to the station desk or to the newscaster who will then run with the material to make his or her deadline. Documentary makers, in contrast, write their camera reports, log their material, and make plans for the next shoot, hoping to add another piece to the puzzle. Eventually they create a complete picture of successive events that, they hope, sheds more insight into their causes and trajectories. For newspeople, covering the event is everything. With documentary filmmakers, coverage of a particular event is only as valuable as it allows them to link that event to others, to paint a broader picture, and to tell a deeper story.

The differences don't stop there. Reporters tend to enjoy and seek their colleagues' company. Documentary filmmakers prefer to spend more time in the field with their subjects and pursuing their story. They might get a bigger kick out of sharing blood and milk in the African bush with a Samburu warrior than sharing a steak at the Hilton Nairobi with their own countrymen. They tend to choose the

long-term camaraderie of their stories' subjects over swapping accounts with their colleagues at the bar after the day's adventures. Filmmakers therefore tend to be loners with their eyes on a longer-term prize. And to be candid, I think many of us doc makers often use the camera as an excuse to explore other worlds and experience other ways of living.

Finally, the documentarian looks past the significance of the isolated incident to the context and life cycle of the persons or stories involved. He tends to be more interested in how the people involved dress, what they eat, what they read, what makes them fight, what makes them laugh, and what they believe. Filmmakers want to portray the smells, tastes, textures, and rituals of a culture rather than the revelation of a single newsworthy moment. They like to capture entire landscapes with their camera, not simple snapshots.

These two approaches to covering and disseminating events should work hand in hand, with the news providing the daily blow-by-blow accounts and the documentary probing the longer-term causes and effects. But our world has changed. Across the board decisions regarding the direction of news reporting has been taken out of the hands of traditional journalists and placed in those of corporate heads and committees with no knowledge of or regard for what journalism entails. Their interest is only in what they call "the bottom line." While perhaps this concern is a hallmark of the business world, in journalism it is catastrophic. Journalism is more than a business, and thus it must be governed by more than the rules of business. Similar to medicine, it must be based on a code of ethics or it will degenerate into propaganda.

The traditional documentary has been the first victim of this new order. In its place we have been treated to generic, anemic Discovery and A&E versions of reality programming. Gone are the docs by the likes of Robert Flaherty and Marcel Ophüls and the news specials of Edward R. Murrow. Gone are documentaries that follow the examples of such classics as *The Sorrow and the Pity*; *The Sky Above, The Mud Below*; and *Hearts and Minds*. These films rendered a deeper slice of life, of war, of history.

And while business directives have cut the documentarian's vision first, they have gone after the news journalist next but in a different way. As this book shows, news reporting over the last two

decades has devolved with a disregard for truth and depth. The current adage appears to be if the facts aren't exciting enough to get or keep a good rating, then forget about them. The process still requires producers, cameramen, station editors, commentators, and analysts, but it no longer encourages real reportage. "All the news that's print to fit" is no longer just a humorous reversal of the *New York Times*'s motto. The principal purpose of reportage is now, as Noam Chomsky says, to "manufacture consent."

In the chapters that follow, I have recounted my personal experiences in the wake of 9/11 with a number of network journalists, from ABC and MSNBC in particular. While I have changed the names of these newspeople to avoid attacking individuals—for they are not the problem!—I have written of these events as I witnessed them. They do not, at least in this documentary filmmaker, inspire journalistic inspiration or trust in the media.

The coverage of Afghanistan's twenty-five-year liberation struggle is the most revealing case study I've ever witnessed. Although it's been in the news for years now, most viewers have little appreciation of the complete, real story—a wide-screen drama that features some of the greatest heroes and villains of the modern reality stage. Afghanistan's story reveals both the blessings and curses of the American way: the myopia of the Central Intelligence Agency (CIA) and its dependence on other nations' intelligence agencies for factual advice, the willingness of both Republican and Democratic administrations to turn a blind eye to gross human rights abuses, their failure to honor promises when those promises prove inconvenient, and, perhaps the most damning element of all, their willingness to partner with anyone who promises the most brutal fight against America's enemies of the moment.

If the following pages capture the pain, struggle, and at times despair of being a documentary journalist, I'd like to think they capture as well a bit of the joy and exhilaration at meeting some of the most resourceful, resilient, and courageous people on the face of the earth. And I'm pleased to know that I captured these things through the eyes and ears of both the youngish man I was when I started and the older man I am today—having experienced the story from both sides of the great divide.

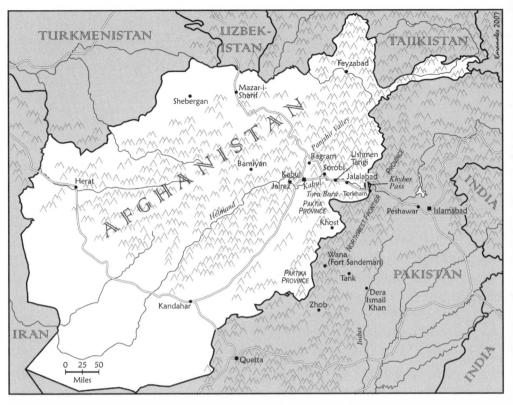

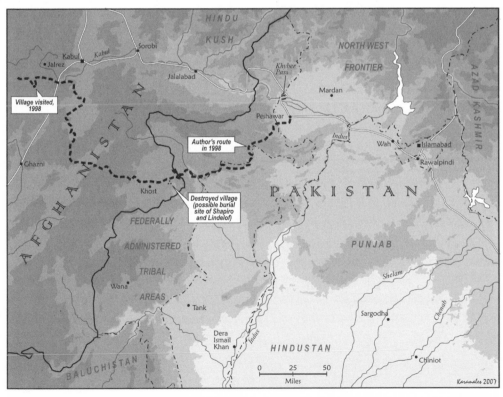

My story is not a pleasant one; it is neither sweet nor harmonious, as invented stories are; it has the taste of nonsense and chaos, of madness and dreams—like the lives of all men who stop deceiving themselves.

HERMAN HESSE, PROLOGUE TO *DEMIAN*, 1925

# Hotel Taliban

After the flight set down in Islamabad on Sunday, November 19, 2001, at 9:00 a.m.—three hours late—Wakil Akbarzai's men met me outside customs holding a piece of cardboard that had my name scribbled on it in neo-Sanskrit. When they asked where my camera equipment was I pointed to the carry-on bag that housed two small Sony VX 1000s. One of the guys, who was in his forties, remembered that fifteen years earlier my partner, Dan, and I would show up with bulky Arriflex and Aaton film cameras and an ice chest full of 16 mm film stock. Time had passed and some things, such as film and hair color, had changed. Many other things, I would find, had not.

Aside from negotiating three Pakistani military checkpoints and colliding with a donkey that heehawed loudly after an encounter with our bumper, the drive to Peshawar was uneventful. We arrived at the Akbarzai compound in two hours. Over the years, Peshawar became a kind of fairy-tale, Arabian Nights place for me. As is most of Pakistan, it's hot, dirty, and crowded and smells overwhelmingly of the rancid aboveground sewer systems. But it has an element of excitement that's born more of its Afghan Pashtun heritage than its current geographical placement in Pakistan about thirty minutes from the Khyber Pass. I always discover wild things here and look forward to that walk through spice-scented, kebab smoke–filled bazaars where I'll stumble onto an extraordinary silk carpet from Herat, or a 200-year-old muzzle-loader, or a Rudyard Kipling first edition. I did not know what awaited me this time, in the wake of 9/11, but I was hoping for something to take my mind off it. I would not be disappointed.

Forty-eight-year-old Wakil greeted me warmly with his usual 280-pound bear hug and introduced me to the ABC news crew members he was escorting to the Afghanistan border. To facilitate my journey, he'd arranged for me to enter Afghanistan on their group permit. They had been waiting several hours for me and did not look happy. Fred and Josh, who were in their forties, were the cameraman and soundman, respectively. Doug, twenty-five years old, was the coordinator and swarthy enough to pass for an Afghan if he'd wanted to. Meredith, in her early thirties, was the pretty but abrasive producer. JM was the elder, savvy, and streetwise correspondent. And along for the ride in a sense was Bill Roberts, who had managed to secure a mandate from his boss, Peter Jennings, to do a "traditional" (today referred to as "long-form") documentary. My partner, Suzanne Bauman, had brought Bill and Wakil together in what we thought would be a mutually productive relationship. We would all be disappointed.

Anxious to get going, I ducked into Wakil's bathroom and donned one of several *shalwar kameez* outfits that have stood me well over the years. You've seen the suits with the baggy Aladdin-style pants and the long overshirts, or tunics, that everyone wears in the region and, in fact, is the male's traditional garb with minor variation in the entire Islamic world. When I reappeared, it only took a glimpse at the glances and body language of the ABC folks sitting around in jeans, Nikes, Laker shirts, and Yankee caps to realize they had no intention of doing the same. I gathered they were of that new brand of American journalist who had no intention of blending in with the locals. I was surprised, and I guess they were too. We were off to a bad start.

From what I'd observed while filming in other trouble spots over the last decade and from watching the evening news, I had a jaded view of recent trends in TV journalism. While I was still a firm believer in the instinctual animal beneath the new corporate veneer, I arrived at this latest conflict with some expectation of seeing the journalists' herd instinct I'd observed in the Gulf War. After all, I was a documentary maker and not a news journalist. My kind always tended to be loners and a bit eccentric.

I held my camera in my lap during the ride from Peshawar to the border, but I didn't notice my battery kit was missing (packed in

one of the other vehicles) until we were already weaving through the Khyber Pass. This time was only the second in more than a dozen journeys through the legendary pass that I had not been forced to hide under blankets and sacks of grain to avoid the prying eyes of the Pakistani military at the checkpoints. The Khyber is the principal route through the Hindu Kush Mountains that links Pakistan with Afghanistan—a piece of work in both the natural and the historical senses—and this drive was my chance to grab a few more shots of it without fear of arrest. I wanted to smack my forehead when I realized I had no power for the camera. Yeah, because of minimal funding, I was also working without an assistant. Tough luck, buddy, I told myself, there's no excuse for not having your camera up and ready! I thought since Fred was in the front seat with his powered Beta SP camera, I could probably count on him to get the shots and dub off a few for me. In spite of several opportunities when the convoy stopped for other reasons, he never raised his camera to capture the dramatic, twisting, upgraded camel path that drops nearly 3,000 feet in a couple of miles. Perhaps he figured that ABC had plenty of this kind of filler in its archives. Or perhaps he just didn't want to wrestle with the tripod, but then he never shot anything at the border either, and that location didn't require the sticks.

At Torqam, the main gate dividing Afghanistan and Pakistan, we saw refugees shouting and pleading in four languages, overladen donkeys, angry camels, bursting suitcases, and tough Pakistani faces beneath army berets, all of them pushing and shouting on both sides of the fence. The smells of human sweat and camel dung clung to everything. We encountered demands for identity (ID) cards, documents, visas, money, and water for a sick grandmother. This final checkpoint before crossing into or out of Afghanistan is always a scene of desperation, but that day, almost ten weeks after New York City's Twin Towers had come down, the panic and confusion were over the top. Wakil, who was dealing with the Pakistanis to secure our entry, was shuttled from one official to another in the dusty, ninety-degree heat. For the first time in sixteen years of working together, this veteran of countless missions—a guy with the look of a wrestler and the skills of an articulate, soft-spoken diplomat—was losing his cool. As JM remarked,

"When you see a guy that big, who always walks, suddenly running and out of breath, you know things aren't goin' smooth!" JM was right, of course, but then this veteran of many decades in network news should have known that things never work smoothly along international borders during wartime. More money than anticipated changed hands and drawn-blood promises of gaining reentry were extracted from the border chief. I remembered the guy from twelve years before when he let me pass into Afghanistan only after guaranteeing my return by holding my passport, as if I might want to take up permanent residence "inside."

For those who can remember back far enough or have heard the tales, the setting had the touch of an acid trip: swirling colors; deafening clatter; guys with guns pushing refugees with rugs, bicycles, babies, and old sewing machines; and me with a limp camera and no way to get to the part of the convoy where my camera batteries were packed. And then there were Fred and Josh, sitting idly behind the rolled-up car windows, probably sweating more than any of us, and not once raising a camera or mike to capture the moment.

The sun was setting in the treeless mountains to the west when Wakil bid us farewell. Escorted by four pickups with two dozen well-armed mujahedin, our caravan began the seventy-mile drive across the plains to Jalalabad. Though the city had been liberated a week before, Wakil knew the dangers along that notorious road and took the required precautions. He would not accompany us but placed us in the hands of Ahmet, one of his most capable lieutenants. I waved good-bye to my friend of many years as he stood in the orange twilight, somehow separate from the swirl of dust and chaos around him as though lit by an arc light on one of John Ford's Westerns.

When I first met Wakil Akbarzai, the thirty-two year old was assisting Western journalists who wanted to cover the Soviet-Afghan war. He was a sensitive and retiring young man who could be forceful when required, who had traveled a great deal, and who knew much about the world both in and outside of Afghanistan. He had been in graduate school in Bangalore, India, when the Soviets marched into Kabul. When he returned home to Jalalabad, Wakil learned of his brother's death in an air attack, boarded up the family home, and

moved his parents to the safety of Pakistan. With his family closely related to that of Pir Sayed Gailani, the foremost moderate Afghan commander in the struggle against the Soviets (and a Sufi mullah), Wakil immediately took up arms with Gailani's military arm, the National Islamic Front of Afghanistan (NIFA). Gailani, ever the astute leader, quickly saw his talents and moved him to his diplomatic corps. Over the years that followed Wakil honed his diplomatic skills to such an extent that, after the Soviets had left the country, many sought his services, including the United Nations and then the Taliban. He deferred on the last, preferring to live in exile. Today, with thirty more pounds on his robust physique and a graying beard, Wakil was at the top of his game.

Since I had first met Wakil, he had arranged and accompanied me and my crews on ten trips inside Afghanistan. With Wakil at the helm of any enterprise, I knew I would be well cared for and safe. The ABC crew, however, never took the time to inquire about their facilitator. While waiting for me to arrive in Islamabd, Wakil had explored reports of trouble along the Jalalabad road; retreating Taliban soldiers were sniping at vehicles. The ABC crew was certain the road was safe (as if anywhere in Afghanistan was "safe" then) because the BBC had had a base in Nangarhar Province for five days. They figured Wakil's story was simply to cover up my delayed flight. It's certainly true that whether trouble was on the road ahead or not, Wakil would never have left without me. That was the established plan, and he'd stick to it in spite of the ABC crew's impatience. An Afghan's loyalty has little or nothing to do with money or business; it is based on honor among family and friends. It may not be the American way of conducting business, but to write it off casually would be a great loss.

As we left Wakil and the border, we passed a sign I would have given a contact lens to shoot. Awkwardly hand-painted big black letters welcomed us in English:

> The Emirate of Afghanistan . . . Drugs, cameras, and illicit books with photos will be punished with hard penaltys and deaths possibility.

Alas, the sign was gone when I returned a month later on my way back with a hot battery.

The Taliban had obviously repaired the roads since my under-cover trip to the area three years before, and we were able to move at an average speed of around thirty miles per hour. We arrived in Jalalabad close to 9:00 p.m. and stopped first at Haji Zaman's compound, where the new deputy governor (just recently arrived from Dijon, France) welcomed us with green tea. JM complained loudly of needing sleep. Haji Zaman nodded, understanding, and released us all from further tea. Back in the trucks, we headed for the Spinghar Hotel, where Meredith said rooms had been reserved for us. As we pulled into the old building's circular courtyard, the caravan's head-lights caught the blanket-wrapped mujahedin rushing from the door-way to greet our guards and drivers, all in the warm, time-consuming Muslim manner.

Meredith disregarded the local protocol and pushed her way through the crowd of other journalists and commanders to the hotel's front desk. When told no rooms were available, she called for Ahmet to translate her indignation, but anger achieves little in this part of the world. The hotel didn't have a functioning telephone, explained the heavy, turbaned guy behind the counter, so he couldn't alert her that dozens of other journalists had arrived the day before and taken the rooms. As a matter of fact, no one in Jalalabad had had phone service since the last Talib had left town (or cut his beard and thrown away his turban). The counterman added unapologetically that the Spinghar was the only hotel, and while no rooms were vacant then, *Insh'Allah* (God willing), there would be soon.

Noticing Ahmet's discreetly opened wallet (which Meredith did not), the clerk suddenly reconsidered. He thought one small room just might be available, if Meredith didn't mind paying a higher price since the entire crew would be staying in it. Meredith and her gang were exasperated. How could all six of them plus the "independent" (me) stay in the same room?

The ABC folks were pissed off and tired. Delays, hassles at bor-ders, payoffs, bad roads, no phone service, people taking their rooms,

suddenly escalating prices, chaos, and deceit—it had all taken its toll. When Meredith shouted about "highway robbery," the clerk merely smiled and shrugged his head with that familiar sideways tilt that in South and Central Asia means whatever you want it to mean. Did the lady desire the room or not?

The situation at the Spinghar produced the first crisis for the ABC team. They couldn't decide on the sleeping arrangements. Would they all stay in the same room? Would some sleep in the hallway or on the couch downstairs (where they could be "robbed or murdered in their sleep")? Should some go back to Haji Zaman's and sleep with the mujahedin, where they'd have to sip their scotch under the covers? They kept changing their minds about what to do, loading and then unloading the twenty heavy cases of camera and sound equipment. In bemused disbelief, I found my camera batteries and filmed some of the routine. Meanwhile, JM found his bottle of scotch and disappeared.

While the others wrangled over sleeping arrangements, I decided to return to Haji Zaman's with our drivers and sleep in the soldiers' compound. I said good-bye to the team as they searched through their suitcases for towels and other items to create bedding.

I woke up the next morning at Haji Zaman's much earlier than I would have liked. During the month of Ramadan, Muslims do not eat or drink from sunrise to sunset; consequently, breakfast in the dark at 4:00 a.m. is a big, festive affair. People ate heartily, drank buckets of tea, talked, and laughed until the sun peaked above the horizon, when consumption would cease for the next twelve hours. So there I was, wide awake and bone tired, watching the first burst of Asian dawn "coming up like" Kipling's "thunder" and wondering what I was really doing here.

These last weeks since the Towers had come down had passed so quickly that I'd scarcely considered the purpose of my visit this time. Was I here to get material to explain how the Taliban and al-Qaeda had evolved? Or would I gather more footage for our sixteen-year effort that was as much a coming-of-age video–memoir of me as it was a documentary film on Afghanistan's long struggle? Or would I shoot footage to help Direct Relief, the refugee aid organization, do its job in a world that now suspected every Muslim of being a terrorist? Or, last,

was I, as so many other journalists, just covering the latest sensation to make a few bucks?

That morning at Haji's, sixteen years after I'd first come to this troubled land, I knew my reason for being in Afghanistan yet again was a combination of all the above. But the ongoing incarnation of horrors in Afghanistan also resulted in the most amazing story I had covered in a long career. This improbable tale, now having taken yet another improbable turn, was still evolving. I had to admit I was hooked on the whole monstrous epic, feeling perhaps the same way as a songwriter who'd written a good verse and chorus but couldn't find a way to end the thing. I couldn't fade to black on such an unfinished mega-tale as this one.

When I rejoined the ABC crew members at the Spinghar around 9:00 a.m., they were eating breakfast on the bright, sunlit upstairs patio for all the locals to see. This was not a cool move in a Muslim country during Ramadan, and the veteran JM, if no one else, should have known better. I grabbed a quick shot of them. Bad call. The moment they saw me filming, I knew that their attitudes, especially Meredith's, had shifted from discomfort to outright hostility. What the hell was I doing there with them anyway? The unspoken question was written clearly across her uptight face. I had presumed Bill Roberts had told her about discussions he and I had had back in the States, about my experience in Afghanistan and my reputation as a good "shooter." He was considering using some of my new stuff along with my old material in his long-form piece on Afghanistan. None of this information made any difference to Meredith, who only saw me as a tagalong with no commitment to ABC. They were on the payroll, and I was not. All deals were off. She suggested I find my own transportation to Kabul.

I understood her position and held no grudge. They had every right to tear up the entry visa fiction Wakil had created to get both them and me across the border in one caravan. What I didn't understand, however, was why I had seen neither Fred nor Josh raise a camera or a mike to get a single shot yet. Jalalabad held little attraction for them. At noon they and more than a dozen other journalists were going on to the big show in Kabul in the eight-vehicle caravan. That was OK by me. There was plenty to keep me busy in Jalalabad. After all, aside

from being Afghanistan's number three city in military-industrial terms, it was rumored among the mujahedin to have been Osama bin Laden's favorite hangout. Certainly a few big clues could be found here to fill in the picture of this mysterious mastermind.

I ran into Roberts before he left and wished him well. He didn't seem happy and wondered aloud if he should go with the gang to Kabul or stay with me. He affirmed that "this was not the crew" to do what he had in mind. (What did he have in mind? Surely not the bin Laden special that would be broadcast four months later, bearing his name among a legion of others, and that would suggest our under-cover guys could easily track the arch terrorist through kidney dialy-sis machine sales!)

I bid the crew farewell and headed for the hotel room it had vacated, determined to catch up on my sleep. I cleared away the half-empty water jugs, cigarette butts, and dead scotch bottles and closed the curtain to block the midday sun. I stretched out on the bare mat-tress and reflected about the ABC crew's prissy, pissy attitude and some of the goofy conversations I'd had with NBC and CBS before I'd left the States. Then I thought about the large convoy of innocents choosing to leave town and head north through some troubled terri-tory without a military escort. Wakil had two dozen armed guys ac-company us to Jalalabad from the border. These folks were in a hurry, I guessed; reporters are always in a hurry. They were probably safe enough while traveling in large numbers. At least their drivers prob-ably had pistols.

Before I dozed off I thought about two other journalists—Lee Shapiro and his soundman, Jim Lindelof—who had headed from Pa-kistan to Kabul fifteen years before. I'd followed their story ever since I'd first talked with Shapiro's colleague, Dr. Carmen Zuniga, in 1988. I had been deeply moved as she shared with my partners and me their personal quest—that is, to make a feature-length film of Afghanistan's plight and to play it in theaters across the United States. When Shapiro and Dr. Zuniga had first traveled to Afghanistan back in 1986, they had gone in with guns too, and with ideologically sympathetic mujahedin. But later, when Shapiro and Lindelof took that trip to the Panjshir Valley in quest of an interview with Commander Ahmed Shah

Massoud, they had grown impatient while waiting for a moderate organization to arrange their travel. Agitated and in a rush, they'd gone in with the wrong people, the Wahhabi fundamentalist Hezb-i-Islami (the Islamic Party). In fact, the organization's messianic leader, Gulbuddin Hekmatyar, was the arch foe of the religiously moderate Massoud, the "Lion of Panjshir," who had harassed the Soviets at every turn.

Maybe Shapiro didn't see these facts as clearly in May 1987 as we do today, but if he had done his research and asked around, many other journalists at the time would have set him straight. Carmen has since said on many occasions that Shapiro was not a journalist but a documentary filmmaker. As I noted in the preface, there's a difference, perhaps a big difference, between the two professions, but when it comes to the art and science of survival, both should take the same precautions.

Shapiro's unfortunate, mysterious story made a good handle with which to tell the far bigger story of Afghanistan's struggle with the Soviet Union. He was an American documentary filmmaker who had felt the Afghans' tale was so important that he'd risked his life to tell it but, I must add, too few were interested in hearing it. Journalistic coverage—or rather, the lack of it—had been one of the primary themes of our story in the 1980s and '90s, and we'd seen no reason to change it because of 9/11. Little did I know at that moment in Jalalabad on November 21, 2001, Shapiro's personal story would become even more pivotal to our effort.

Why had so few television journalists and documentary filmmakers from the West covered that amazing David versus Goliath encounter between one of the poorest (in terms of per capita earnings) nations in the world and one of the two superpowers on the planet? Was it not Jewish enough in context for U.S.-Israeli relations? Did it not have a Christian hook for viewers in the Midwest? Was it not left wing or right wing enough for respective U.S. administrations? What the hell was the reason? Why was the actor Sylvester Stallone the only American who could imagine himself a warrior in Afghanistan when British readers in the nineteenth and early twentieth centuries were starved for the latest Kipling or Sir Richard Francis Burton account of

the battles and conspiracies there? Now I remember, in his movie Sly was there to save the helpless mujahedin from the Ruskies with his American muscles. Journalists didn't need to cover the Afghan story when Sly had it in hand. Whatever the reasons, the real story was ignored then, but in 2001 many folks were interested in it. Everybody was here at the Spinghar.

But something didn't feel right about the scene. In fact, it felt downright wrong. I finally nodded off with a sense of foreboding.

# 2

# *Nation of Exiles*

**Our long journey through Afghanistan began** in March 1986. My team—fellow producers Suzanne Bauman and Dan Devaney (Seven League Productions)—and I had produced two documentaries during the preceding five years on refugees for PBS. Perhaps my Catholic upbringing was telling me that important things, beginning with the Holy Trinity, usually happen in threes. The first documentary, *Against Wind and Tide: A Cuban Odyssey,* which covered more than refugee issues and logistics, had at its core the story of the 120,000 Marielitos who had fled Fidel Castro's Cuba in 1980 for a supposed safe haven in America. Of course, Castro had mixed the good apples with fruit flies when he allowed 10,000 prisoners and mental patients to board the refugees' shrimp boats along with simple freedom seekers. (My bleeding-heart wife and I had even ended up sponsoring one of the latter, with the final chapter of that story reminiscent of a scene from *Law & Order*.) Castro's brilliant but unconscionably cynical ploy undermined any legitimacy the Mariel refugees tried to claim for years to come. Still the Immigration and Naturalization Service (INS) awarded preferential treatment to anyone who sought safe haven from communist dictatorships and in the long run granted most of the Marielitos legal asylum status in the United States.

Alas, the Haitian refugees who began arriving on U.S. shores the following year had no such pedigree. They were merely fleeing a brutal dictatorship, not a communist one. In our second refugee opus, *The Closing Door,* we sailed with these people in their leaky boats with patched sails a far greater distance than Havana to Key West, only to see them incarcerated with little fanfare upon arrival. Many were even

stopped at sea and sent back. To complicate their status, U.S. authorities had deemed the Haitians were also carrying a terrifying new disease the press was calling the "gay plague."

So I was well aware not all refugees were treated equally when I accepted an assignment with the U.S. Committee for Refugees. I'd shoot part three of the trilogy and take my team to other key points around the globe where people were running for their lives. In northern Guatemala in January 1986, we filmed the exodus of an entire village of indigenous folk fleeing to Mexico. The evening before, as these people explained, they had heard gunfire and screaming from a neighboring village. They soon learned Guatemalan army forces had locked its entire population in the church and then set fire to it. All were killed, they said. Within minutes, the frightened villagers had taken to the path with their kids, goats, cook pots, and sewing machines. Following Guatemala there was Mozambique, where South Africa's apartheid government had sent paramilitary squads to quell with extreme prejudice that nation's growing revolutionary movement, resulting in an exodus of refugees into neighboring Zimbabwe. From there we visited the Thai-Cambodian border, where we filmed a prosthetics factory manned by maimed survivors of the Khmer Rouge's genocide program. These people had plenty of reasons to run from Cambodia, but first they needed legs. All these people seemed to me to have valid claims to refugee status.

But the Afghan refugees didn't merit it, not in my opinion. I imagined the reports of 2.5 million people supposedly huddled together in camps along the border in Pakistan were another Cold War fiction the U.S. government disseminated just to one-up the Soviets. And I still felt that way when I arrived there with my three-person crew in March 1986. I was so uncommitted to this segment of our refugee coverage, in fact, that I had failed to obtain the necessary documentation from the Pakistani consulate in the States. Of course, we faced a big hassle at the Islamabad airport, but I still managed to get the team into the country. The officials told us there weren't a heck of a lot of journalists in Pakistan at the time, and they seemed delighted to see us. It all simply reinforced my hypothesis that something bogus was going on there. While I would encounter much in the years ahead

that I could label "bogus," especially regarding Pakistan's ongoing effort to manipulate Afghanistan's political scene, I soon discovered the tales of the millions of Afghan refugees and their camps were real.

We checked in with the United Nations High Commissioner for Refugees (UNHCR) in the Pakistani capital for a briefing on the situation. The Soviet-Afghan war had heated up again in the eastern Afghan provinces, and a massive wave of new refugees was flooding across the border. They said Soviet helicopter gunships were even attacking in Pakistani territory in the Khyber region, killing great numbers of Afghans who had made it as far as the pass.

I asked if the UNHCR could arrange for us to cross the border via the Khyber, knowing full well that by mandate the UN could not and would not cooperate with such a request. The deputy offered instead to have her people fly us to a remote region in Sindh, where we could link up with a Pakistani doctor who would take us across the border and where refugees were streaming through the mountains. When I asked why she suggested we go to South Waziristan, which sounded to me as if it were a location from *Raiders of the Lost Ark,* she replied that Waziristan was far enough away from this latest Soviet offensive for our team "to get in and get out alive, with a bit of luck."

This strange response was an odd departure from the UN's traditionally neutral position. To be honest, the deputy's willingness to help disturbed me, as did her final caution: we should always "walk in the footsteps of the mujahedin." It struck me as almost biblical. Clearly, she didn't think the Afghan refugee program was a phony operation.

A UN driver took us straightaway to Peshawar in the Northwest Frontier Province. I had read enough to know this exotic, fabled city had been a key crossroads for centuries in the histories of India, Afghanistan, and now Pakistan. Once there, we went directly to the National Islamic Front of Afghanistan's offices. A moderate Islamic military organization, NIFA held close ties with the West and believed in the return of exiled Afghan king Zahir Shah. At NIFA we met a sturdy, bearded man in his early thirties who, we were told, would make all necessary travel arrangements. He spoke near perfect English. His name was Wakil Akbarzai.

The next morning we awoke in our rooms at Door's, T6 celebrated, seedy hotel from the British colonial period. Wakil, now joined by four armed men, waited outside in two muddy Land Cruisers. He had come to escort us on a tour of the refugee camps before our trip to Waziristan.

The rain began falling in thick, wind-blown sheets as we arrived at the first camp. Thousands of people, mostly women and children, huddled together under leaking tarps and tents. Wakil stepped out from behind the wheel of the Toyota with one of the soldiers and began sloshing through the mud as though it were an average day. He stopped and glanced back at us, still sitting in the car. Water dripped from his chitrali cap in great rivulets, as he waited for us to join him. I felt irritated, almost angry, and inclined to let him know that $30,000 cameras didn't do well underwater. But after watching him stand quietly in the deluge, restraint got the better of me. If he wanted us to film something there, we'd goddamn well do it, rain or not, and show him what we were made of.

As we wrapped and taped the Aaton camera and the Nagra recorder with plastic garbage bags, Jeff, Dan, and Brenda—my camera and sound team—and Kate, my coordinator, began laughing at the absurd prospect of filming in such conditions. I'm not talking about a run-of-the-mill flash flood here; in all seriousness, we may have done better with wetsuits and underwater camera housings. As we climbed out of the truck, Brenda took a header into the mud. For a minute she simply lay there, laughing as rain poured into her open mouth. Then she glanced over at Wakil and pulled herself together.

For several hours we walked with Wakil through the camp, filming him as he checked in on particular refugees. We did our best to record the conversations along with Wakil's translations, but the roar of the rain drowned out most of it. Finally, the high-priced Aaton, with its fragile computer technology, succumbed to the moisture. Then Jeff pulled a wind-up Bolex camera from his backpack and kept filming. He took shots of old wizened men and small boys wearing soaked rags, a young teenager who held a pan above a tiny dog to protect it from the rain, a man who sat before a little potted tree and watched the raindrops hit its leaves, and a boy who played the flute. A woman managed to cook food over an open fire by blocking the deluge with

her ratty shawl. When the shawl caught fire, she stamped it out in the mud and threw the smoking remnant back over her shoulders.

A few hours later we arrived at a pathetic canvas-covered field hospital, almost ready to check ourselves in from the wet and the cold. Small bodies in casts and bandages filled all the makeshift beds and gurneys. Some children were missing a leg, some an arm. Others were missing both, and a few had massive head wounds and had lost parts of their skulls. Wakil said that these kids were mostly victims of land mines. The children simply stared at us, and even with the rain pounding on the canvas, it was strangely silent. No one cried or moaned. No one expressed any pain.

I'd grow accustomed to the Afghans' stoicism in the years to come, but right then it unnerved me. It seemed weird and unnatural. Maybe they were all on drugs, I thought, or maybe some military heavy or mullah had told them to be good little soldiers. I stared at the small, sad eyes that stared back at me. I glanced over at Jeff, Brenda, Dan, and Kate and saw that they too were stunned. We were witnessing a different way of dealing with pain and grief than we had ever encountered. It was disturbing.

The next morning Wakil put Jeff, Brenda, and me on the UN helicopter for South Waziristan. Dan and Kate stayed in Peshawar to scout some way for us to get through the Khyber. The day clear of rain, the flight took about two hours, and we tracked the mountainous border of Afghanistan all the way. Something about this stark, rugged range with the ever-present blue haze beckoned me from the start. It reminded me, ever so slightly, of the mystical corona that veiled the Blue Ridge Mountains of Virginia, where as a kid I went camping with my dad.

We landed in an open field near what looked like an old fort. A middle-aged bearded man with a smile so broad I could see it through our dirty windshield as he stepped from his sport utility vehicle (SUV) bearing a UNHCR insignia. Dr. Wahid leaped from the vehicle to embrace Jeff and me as if we were long-lost brothers. To Brenda he bowed with his right hand to his heart as though taking an oath before God. We climbed into the SUV and headed for the massive, old, brick structure, which I could now see was indeed a fort. As we passed through

the arched gate, saluted by a tribal military guard in a red uniform, Dr. Wahid explained in dreadful English that the British had built Fort Sandeman at the turn of the nineteenth century to protect the region (then India) from incursions from the north (Afghanistan) and further north (the Russians). He said we were, in fact, the first Western visitors in many decades. Perhaps longer than that, I mused to myself as I gazed around at what could have been a massive movie set from such old films as *Gunga Din* and *Bhowani Junction*. Maybe we were the first visitors since the local Pashtuns had seized the fort and sent the British running. As we pulled to a stop, another uniformed guard rushed over, saluted us, and opened the heavy wooden door to the fort's main courtyard.

We were introduced to numerous local dignitaries, who, along with everyone else in Waziristan, spoke no English whatsoever. We were then led into a great stone-and-brick anteroom, past an enormous fireplace with roaring fire, to the two connecting bedrooms that were to be our quarters. The few appointments, which included a nineteenth-century water closet, were primitive but clean and functional. Another man entered carrying a tray with a teapot and cups and bid us in friendly gestures to make ourselves comfortable. Then he brought us towels and stirred the fire before taking his leave, walking backward on bare feet and bowing as he left. Just maybe we were the first Westerners here since Robert Clive.

The doctor arrived the next morning with several men who also spoke no English. None of them were armed that we could see, but they had the look of important, weathered, tribal leaders, wearing rugged lambskin coats and a strange, heavier version of the chitrali cap that was worn by other mujahedin we had encountered. The only problem we had was we could barely communicate, even with the good doctor, though he sincerely tried. I figured we were nevertheless in good hands and decided to relax and see what developed.

Then Dr. Wahid pointed to Brenda's hair. She had donned the local clothing in Peshawar, as had all of us, and was wearing a head scarf. He gestured to her woman's clothing and spoke with the other men in Pashto. From the back of his car, he took out a man's shalwar kamees and chitrali cap and proffered them courteously to Brenda.

She stared at him. After several awkward attempts, he found a way to explain the delicate issue. Since Brenda would be doing the work of a man, she should dress in men's clothing. He seemed to say the Afghans wouldn't mind that she was a woman (which given her statuesque build would have been hard to hide); they would accept her wearing the man's costume as respect for their ways.

Brenda went back to our quarters to change and returned, appearing hesitant in her new outfit, but Dr. Wahid and the others smiled, confirming their approval. We all climbed into the doctor's vehicle and headed for the rugged mountains with the blue haze.

An hour later, as the dirt road entered the foothills, light snow began to fall. Snow, of course, is nowhere near as problematic for cameramen and cameras as rain is. Besides, this time we were prepared. The higher we climbed into the mountains the harder the snow fell and the deeper it got. Several times we got stuck in snowdrifts but managed with our manpower to extricate the Toyota.

At the edge of a precipice overlooking a several thousand–foot drop, Dr. Wahid stopped the vehicle without warning or explanation and stepped out with the other men. They observed the late-morning call-to-prayer and spread out on the windy, snow-covered landscape to find their own private places to pray. No one looked for us to participate. We stayed by the car and filmed them as they performed their dry ablutions and prostrated themselves in the snow. Both Jeff and I had filmed Muslims praying on other occasions in other lands, but these Pashtuns displayed none of the performance element we had occasionally observed.

With the snow now coming down hard, the doctor stopped the vehicle in a small canyon where a rock overhang blocked most of the blizzard. We had gone as far as we could by vehicle. The rest of our journey would be on foot. Reading my mind, Dr. Wahid produced a hand-drawn map, and I was able to understand enough to know that we had covered a third of the distance to our destination, marked by an X. We had another few hours to go on foot and would probably spend the night somewhere higher in the range. It appeared that the X marked the spot where refugees were crossing through the mountain passes.

As we left the vehicle behind and headed into the snow, our team carried their L.L.Bean backpacks and camera gear, and the doctor and the other men their carpetbags. As we walked along, one man produced an automatic rifle from beneath his clothing while another shoved an old revolver into his pocket. I learned then that the tentlike shalwar can hide a multitude of crimes. We followed in single file behind the rifle-bearing man along where the road must have continued beneath the snow. The silence was broken only by the crunching snow beneath our feet.

After hiking an hour, our guide held up his arm for us to stop. He gazed around carefully for a minute or more and then called out across the steep chasm. From the far side came a responding call. With the wind now driving the snow at a sharp angle, we couldn't make out a form to go with the voice. Then our guide led us around the gorge to a high point, where a solitary figure sat motionless on a rock. His beard a tangle of icicles, the man wore a turban and sheepskin clothing with woven red designs. Judging from the amount of snow on him, he must have been sitting in that spot for quite a while. A vintage World War I Enfield rifle in an embroidered sheath lay across his lap, and with eyes narrowed to slits, he stared into the driving snow. I followed his stony gaze to a deep canyon pass ahead of us. While the man spoke with our guide, he never took his eyes from the canyon, not even to check us out. He raised his hand and pointed to the far end of the pass. I strained to see and gradually made out forms moving through the shimmering white veil. Several groups of people, each with a few camels and goats, headed in our general direction. This man, I realized, was guarding the pass and protecting the refugees making their way to Pakistan. As we left him to his lonely duty, I wondered if another sentry ever relieved him.

Once in the pass, we encountered the refugees. Some in ragged blankets trudged through the snow with children and bags on their backs, and some sat beside small fires, trying to warm themselves before going on. The only sounds were those of the snow falling and the bells on the necks of their goats, tinkling as if in a ritual.

Something in particular about the image of camels in the snow haunted me. From my own experience it seemed an incongruous match.

Camels belonged on sand dunes, not in the snow. The image has never left me.

The elderly, the sick, and the injured rode the camels. A few of the beasts had beds strapped to their backs so the infirm could lie flat beneath heavy blankets. We hiked deeper into the pass to film the people, trying to maintain what we hoped was a respectable distance.

In one small caravan headed directly toward us, a camel carried a boy of about ten or eleven years old. The camel stopped in front of us for a good minute, and I noticed from the way the boy sat that he was injured. He was wrapped in a blanket that half covered his head, and he stared at me through the snowfall with the same sad, silent expression I had encountered in the field hospital. Then I noticed a small, red puddle forming on the snow beneath the camel. I traced the red drops up along the camel's flank and saw the boy's leg was missing.

I gazed up, transfixed by the sad young eyes that for a brief moment pierced the snowy gulf between us. In a breath I was tied to him. Then in another, the distance between us stretched to what I knew would be forever. I would never know more about him.

Then the camel stepped forward, continuing its journey. The boy turned to watch me as the animal carried him off, his face slowly dissolving into the snowfall. The goats' bells tinkled in the distance. Then he was gone.

# 3

## *A Road Less Traveled*

**The journey back to Peshawar did not go as planned,** and our ignorance of the region would prove a real liability. The UNHCR radioed that it was unable to send its helicopter to get us. Numerous bombs had been detonated in Peshawar's business district, they said, leaving dozens dead and many more wounded. Since the UNHCR choppers were flying the victims to hospitals in Islamabad, we would have to make our own way back over land across the Pashtun tribal belt, 200 miles of the most xenophobic part of Pakistan.

The good doctor came to our aid—again, gathering together a small coalition of tribal chieftains from the areas through which we would have to pass. To a man, these Pashtun chiefs were grizzled, gray-bearded men of hard countenance. Smiles seemed quite out of place on their faces. Dr. Wahid also rounded up three vehicles for the journey. The first would carry the five chiefs, and the last vehicle, five warriors of their choice. Jeff, Brenda, and I were told to ride in the middle vehicle and to stay on the floor at all times, never raising our heads above the windows.

This advice seemed a bit drastic—after all, we were only filmmakers—but we would soon learn the doctor was not exaggerating the danger. We would be traveling through some places that had not seen a Western visitor since the second Afghan-British war in 1878. Foreigners, even members of other Pashtun tribes, were not welcome there, and punishment for territorial encroachment was severe. This journey was not to be taken lightly.

We left Fort Sandeman at three o'clock the next morning to cover a particularly dangerous stretch before daybreak. Crowded on the floor of the car, we made ourselves as comfortable as we could under blankets. In spite of the warnings, Jeff insisted on keeping his camera ready, just in case. Lying at an angle on the floor, I felt the vertebrae in my back slip more out of line with each pothole we hit on the dirt path.

It was a strange experience indeed to pass through this land while staring up from the car's floor at the high passes and forbidding canyon walls. When the sun rose we were in different terrain, undoubtedly the most rugged I have seen before or since, and my spine has never been the same. Great jutting peaks of ragged rock and harsh, twisted geological formations seemed the creations of a disturbed cosmic mind. We did not see a blade of vegetation. It made John Wayne's Old West movie sets seem lush by comparison.

The slanted horizon and the vehicle's violent bucking made us sick if we kept our eyes open for long. At one point Brenda had to throw up, and she sat up to lower her window. Our driver slammed on his brakes, and several men from the rear vehicle rushed up to block any view of the alien woman from possible eyes in the barren landscape. They stood in place until she had recovered and returned to the floor of the car. If any people were out there in the rocks I never saw them, but our tough escorts' quick reaction spoke volumes about what might happen if we were seen.

By midday, the journey had become excruciating. My back pain and now leg cramps were out of control, and the claustrophobia had become stifling. Jeff couldn't stand it any longer and at one village peaked over the windowsill with his camera to grab a shot. The men were on his case in seconds, shoving his head roughly back down to the floor. They were beyond edgy now and clearly indicated we had to stay out of sight all the time. No exceptions! Jeff got the message and put away his camera.

As the daylight waned we approached another village where we could hear the sounds of people and vehicles on the street. My stomach churned nervously and I gripped the floor. Our driver stopped the car and shouted something we could not understand. A chief

appeared at the window and pointed to the blankets under which we were supposed to be hiding. We lay as still as statues. The conversation we heard outside sounded none too friendly.

In a need to see what might be coming next, I maneuvered a small slit in my pile of coverings to watch the window. Suddenly a man's turbaned head materialized from nowhere and leaned its face against the glass. I held my breath as his breath fogged the window. There was a long pause, then his eyes met mine. He turned, gave a loud shout, and was joined in an instant by several other men who began pointing inside the car and growling.

With my head back under the blankets, I could hear our men arriving to bust up the scene, but the shouting increased with the growing size of the crowd. I held my breath and clutched the blankets, feeling like a terrified child in bed listening to the creak of an opening closet door. After a minute I heard the car door open and felt someone pull off the blankets. I looked up at the anxious face of one of our chiefs, who gestured for us to get out. The jig, as they say, was up.

About fifty men eyed us as we stumbled out. The shouts subsided as our men presented us to the crowd, probably to show them that we weren't desperadoes or Soviet spies. Then one middle-aged man began screaming in a high-pitched, singsong voice. I figured he was the mullah of the village. He pointed an angry finger at Brenda, who did her best to cover herself with her blanket. A hum went up from the crowd. Our escorts shouted back at the mullah, and the crowd grew nastier. I noticed every man was carrying a weapon of some sort, and many wore the traditional crossed bandoliers featured in photos from Kipling's era. Some began shaking their fists.

One of our escorts ushered us back into the car as the shouting match continued. Our driver started the engine. In seconds he had the car in gear and moving through the mob. Villagers began pounding on the hood and the roof. I looked back to see the other two vehicles following us through the mob. Several rocks hit the side of our car, and one cracked the rear window.

When we were free of the crowd, our driver floored the accelerator. We ducked under our blankets and braced for a ride from hell.

We had finally met the legendary "Pathans," as the British called them, notorious in both literature and war.

Late that afternoon we left the mountains and descended into the plains, where the temperature rose twenty degrees. For the next ten miles security eased, and our driver gestured that we could sit up and look out the window. Clearly we were in a more laid-back region.

We arrived at the city of Dera Ismail Khan and stopped at a stark concrete building in the center of town. The monolith looked as if it were under long-term reconstruction, with tie-rods and dusty timbers sitting in several corners waiting for mortar. Our escorts spoke to the hotel man who smiled at us with a broad toothless grin. We would be safe and happy at the Shalimar Hotel, he assured us in reasonable English. We checked in (which means we paid up front) and then joined our Waziristan guardians in the adjacent restaurant to share a quick meal of Coca Cola, yogurt, and naan (unleavened bread). While we ate, our grizzled guys struck up a conversation with a truck driver, who agreed to take us to Peshawar in the morning. Then they bid us good-bye with firm handclasps and out-of-place smiles and climbed into their cars. I have never met another group of men like them— though as boot but on your side to the end if they liked you.

Later, the hotelier led us by flashlight upstairs and down a dark hallway to our room. He pulled a cord that illuminated the dingy space with a bare, twenty-watt bulb. Jeff and I were shown the double bed, which lay at a thirty-degree angle, while two of the manager's helpers carried in a traditional rope-webbed cot for Brenda. The three men bowed and left the room, closing the door as far as it would go. Jeff lit one of our gas lanterns to lighten the gloom, and I poured the last of the rum I'd brought along in a thermos. We sipped without speaking and gazed at each other in the flickering light that was already attracting the bugs. It had been a hell of a day, and we knew that not even malarial mosquitoes would bother us.

Then in the hiss of the lantern we could hear buckets of water being poured in an adjacent room. Someone was flushing a toilet. About thirty seconds later, we heard water trickling across the floor. I dug in my pack for my flashlight and shined it on the yellow stream that passed through the center of the room to a hole in the exterior wall.

The waterway was no accident; it followed a shallow trench that had been gouged out of the floor. Our room was in the path of the hotel's sewage system.

Despite the inconveniences I slept well and was up and out on the street before sunrise, looking for a cup of coffee. I hadn't yet learned that in the Pakistani outback this brew was nonexistent. Alright then, a strong cup of tea would do. Everyone I encountered stared at my fish belly white skin, but at this early hour only a few people were out on the street setting up their vegetable and meat stands. I decided to wander a bit and headed up one dirt street and down another. Wherever I traveled in remote regions of the world, people generally stared but never as harshly as the Pashtuns did. When I smiled they managed to nod a bit but that was it.

I stopped at a food stand and pointed at a banana when my attention was drawn to a loud, clanking sound. I turned and saw a large metal door opening slowly across the street. More than a minute after the door squeaked to a halt, there suddenly appeared a legless man on a wheeled platform that he pushed along quickly with his hands. Behind him wobbled a dwarf with hands that grew directly from his shoulders. After them came a long line of deformed, crippled, and maimed humans, all with cups in their hands or hanging around their necks. In my mind, there should have been some Fellini circus music, with tuba, accordion, and clarinet, to score this parade of the disabled. I stood there silently cursing that I had left my camera in my room, and watched as they made their way past me to the street corner. There, those who had arms embraced each other in the Muslim manner. Then they split up to spend their day begging on the hot, dusty streets of Dera Ismail Khan.

# 4

# *Discretion and Valor*

**The trucker delivered us to Peshawar later that day.** I was relieved to see Kate and Dan with their limbs intact after the bombing reports we'd received in Waziristan. I knew they'd been busy with Wakil, arranging a sortie for us across the Khyber, and the operation was only awaiting our return. Peshawar was now a troubled place, and everyone was expecting another attack. The Soviets had launched another air strike in Pakistani territory just across the border in the Khyber village of Landikotal, and a tank mine had blown apart a bus filled with Pakistani civilians in another town along the Khyber road in Pakistan. Nevertheless, Wakil had made arrangements with NIFA's highest-ranking commander, Rahim Wardak, to smuggle us through the Khyber the next morning.

Kate and Dan, however, were upset about the plan and dead set against us going across the border. I had not worked with Kate before this project and didn't know if she was overreacting, but I had been in many extreme situations with Dan, who always maintained a cool head. If he was concerned about the situation, I had to take notice.

That night as I lay in bed in my room at Deen's Hotel, I stared up at the squeaky ceiling fan, which was doing its best to cool the steaming room. I recalled the field hospital and the eyes of those Afghan children missing limbs and parts of their skulls. And then there was the boy on the camel, who bled red onto the white snow. I saw the boy staring at me once again as I dozed off with the lamp on.

As I dreamed, the fan blades morphed into a gunship propeller that separated from the chopper to become its own vengeful force. I was on the ground, staring up at the metal beast, as it began falling

from the sky. Suddenly I realized the propeller, with its glistening blades spinning faster than those of Edward Scissorhands, was targeting me. Across a stark landscape littered with corpses, reminiscent of World War I's trench warfare, I ran to escape the blades and dodged land mines peeking just above the surface with Cyclops eyes. With nowhere to turn, I began leaping from space to space between the mines as the noise of the spinning blades came closer. I leaped faster, the mines a blur below me, the blades just above.

I woke up screaming, falling from the bed and pulling the dresser and lamp down on top of me. The hot bulb burned my face and shocked me from the dream. I sat up in the rubble and gazed up at the fan, still spinning above me. I made my decision.

When Wardak's men arrived for us an hour later, it was embarrassing to tell them we'd changed our minds.

"We're very sorry," I said, "but we've just received word from our New York base ordering us immediately to Thailand. A new refugee situation has just developed."

The commander, Kamaluddin Koochi (who, I was to learn later, was also a cameraman), stared at me in disblief. "All the arrangements have been made," he declared. "Men are waiting for us with change of cars at several points along the route. All the NIFA military in the Khyber and the lower Nangarhar regions have been alerted."

Knowing I would have to live with a gnawing sense of cowardice in spite of overwhelmingly rational reasons, I nevertheless reaffirmed my decision. "We have to cancel the sortie," I said again, "and do it on our next shoot here."

Later that morning we changed our flights. We skipped out of town without contacting Wakil or NIFA.

# 5

# *The Great Game*

**When I returned to the States a month later,** images of Afghanistan and the refugee camps in Pakistan filled my head. Before then I had had little knowledge of this region, having seen the flag of the country in a collection of bubblegum card wrappers as a kid and having remembered the code "Afghanistan banana stand" from a Robert Redford bank heist film in the 1970s. As a child I had also seen the movie *Kim* with Errol Flynn, and I managed to find a video of it and watched it again. Then I read the Kipling book upon which the movie was based. It made such an impact on me that I began studying the history of Afghanistan.

Throughout the nineteenth century and the first third of the twentieth century, the British and Russian empires had vied with one another for control of Afghanistan, doing whatever they thought might extend their influence along this critical 600-mile segment of the ancient Silk Road connecting East and West. For the land-locked Russians, Afghanistan was the path to its long-coveted access to the Sea of Arabia, or its "window on the sea," as the court of Peter the Great termed it, and to seizing India from the British, who had held it under the banner of its East India Company since 1757. For the British, Afghanistan was the route to Central Asia and to the mesmerizing mercantile dream of extending its influence into vast, new markets for its manufactured goods. It was also the geographical location of the Bolan and Khyber passes, the most obvious paths through Afghanistan for a Russian invasion of India. In this chess match, each power feared the other might gain a leg up by seizing various cities and khanates in the

greater region, and paranoia consumed both empires. As the nineteenth century progressed, neither Russia nor Britain was prepared to come to direct blows over Afghanistan, but they were always up for whatever might undermine the other's plans and efforts there. Historians have referred to this century of conflict in Central Asia as the "Great Game," though the two powers' moves on the board frequently resulted in the deaths of operatives and innocents alike.

Little did filmmakers Lee Shapiro and Dr. Carmen Zuniga know in November 1986 when they took the film they'd just completed to a prestigious film festival in Colorado that they were taking their first step in a modern version of this dangerous game. After returning from their first trip to Afghanistan and while preparing to return, Shapiro and Carmen were invited to the Telluride Film Festival to present their controversial documentary on the plight of the Miskito Indians in Nicaragua that they'd completed the year before. *Nicaragua Was Our Home* was a conscientious film about the struggle of the indigenous tribal peoples on Nicaragua's Atlantic coast to be left alone by the Sandinista government in Managua and to follow their own traditional ways. Instead of warm acceptance at Telluride, they came into conflict with the leftist bent of the audience that supported the Sandinista movement and thereby that aspect of Marxist-Leninism that views all traditional beliefs and rituals as social evils to be stamped out, if necessary, by force. Even though the Sandinistas had two liberation theology Jesuits among the ruling junta, they had no tolerance for the Miskitos' "primitive" beliefs and traditions.

Curiously enough, I had been filming in Nicaragua while Shapiro and Carmen were there, but my crew and I preferred to hop back and forth across the San Juan River in the south to document the efforts of both the Sandinista military and the Contras. The Miskito Indians were not in my camera sights. Nor had they been in those of Bruce Lane, another filmmaker who had long monitored the struggles in Central America. Bruce—or "Pacho," as he had been dubbed because of his Latin American pursuits—had also filmed extensively in the Soviet Union and Eastern Europe. While his connections were undoubtedly fostered by his leftist politics, Pacho was too well steeped in the study of history and too involved with facts to resort to polemics.

As one might have predicted, Shapiro and Zuniga's film on the plight of the Miskito folks was poorly received. In fact, the audience booed Shapiro when he took the podium to answer questions after the screening. From what Carmen told me, he was completely dismayed and just about to step down amid the catcalls when Pacho Lane stepped up to the dais beside him. In spite of his pro-Sandinista leanings, Pacho recognized when revolutionary rhetoric degenerated into plain old prejudice. He knew the film was good and should be judged on its merits. He lashed into the crowd as only one of its kind could do and, according to Carmen, did so with flamboyant relish. This shared sense of justice established a bond between the two filmmakers.

After Telluride, Shapiro and Pacho met and devised a plan for covering events in Afghanistan with the sweep of a Leo Tolstoy novel. As Shapiro had only half-joked on an audiotape from early 1986, his film *Against the Empire* was "going to be the greatest documentary ever made." Their strategy would be epic indeed. Shapiro and his crew would enter the Afghan battleground from Pakistan in the south, as he had done the year before, while Pacho would call in his chips with Moscow and enter from the north along the Soviet military supply line. They planned to meet in the region of Kabul, and their combined coverage would tell the whole story. After Shapiro came up with the funding for their venture, Pacho's only caveat was that rhetoric of any kind had to be struck from the finished product. The facts must speak for themselves. Shapiro agreed wholeheartedly.

In an interview years later, Wakil Akbarzai said he had felt Shapiro and Pacho's plan was "a bit crazy." Idealism, he said, was similar to a rubber band that could only stretch so far before breaking. If these men chose to ignore real obstacles while pursuing their goals, disaster would follow. This observation was, of course, spoken by an idealist who spent most of his adult years at war in the homeland he vowed to liberate or die trying.

On March 24, 1987, according to the master plan, Shapiro, Carmen, paramedic and soundman Jim Lindelof, and camera assistant Linda Olszewski would board a flight for Peshawar, Pakistan.

From there they would cross the border and begin the long and dangerous trek to Paghman Province in the north where the great mujahedin commander Ahmed Shah Massoud was operating. Lindelof had spent time with Massoud the year before and claimed to know both the route and the trouble spots along the way. The journey would take many months. They all agreed Pacho would not leave the States for Moscow until he received word through mujahedin channels that Shapiro had made it to Massoud's territory.

On the ground in Peshawar, however, Shapiro and his crew were delayed, forced to wait while Jamiat-i-Islami (Massoud's military organization) and the National Islamic Front of Afghanistan (Wakil's organization) tried to arrange for their safe conduct. During that time they filmed in the teeming refugee camps along the border. While there, Linda came down with such severe dysentery that even Carmen, a physician, was unable to control it. Linda was forced to return to the States, and Carmen followed her on April 28 to take the exposed film they'd shot up to that point to DuArt Film Labs in New York for processing. Still delayed at the border, Shapiro returned to the States to repair his camera before finally starting out on the trek to Paghman and Panjshir in late May. But having grown impatient with delays, he made what I believe was an unwise decision.

With Jamiat and NIFA still unable to arrange for safe passage, Shapiro chose to go with Hezb-i-Islami, the fundamentalist organization led by Gulbuddin Hekmatyar. Even then, most journalists considered him to be a dangerous and untrustworthy man, for he was an Islamic populist of the worst sort who would change sides the moment it seemed advantageous. He was closely aligned with the Wahhabi Saudis, receiving direct funding from them, and was rumored to be a drug kingpin (which would prove no mere rumor in coming years). At the height of international irony (or myopic stupidity), Pakistan's Inter-Services Intelligence Agency (ISI) and the American CIA, who trusted and worked through the ISI, designated Hekmatyar and his organization the most likely candidates to succeed against the Soviets. Hekmatyar and his extremist colleague, Abdul Rasul Sayyaf, would continue for another decade to receive more than half of all the U.S. military aid to Afghanistan, while such West-friendly moderates as

Jamiat, NIFA, and the National Liberation Front of Afghanistan (NLFA) would receive a pittance by comparison. (But more on this later.)

Shapiro must have known, at least in part, what he was getting into when he cast his lot with Hekmatyar, but he was prepared to take the chance. Thus, Hezbi warriors under the care of one Abdul Malik, Hezbi's press spokesman, escorted Shapiro and Lindelof into Afghanistan for the long trek. The journey would take three or four months and would take them through some of the worst fighting of the war. They did indeed manage to make it to Panjshir and even (it is rumored) to interview Massoud before beginning the long return trek to Kabul and the planned rendezvous with Pacho. Then they fell off the radar.

Disappearing into deep cover is not the worst thing for such documentary journalists as Shapiro and Lindelof. Their strengths were what many of today's corporate media would consider liabilities. They were willing to shed their Western journalistic armor, hide their American identities as best they could, and don the clothes and persona of the indigenous people. Dangerous? In some ways, of course, but in other ways they were safer than high-profile news targets. As long as their escorts remained loyal.

A few pertinent journalistic examples come from the turn of the nineteenth century in Africa and the Middle East. At that time, Africa was still a mystery to Europeans. Although they heard of great lakes, rivers, and mountains on the continent, most Westerners felt anyone who dared stray south of the Sahara would meet a quick end. Mungo Park, a young Scottish doctor straight out of medical school in Edinburgh, perhaps having read too much Defoe, contacted the British African Association (for Exploration) and decided to risk it. He stepped ashore in 1795 in what is now the Ivory Coast with only his horse and several pistols. Within six months he was able to reach the city of Ségou and make the extraordinary observation that the Niger River ultimately flowed eastward, not westward, toward the legendary city of Timbuktu. He got as far as he did, not by playing soldier and shooting people, but by befriending the Africans and being fluid in his dealings with them.

In 1805, on a contrary course, for whatever reason, Park embarked on a new expedition. Determined to trace the entire course of

the Niger River, this time he was joined by a contingent of eighteen British soldiers. In 1806, almost within sight of Timbuktu, he drowned in the Niger while under attack from local warriors. No one from the expedition survived.

In 1827, René Caillé, taking Park's first expedition as the strategy for maneuvering in Africa, studied North African languages before he left for the Ivory Coast. When he arrived in Africa, he could speak the locals' language and knew the local Muslim prayers and traditions. By the time he had arrived in the ancient Muslim city of Djenné many months later, he could be mistaken for a Muslim trader with a foreign accent who traveled the routes from the Middle East.

Caillé learned to fit in and understood the culture through which he traveled. As Mungo Park did on his first successful journey, Caillé traveled alone without military support and made few waves. Thus, he lived to write extensive accounts of what he had seen.

And, when that last and greatest of British explorer-journalists, Capt. Sir Francis Richard Burton, chose in the mid-nineteenth century to enter the Muslim cities of Harar and Mecca, forbidden to non-Muslims under pain of death, he disguised himself as an Afghan Hajj pilgrim. He had learned to speak Dari as well as an Afghan native and recite the Qur'an by heart.

Lee Shapiro was of the Caillé-Burton school of journalism, having steeped himself in its lessons. When he and Jim Lindelof left with Hezb-i-Islami, they unknowingly threw in their lot with those who had already determined the United States was just another "Satan" (one to be exploited, of course). Shapiro and Lindelof became for the Hezb-i-Islami just another couple of greedy, American reporters in a rush to get a story.

# 6

# *Mixed Motives*

**Throughout the summer, fall, and winter of 1986,** I wrestled with my abrupt departure from Afghanistan. If Lee Shapiro and a few others were doing the good work there, I consoled myself, why should I go back? I'd done the job I'd been sent to do and filmed the refugee situation. I'd captured provocative and informative images that would benefit both the U.S. Committee for Refugees (our sponsors) and the UNHCR to raise awareness of the situation. I'd even steeped myself of late in the region's history and become a believer in Afghanistan's cause. I remember sitting with my soundman and partner, Dan Devaney, on our long flight back from Asia in April 1986, discussing what we'd seen there and how it had probably changed us forever. Filming in the refugee camps in northern Thailand and Cambodia only reaffirmed what we'd learned in Afghanistan.

It was all about land mines back then. At this point in my sociopolitical evolution, for me the land mine and the toy bomb (a bomb made to look like a toy to target children) became symbols of the cynical, downright primitive military efforts being waged against civilians. Soviet authorities and even the Khmer Rouge might claim injury and death from these devices was discriminate, but these assertions are far from the truth. The Afghan resistance, or the mujahedin, was trained to detect mines (in many instances by the CIA), and a few of them even learned how to disable them. Civilians, especially young children who knew nothing about such things, were the primary targets. When something colorful attracted their eye, they went to explore it as children do anywhere. And what could an elderly man with poor vision do when he encountered the trip line of a booby trap along a familiar path?

In one refugee camp in northern Thailand just across the border from Vietnamese-controlled Cambodia, we visited a local factory that made prosthetics. Looking for one item to shoot among the hundreds of artificial limbs piled on shelves and tabletops was disturbing, but this little house of horrors outdid itself. Manned by the maimed themselves, the shop serviced new refugees. From the long lines at the door, it appeared that an active mine-seeding campaign had recently taken place across the border. In some ways the factory reminded me of a shoe store, where salespeople presented different styles for customers to try. Once they made a decision, the remains of the victims' limbs would be covered with a kind of quick-drying plaster mix to form an exact reverse mold of the joint to be fitted. Of course, not all first fits worked that well, but for the most part, the process moved along quickly.

The fitters' injuries slowed down what might have been an efficient assembly line. One man, missing both an arm and a leg, lost control of his crutch and collided with a crippled female coworker, sending them both along with a lathe crashing to the ground. Another man, missing a leg at the hip, bent down to fit a tiny artificial foot on a two-year-old only to have his own artificial limb buckle, causing him to collapse on top of the child. These occasional grotesque images were at the same time so comical that our conscious, civilized minds had to struggle to overcome our initial reactions.

While my heart went out to these and other unfortunate refugees, I kept flashing back to Afghanistan. Why the Afghans? My first answers might not be so edifying. Afghan warriors, I thought, behaved similar to Hollywood's Old West good guys; they talked less and acted resolutely. They believed in rugged individualism, at least their brand of it. They liked to live and let live, at least before the Soviets arrived. By and large they were taller and more muscular than the other refugees I had encountered who had also run for their lives. In that stark, mountainous Afghan landscape that resembled the Four Corners' setting of the John Ford movies I'd been raised on, the Afghans rode horses just as the U.S. cavalry had in those films. They reminded me of my own tribe more than the other refugees did.

Of course, such unconscious motives should not influence our inclinations, but they do—they always do—no matter what good

people say. But that influence need not denigrate or detract from the decisions we make. Whereas I feel deeply for the Cambodians who have suffered both Pol Pot and the Viet Cong and for the Guatemalans who have been brutalized by their government's military regime, I still have the right to choose the battles I will fight in the struggle for human rights.

When I returned to the States in April 1986, I had no idea that Afghanistan would play a part in my life for even another year, let alone decades. I did not foresee it, even though the following April I called Dan and suggested we pay our own way back to Peshawar to cover the escalating war around Jalalabad. He ridiculed the idea mercilessly but ended up on the same flight with me to Pakistan.

What led to this decision? In the summer of 1986, as I noted earlier, I went to Mexico to film refugees escaping the Guatemalan military government. Then in August, I traveled to Turkey to film a group of accredited scientists who felt they had found an ancient, 500-foot-long ship in the mountains along the Iranian border, twenty-one miles from Mount Ararat. But even this gentle adventure became troublesome when Kurdish rebels took hostage a group of Christians climbing the mythic mountain. Shortly after that I was in Cuba again, interviewing Castro, and then in Nicaragua to film Daniel Ortega.

The rush was kicking in. Every month I visited a new country, facing new dangers and new challenges. It's a great way to build an ego and avoid fretting over marital troubles or bills. I was not the first documentary filmmaker or journalist to be seduced by the kick of danger, but I had a big case of denial to go along with it. Unfortunately, the publicity and promotional base on which my career relied was disintegrating from lack of attention. I discovered it didn't matter what I'd produced or what awards I'd received, if I was not around to return phone calls.

Deciding to return to Afghanistan came from the rush, of course, but in a different way. Given the circumstances of that earlier visit, I'm sure it had much to do with the morning I'd turned down the ride through the Khyber. Even though I'd made a well-informed decision, it hadn't meshed well with that part of my psyche that allowed for deep sleep. I don't know how Dan as a former Marine felt about it, but

I suspect his claim to valorous behavior had been challenged as well. To make matters worse, reading the news periodicals' reports of the Soviets' new gunship strategy and alleged atrocities in Afghanistan—but seeing nothing about these developments on television—inflamed my sense of injustice. It grew day by day, month by month.

So Dan and I called Wakil Akbarzai and NIFA. Then we broke open our piggy banks, managed a discount flight on Pakistan International Airlines (PIA), and showed up in Islamabad, a crew of two, without the auspices of either the UNHCR or the U.S. Committee for Refugees.

After all, I asked myself, why did I make documentaries? In film school I studied feature filmmaking, but after I received my degree, I found myself pulled away from re-creation into the excitement and challenge of filming the real thing. Covering a breaking event as a news journalist or telling an entire breaking story as a doc maker is not re-creating anything. They are right there in the thick of things with only their sense of journalism and survival to see them through. Training is a part of it. Just as a martial artist and a marathon runner are, documentary filmmakers in particular are challenged by the physical situation, the landscape, and the logistics of events. They have to be able to run, climb, and carry a heavy pack. They have to do their research not only on the latest event but also on the entire history of an affected people or region. They have to know their equipment and how to maintain it in adverse conditions. They have to learn how to work with different kinds of people and ideologies and to hone their skills at communicating the results of their work. It challenges the hell out of a person, but that's part of the attraction. If, as a filmmaker, you have a need to prove your metal as a man or a woman, making documentaries is light years beyond the feature film world.

# 7

# *Ghosts of the Khyber*

**When Dan and I arrived again in Peshawar in April 1987,** Wakil received us warmly, never once alluding to the aborted trip across the Khyber the year before, and arranged our passage through the pass. This time he would accompany us, along with four armed escorts, and we would be part of a reconnaissance mission to Jalalabad under the command of General Safi. We came to learn that the general, a magnificent-looking old gent with white hair and a long white mustache, was well known in both Eastern and Western military circles.

This first trip across the Khyber would foreshadow many others in the years to come. As during our trip through Waziristan from Fort Sandeman to Dera Ismail Khan the year before, we had to hide, this time from the Pakistani military. We traveled in Wakil's Land Cruiser under sacks of flour and rolls of carpets, and we hid our equipment in the flour bags. In the age of 16-mm film and heavy tape recorders, the equipment was bulky and not easy to cache. Of course, Dan and I dressed in the local garb, but with blond hair, Irish fair skin, and blue eyes, I wasn't going to fool any Pakistani checkpoint guards. Dan, however, could actually pass for an Afghan with his dark hair, beard, and amber eyes. But Wakil's plan was to keep us both hidden on the vehicle's floor with the Afghan soldiers sitting on top of us. Although it was a hard ride, the ruse worked and continued to work for years to come.

Curious, I looked into the checkpoints' history and discovered they go back to ancient times. Afghanistan was the principal route to Central Asia and China, and whoever wielded the power in the Khyber

at the time collected all the tariffs. Nothing much changed in succeeding centuries. When the British arrived south of the Khyber and the Karakoram Mountains in what was considered India, they saw the Khyber Pass as their key access to Central Asia. The Russians, meanwhile, had their eyes on it, too. The British army advanced through the Khyber and Bolan passes several times to take Afghanistan but paid dearly for its transgressions at the hands of the Afghan warriors who demonstrated the ferocity for which they'd become notorious. In 1842, in fact, only one man survived the slaughter of the entire 16,000-man British 144th Regiment.

In 1947, before his nonviolent efforts had driven the British from the subcontinent, the great Mahatma Ghandi anticipated the future violence its partition would cause. He believed the only way to avoid a possible civil war was to give the Muslim minority a first shot at running the country with a joint Hindu-Muslim democratic collaboration. He suggested offering the role of India's first prime minister to its Muslim leader, Muhammed Ali Jinnah.

Unfortunately, Jawaharlal Nehru, Ghandi's right-hand man during the long struggle for independence, refused to go along with such a concession to the Muslims. As a result, Jinnah gave the long-anticipated word signaling the greatest exodus in recorded history, and 8 million Muslims left India for the western and eastern sectors of the country that the United Nations had just declared (East and West) Pakistan, or "Land of the Pure." Another 8 million Hindus and Sikhs retreated to India. The bloodshed in the process was horrendous. And immediately in West Pakistan, trouble developed between the *muhajirs,* or new pilgrims, and the indigenous inhabitants of the northern part of the new country, known as the Northwest Frontier Province (the NWFP), representatives of whom we had already met on that long drive through South Waziristan. Just as the muhajirs, the NWFP inhabitants were devout Muslims, but they were also a territorial, tribal people who had their own ways and their own language (Pashto), which was quite different from the newcomers' Urdu. They also lived according to a strict code of justice known as *Pashtunwali.* Derived from—but harsher than—the Muslim Shariah law as prescribed in the Qur'an and the Hadith, the local code did not accept the borders of

the new state of Pakistan any more than it had observed those borders drawn by the Mughal rulers of India centuries before. They certainly did not consider themselves a part of the new Pakistan. They were Pashtuns and wanted their own nation, Pashtunistan (Pukhtoonkhwa).

So the tribal areas, as they are still referred to today, are off limits to the Pakistani military, and only a fragile peace exists. Any infraction that might demand an incursion by Pakistan into the area is the ongoing dread of every government in Islamabad.

Add to this volatile mix a new ingredient: drugs. The Afghans have always grown the opium poppy, mostly for indigenous consumption, and since the 1960s it increased cultivation to meet rising drug use in the West. Various exit points from Afghanistan—such as Herat, the Bolan Pass, Paktia, the Khyber Pass, and Gilgit—were manned both for political control and traditional taxation of legal trade as well as to ensure Pakistan's participation in the rewards of the illegal trade. Under President Muhammad Zia-ul-Haq (1976–88), there had been a genuine mandate against the drug trade, and most of the business thrived then because of the initiative of individual Pashtun warlords and of Pakistani military on the take who worked closely with international cartels.

Are the Pakistanis bad people for allowing this situation? You should walk in their worn, torn sandals a while before you answer that question. Since the foundation of their democratic constitution in the early 1950s, the people of Pakistan have been struggling from coup to coup just to survive.

On this first Khyber trip, I was still naive. Dan and I had seen the film *The Man Who Would Be King* the previous summer, and the romance of the movie and the Kipling novella on which it was based was still with me. Kipling's two main characters, Danny and Peachy, were former British soldiers looking for their fortune in what is now Afghanistan. Ruthless, relentless, wanton killers who were prepared to sacrifice anyone for their own greed, they were also clever and colorful. At that first viewing, Dan and I had laughed and cheered for these two wild and crazy Brits. We hadn't yet grasped the deeper, darker side of the story. Danny and Peachy were not nice fellows, but

the sort of bold, efficient warriors who put the British Empire on the map. Empires are not built by nice people.

When we entered the Khyber Pass, we saw several old markers from the British occupation. One sign from the 1800s reads, "Khyber Rifles," referring to the legendary British contingent, and another huge stone carving on a bare hillside reads the same. It is not certain whether the Pakistani government has permitted the designations to remain out of respect for British history or because travelers might think the terms refer to Pakistan's "rifles."

After clearing two of the five checkpoints, Wakil told us we could sit up and relax. He called our attention to a huge compound off to our left, a great dried-mud affair about a half-block square. It had only tiny slits for rifles—not a single window—and a great, formidable closed gate. Wakil said it was a major station connected to the Italian mafia. Michael Griffin reports in his 2001 study of the Taliban, *Reaping the Whirlwind: The Taliban Movement in Afghanistan*, that a syndicate run by one Haji Ayub Afridi, who was related to people in high places in Pakistan, controlled the fortress. By 1994, nearly half of what was considered Afghanistan's opium was grown in the Khyber region and Nangarhar Province.

Shortly after we were allowed to sit up I noticed our driver, a man in his sixties, had such dark circles under his eyes that I asked Wakil if he was well. Wakil explained the driver was tired because this was his third trip across the canyon in thirty-six hours. Then Wakil urged us to bury ourselves again under the rugs and flour bags because we were approaching the summit checkpoint. We did as we were told and a good ten minutes passed during which we heard little discussion from the six other passengers. Soon all talking ceased. As my legs began to cramp, I wondered how far we were from the checkpoint.

Suddenly I felt the road rock and grind beneath us but in a different way. Big bumps tossed us, the rugs, and the guys sitting on top of us around as if we were rag dolls. Still no one spoke. I pulled my way up through the falling carpets just as the vehicle hit a huge cavity and sent my head crashing into the roof. I shook off the blow and looked around at the others. In a heartbeat I realized everyone had fallen asleep,

including the driver! We were off the road and bouncing at forty miles per hour across a plateau in the middle of the Khyber Pass.

I punched the driver and screamed in his ear. Wakil woke up first and stared wide-eyed through the windshield a moment before shouting at the old man and grabbing the wheel. The driver opened his eyes and slammed on the brakes, swinging us sideways in a great cloud of dust. The truck came to a stop, and as the dust slowly cleared, everyone sat speechless. We could see no more than twenty feet away a sharp drop into the kind of abyss for which the Khyber is so notorious.

The old driver shut down the engine. Still no one spoke. After a minute or so Wakil opened the door slowly, got out, and walked toward the edge of the cliff. I climbed out and followed him. We looked down at a drop of a thousand feet.

"I guess he made too many runs," Wakil said as apologetically as he could. "He needs a little sleep."

"Well," I added, emboldened by near death, "I guess either he sleeps or we do."

Wakil glanced at me with an inscrutable smile and turned again to the precipice. He seemed almost to meditate for a bit.

No one said a word as we climbed back in the vehicle. Wakil said something softly in Dari to the driver, who nodded courteously. Then he added something else in a much louder voice that the old man clearly acknowledged. The driver turned on the engine and threw the truck into reverse.

# 8

# *First Blood*

**An hour later at Torqam, the last checkpoint** before entering Afghanistan, still buried under the carpets and flour bags, we listened to Wakil hassle it out with the Pakistani commander. Voices rose and fell, and I got my first taste of the kind of negotiation I would encounter here on later runs. With the deal concluded, Wakil returned to the vehicle and the engine started. As the truck moved again, I breathed a bit easier. Ten minutes later it pulled to another stop, and one of Wakil's men pulled the coverings off of us. As we stepped out, we saw several other vehicles parked in the cover of bombed-out ruins on the side the road. It was Safi's contingent of four vehicles and about thirty men. Wakil was already with the old general, no doubt discussing our part in the strategy ahead. When he came back, he told us we'd be going the rest of the way in another vehicle. We would join him later, once Safi's men had secured positions near Jalalabad. Meanwhile, he said, we should relax and have some tea with the new driver.

The message was clear, and we took no offense. Having a couple of greenhorns along in the middle of a military reconnaissance in Jalalabad would not be a good idea. Though we felt we were up for whatever they had planned, we certainly did not want to jeopardize anything or anyone with our ignorance.

Wakil left us in the care of another driver and a mujahid who looked older than Safi. It sounded as if his name was Claude when Wakil introduced us to the silent, bristly force, but I'm sure I misheard. The man was obviously a disciplinarian without much experience with *ferangii* (all foreigners), and he directed us toward another Land Cruiser

with a brusque gesture. Dan and I smiled and headed for the vehicle. Then Claude turned abruptly to the tiny fire he'd made to heat water for his tea and seemed to forget all about his two new charges.

When Safi and Wakil were a good hour ahead of us, Claude glanced up at the sun and then down at the shadows and headed for the Land Cruiser, grunting something to us in Dari. Apparently it was time to go. We smiled again as we climbed into his truck. I heard another grunt as we took our seats in the back. If Claude had a soft side, I never saw it.

The road to Jalalabad was unlike anything we'd experienced. Near the border for twenty or thirty miles, the Soviets had bombed it repeatedly to impede the mujahedin's resupply efforts. Huge craters occasionally blocked the way for hundreds of yards. It took an hour to negotiate one of the holes. We had to drive directly through it because off-roading could mean an encounter with buried ordnance. Added to this concern was the omnipresent fear of attack from the air, to which Claude's eyes were directed much of the time. As we left this border region, we encountered fewer craters on the road as the Soviets also used it to move their troops and supplies across Nangarhar. At this time they had withdrawn from the area to concentrate on Jalalabad, where a mujahedin harassment campaign was under way.

As we drove north along this tiny, broken ribbon winding across the great stark plains, I could see white-capped mountains rising in the distance on all sides: the Koh-i-Baba Mountains to the northwest, the Pamirs in northeast, the Karakorams behind us, and the greatest chain of all, the Hindu Kush, which pushed northward. This road and camel path would weave its way for another 600 miles through Afghanistan before crossing the Amu Darya (Oxus) River into Central Asia and continuing thousands of miles across China. Traders and their caravans had traveled this link between East and West, once known as the Great Silk Road, for more than twenty centuries. But from the perspective of that bouncing, twisting Land Cruiser, the venerable highway looked small and trivial. I found it hard to imagine its historical significance or the thousands of hooves and millions of feet that had once trod here.

At points along the way we encountered carcasses of Soviet tanks and other vehicles abandoned among shelled ruins of homes that had once housed simple people. I wondered if it had looked somewhat the same, except with broken wagons and chariots instead of twisted metal, after Alexander the Great, Genghis Khan, and Tamerlane had passed this way. For Alexander, the goal had been to conquer the people, pure and simple; but for the others, the Soviets included, it was "depopulation," or in more candid terms, as we shall see, mass murder. They felt the Afghans were too troublesome for containment.

We were about to see an example of Soviet military policy. Up ahead, an old bus headed for Pakistan had pulled to the side of the road, and a group of refugees had gathered around it. The vehicle had blown a tire. I gestured to Claude that we wanted to film the scene. At first he ignored me, but my face directly in his finally got his attention. He pulled over, and Dan and I jumped out of the truck with camera and sound. The people took little notice of us. They were only concerned with changing the tire and quickly escaping that open space along the road, where they were an easy target for Soviet MiGs and helicopter gunships. They had obviously encountered journalists before and ignored us.

We moved among the men working on the truck and then ventured off the shoulder, where the women were sitting on shawls and carpets with the kids. They pulled their scarves across their faces as we approached, and Dan and I kept a respectable distance. Moving back from the road for a wide shot of both the truck and the women, I suddenly felt an explosion to my right. The loud thud knocked me off balance. I fell to my knees, not knowing what had happened. The concussion left me dizzy and blurred my vision. Dan helped me back to my feet and shouted something in my right ear, which was ringing as loudly as a fire alarm. I heard nothing as the Afghan women swarmed past me and gathered around a body on the ground not fifteen feet away.

I grabbed my camera again and moved in with the people to find the victim. He was a man in his thirties whose face twisted in pain. I panned the camera down his torso toward his feet but couldn't find them through the lens. With everyone pushing and knocking to

get past me, I lowered the camera. Then as a woman attempted to apply a tourniquet, I saw the twisted, bloody remains of one of his legs.

I backed away. Dan joined me, and we withdrew to the bus. I was about to raise the camera again for a final wide shot but felt something soft and wet in the handgrip. I turned over the Arriflex and found a piece of bloody flesh. I tried to brush it off the camera but only smeared it over my hand and the lens. Dan took the camera and reached into his vest for a chamois to clean it. Shaken, I leaned against the bus and watched the crowd helping the man. He'd simply strayed off the shoulder—which we were told never to do—maybe to relieve himself. But then without thinking, we'd strayed there as well, to get a shot we could have done without.

Claude appeared out of nowhere, wrenched the camera from Dan's hands, and carried it to the Land Cruiser. I was stunned by his rudeness, but he was right. Our presence at the scene was not appropriate.

The rest of the drive to Jalalabad was a disturbing experience. I kept noticing little pieces of flesh and drops of blood on my clothing and tried to clean them off. Fresh blood is always troublesome, because we see it only when something has gone wrong. Our pulsing, fragile life force carried through long miles of veins and arteries is too finite to contemplate for long before we're spooked. I had no cause to feel guilty, but I kept thinking of Macbeth's wife. The blood was too intimate a thing to ignore, especially since it was someone else's that had splattered on me.

As Claude approached the outskirts of Jalalabad, the sun stood high in a cloudless sky and heavy artillery pounded in the distance. The road to the ancient city was framed by a row of tall trees on both sides that formed a cloister-like appearance to the long, straight approach. These trees, which must have been planted hundreds of years ago, were just a hint, I knew, of Jalalabad's former elegance. After winding through a number of side roads, we joined Wakil in what was formerly an upscale suburban area of the city. In his hands he cradled a tiny puppy. He had found it trying to nurse off its dead mother, a victim of shrapnel. He handed the puppy to a soldier and led us to a group of fine, old houses that had seen better days. The pounding of

the artillery seemed much closer now, and the ground trembled with each hit. Safi and his men had sneaked into Jalalabad proper, Wakil told us, where we would join them shortly. First, he had to tend to the family home of his commander, Pir Gailani.

I stood back and filmed him as he walked up the stone path to one of the houses. It resembled one of those great multidomed Russian compounds in the movie *Doctor Zhivago*. Wakil moved about on the porch and around the sides, checking that the windows were still boarded up and the doors locked. As he turned down the pathway, a shell hit no more than a hundred feet away. Wakil dropped to his knees. I lost my balance and fell to the ground, pulling the cable that was attached to the camera and the battery belt I was wearing. I saw the Arriflex hit the ground lens first as another shell landed. The ground trembled and I held onto it, digging my fingers into the soil. Dust and smoke were everywhere. I managed to disconnect the cable and roll over to a woodpile where Dan was hiding. Wakil shouted for us as he jumped to his feet and headed for the truck. I grabbed the camera, with its lens bent in the shape of a cornucopia. Since we'd left our wind-up Bolex back in Peshawar, we were out of business.

We had suffered our own first casualty in Afghanistan. Fortunately, unlike the bus passenger on the shoulder of the road, it was only a chunk of metal.

# 9

## *Crossing Paths*

**Returning to Pakistan through the Khyber Pass** is just as difficult as leaving it. For Dan and me it was another rough trip under rugs and sacks and the weight of warriors, but we made it past the checkpoints to the sanctuary of Peshawar. Hearing Wakil tell the story of Safi's reconnoiter on the way back, I realized the foray had been harder for his group than it had been for us. One of his men had disappeared, and two others had been wounded.

On Peshawar's outskirts, near the sprawling black-market bazaar, Wakil's convoy pulled off the road at a teahouse-style truck stop. He led us up a spindly staircase to the old building's second floor. From the outside there was no way to gauge what was going on inside, but once Wakil opened the door, all I saw was mayhem. In the anteroom to the restaurant was an arsenal of rocket-propelled grenade launchers (RPGs) and other large weaponry leaning against the wall and hanging on hooks. Safi's men pushed past us into the throng with their Kalashnikov (AK) rifles and grenade launchers over their shoulders, and one still had his 50 mm machine gun strapped to his back. Wakil waved to some sort of maître d', who rushed to lead us to an empty table reserved for commanders.

Except for the notable absence of women and alcohol, it reminded me at first of a biker bar. Afghan fighters with every kind of ordnance in hand, beard to beard, collided with each other as if on a crowded dance floor and shared their war experiences of the day with great relish. Using broad gestures and loud commentary, they slammed their weapons into chairs and dropped them onto tables almost in

rhythm with the Afghan music playing over the crackly sound system. After noticing a fight taking shape at a neighboring table, I thought of the alien bar scene in *Star Wars*. No one sported multiple arms or tentacles instead of limbs, but with the myriad of weapons bristling in the crowd, the effect was almost the same. I couldn't believe that only tea was being served, but I know now that *charras* (hashish) was likely being passed around.

Wakil never consumed anything that was addictive, and so we sat for thirty minutes or more drinking cups of tea. More reserved than the others, Wakil smiled and chatted with many of the men. They were coming down from the adrenalin kick of combat, and they were as manic as anyone I'd ever seen in U.S. military or journalist circles. Dan and I would have liked to join in, but we needed brew or spirits of some sort to help us relax. It would also have helped if we had understood what everyone was talking about. As friendly as everyone was, we were the aliens in this bar. Wakil noticed our edginess, as he seemed to notice everything, and after our third cup of tea, he stood to go.

The American Club was not far from the Defense Colony, where everyone of political influence or money lived. Other than thinking it nondescript, I can't recall much about the outside of the club as I never arrived there in later visits when the sun was up. After we presented our foreign passports, in this case proving that we were not Muslims, Wakil signed us in as friends of NIFA. We strolled into the large room lit with overhead bulbs and looked around. So this was where all the other Western journalists hung out. Dan and I had heard about the club but had never seen it.

Wakil noticed someone he knew, and we made our way to a table where a man and a woman greeted us. The woman, Jan Goodwin, was a good friend of Wakil's and the head of Save the Children in Peshawar. Jan had arrived in town eighteen months earlier as a journalist for the *Ladies' Home Journal* and had just written a book on the Afghan struggle. The American man sitting with her was a journalist as well. We sat down, ordered our drinks, and joined the conversation. Soon it became clear Jan and the journalist knew the situation on both sides of the border as only those who had traveled there could.

After a bit, I noticed the journalist eyeing a new arrival who was joining several people across from us. He provided us with a quick take on the guy: he was Lee Shapiro, a filmmaker from the States who was planning a trip deep inside, someplace north of Kabul. I sipped my drink and sized him up. He was of medium height, had a somewhat stocky build, and was in his mid-thirties. He looked almost Afghan with his beard, but our companion said that he was a Jew from New York. I stole yet another glance at the man, who had instantly become the life of the party at the other table. He looked as if he could have been from the region but Jewish made sense as well. What, I wondered, was a Jew—who was known to be a Jew—doing in this part of the world?

# End Game

_____ 10

The evening of October 11, 1987, found Carmen Zuniga in an office at the New Yorker Hotel in New York City. She sat at the editing machine owned by the Afghan Documentary Movie Project Company (ADMPC), studying again the footage she had brought back in May. Lee Shapiro and Jim Lindelof had left Peshawar on their long trek into the interior of Afghanistan. They had not been heard from since, but then, she knew they would be gone for several months.

Carmen was working alone into the night, and a cold autumn wind rattled the windows of the cutting room. To this day she recalls the unsettling sensation she felt when she glanced at the nearby desk and the framed photograph of herself and Shapiro. Taken nearly a year before, they were sitting at the same editing machine with material from their first shoot in Afghanistan. She felt as if the photograph was trying to speak to her.

This time, Shapiro had gone deep inside the war zone without her. Did he consciously orchestrate the trip to protect Carmen from certain dangers? I think she would disagree with such speculation, but I believe it was Shapiro's intension all along. Shapiro was a large and boisterous presence who, from what I can gather, loved a good party, crazy dancing, and a wild joke, even a practical one—all typical devices to cover up a sensitive, "bleeding" heart. Shapiro had no intention of risking Carmen's life with the blood-brother vow he himself had made while traveling with the Afghan warriors.

During the previous year, Shapiro had let his heavy, black beard grow. He had grown it for his first trip, as it was part of the uniform of

any serious documentary journalist traveling in Afghanistan, but by the time I'd seen him in Peshawar in April 1987, he had stopped trimming it in what appeared to be an expression of his kinship with the Afghan people. The last photograph I saw of Shapiro revealed a man who had stepped through the famous "crack in the universe" so celebrated by the Gnostics. In a real sense, Shapiro had made a big transition. While in his mind he was still a Jew who had also embraced a form of New Age Christianity, in his ecumenical heart he had somehow bowed to Mecca and maybe even rubbed his face with the sacred, invisible waters of Islam. The word *Islam* means "surrender" in Arabic, and Shapiro had done just that. Committed to the Afghan *jihad*, or struggle, against the Soviets, he was prepared to take the biggest chance yet for the cause of religious tolerance that he had embraced with the Unification Church several years before. But he was not about to risk Carmen's life. Such blood rituals appear to be practiced more by the male of our species.

Meanwhile, Shapiro's soundman, Jim Lindelof, had been to Massoud's Panjshir haven the year before and had already been radicalized by the charismatic leader. Lindelof had also been voted the UNHCR's Paramedic of the Year for his training of Afghan medical workers. In that work, he had witnessed the impact of the Soviets' ever more aggressive military policies. He had seen the results of their outright poisoning of water sources and sowing of land mines so wantonly that Soviet soldiers themselves often became their victims. (The Soviet military made no serious effort to map these lethal deposits, pretty unusual behavior for a modern high-tech army.) Lindelof had entered villages to treat the people after Soviet gunships had landed and Spetsnaz (special forces) troops had burned the villages and raped and mutilated their inhabitants. The Soviets' message to Afghanistan that he read in all this savagery was clear: surrender, get out, or die!

The Soviets even targeted Western journalists in attempts to keep their crimes secret. Vitaly Smirnov, the Soviet ambassador to Pakistan, was quoted in October 1985 by the Helsinki Watch and in other journals:

> I warn you and all your journalistic colleagues: stop trying
> to penetrate Afghanistan with the so-called holy warriors.

From now on the bandits and so-called journalists—French, American, British, and others—accompanying them will be killed. And our units in Afghanistan will help the Afghan forces to do it.

Slumbering arrogance seems to awaken with vigor in Afghanistan, whether it is Arab, American, British, Greek, Pakistani, or Russian. It brings out bold determination too. Shapiro and Lindelof were about the best team imaginable to tackle a near impossible task in this harsh place and during a war effort that, as we will see, was beginning to turn on itself. Five months in that war zone would have amounted to a self-imposed death sentence for a documentary novice or for most of today's TV newspeople. Even for Shapiro and Lindelof, it would be a roll of the dice. Carmen knew it.

What Shapiro and Lindelof did not consider, however, was the phase of the moon in that troubled relationship between Massoud and Hekmatyar. These two "stars" of the Afghan drama, as the West viewed them, were polar opposites in both style and philosophy. While both were Islamists, Hekmatyar was a Pashtun and probably more a proponent of an extended Pashtunistan than a liberated Afghanistan, and Massoud, a Tajik with better knowledge of European ways, was far removed from that rough, dusty, vengeful, albeit romantic world of the south. Both had studied at Kabul University, Massoud in business and Hekmatyar in engineering, and had worked together as activists in the seventies to halt the Communists' advance.

In the late seventies and early eighties, however, Hekmatyar traveled to Saudi Arabia and found support for his Pashtun fundamentalism among the Wahhabi princes. He returned with Saudi funding, which Pakistan, under the leadership of President Zia-ul-Haq—that clever and pragmatic leader, who was at heart another Islamic extremist—soon augmented. When exactly it was that Hekmatyar became involved with the drug trade is not certain.

Massoud found Hekmatyar's and Zia's brand of radical Islam unacceptable. Thus, a great breach opened between the Tajik north and the Pakistan-driven Pashtun south. As the war with the Soviets continued through the eighties, the rivalry between Hekmatyar and

Massoud grew. It even affected the behavior of their military forces in the field. By 1986, the two men were keeping a wide berth. Pakistan's ISI knew this situation, for it had broadened the chasm by singling out Hekmatyar as the ISI's man in Afghanistan. The CIA monitored the scene through the ISI, which the agency trusted. And anyone in Peshawar with an ear to the ground knew about the feud.

When the battle for international support and funding finally went public, the two leaders found themselves at sword's point. The West, especially the French, thought Massoud was far more personable, and the Western press found him much more accessible. Massoud was nevertheless a Persian-speaking Afghan, and the CIA's fear of an Iranian-style Muslim takeover in Afghanistan worried its post-shah sensibilities. Both the Ayatolla Rulloha Khomeni and Massoud spoke Persian, so they must be the same kind of dude, right? On the contrary, Hekmatyar was the one who took an ayatollah-like approach to issues.

But never mind the facts, Hekmatyar spoke Pashto and Urdu—not Farsi or Dari, both Persian languages—and hailed from a region long at odds with the Shia "heresy" that now controlled Iran. Thus, his fundamentalist approach to Islam made him far more acceptable to both Pakistani and Saudi Arabian religious ideologues, and whatever Pakistan's ISI decided to do was good enough for the Americans. Furthermore, Massoud had not helped matters when he negotiated a unilateral cease-fire with the Soviets in 1983 to gain time to rebuild his forces. And when it became known in the late eighties that as the military chief of Burhanuddin Rabbani's moderate Jamiat-i-Islami organization, Massoud had accepted some financial aid from Iran—information Hekmatyar used to assert Massoud was indeed tainted with Shia heresy—an actual war within the war erupted between the two commanders' forces on the Soviet-Afghan battlefield. This conflict would play itself out for the highest stakes years later.

Knowingly or unknowingly Lee Shapiro and Jim Lindelof entered this fray. Lindelof and Shapiro—both of whom had traveled inside Afghanistan within the year and spent time either with Massoud's soldiers—accepted an invitation from Gulbuddin Hekmatyar's Hezb-i-Islami to escort them north to find Massoud. Carmen told me she had felt uncomfortable with the decision from the start. Not only because

of what she had heard about Hekmatyar, but because of how his men had behaved toward her and Linda Olszewski. If respect for women was supposed to be at the heart of his brand of Islam, she never felt it in the presence of the Hezb-i-Islami soldiers, who would not allow her and Linda to go along on the journey. Shapiro, she explained, was always the one in charge, and she accepted his decision no matter what her intuitions might be. She knew the timetable and how important the rendezvous with Pacho Lane in Kabul was for the film. So she went along with Shapiro's decision.

But that October night at the New Yorker Hotel, she felt a strong urge to leave the spooky editing room and go home to the refuge of her apartment. As painful as it was, however, Carmen heeded her intuition. She stayed and stared, glassy eyed, at the flickering images on the screen from that faraway world that few Americans had ever known, a world where she and her colleague had shared in a kind of secret spiritual awakening. It was a world from which he would never return.

Later on a night in July 2002, while lying on a carpet and sipping tea under the full moon on Wakil's compound lawn in Kabul, Carmen explained her relationship with Shapiro. He was a married man who was devoted to his wife, Linda. Carmen and Shapiro were never involved romantically; instead they had loved one another almost as though they were brother and sister. Wakil didn't think such a relationship was possible. He argued that a sexual element, even if it's restrained or repressed, always exists between men and women. Carmen disagreed; spirit knows no gender, she said.

That night in the editing room, while watching Shapiro's work, Carmen recoiled at the whistling wind against the windowpanes. The strange night, she recalled, seemed to hint of Halloween, though it was early October. Having been raised in Guatemala, she believed that on the night before All Saints' Day the spirits of the past came to visit and issue warnings for the future. Suddenly Carmen realized what was happening when she turned again to look at Shapiro's photograph. She knew Lee was dead. He had come to say good-bye.

According to the official story, he and Lindelof had been killed in Jalrez, a seedy village just south of Kabul that was filled with spies

and informers. Shapiro had insisted on filming there when he had passed that way the year before. He went against the advice of his Jamiat escorts, who had nevertheless cleared a path for him through the crowds with the barrels of their Kalashnikovs. They had wanted to pass through unnoticed, but Shapiro was a great cameraman who had found a great shot. In the words of Gabriel García Márquez, he filmed "a chronicle of a death foretold." Carmen remembered the footage clearly, even the "hair," or dust particle, that had lodged in the camera's gate that Shapiro must have seen but was too busy to remove. When Shapiro and Lindelof returned through Jalrez the following year, the townspeople, many with strong links to both Hekmatyar and the Soviets, were ready to deal with them.

That night in the editing room, Carmen felt as if Shapiro's spirit had given her a final message, a message so clear that she can recall the moment as if it were yesterday. She was reminded of a conversation they had had earlier that May, before Shapiro left, before they had said good-bye for the last time. He made her promise that if he should die, Carmen would complete the film they'd started together no matter how hard or by what route or how long it might take.

The report of Shapiro's and Lindelof's deaths did not reach the West until October 28, 1987. The *New York Times*, most of the network news shows, and all the print media carried the story. But the report was sketchy and inconclusive. Among other things, it said their guide had been injured as well and was still making his way out of Afghanistan to Pakistan. On Monday, November 23, Shapiro's wife, Linda, received a telephone call from the American consulate in Peshawar informing her the Hezb-i-Islami interpreter and guide, Abdul Malik, had just reached Pakistan. He claimed that Shapiro and Lindelof had been killed in an aerial ambush south of Jalrez on October 9.

Malik also gave the following sworn affidavit at the U.S. consulate in Islamabad in January 1988:

> I am Abdul Malik, member of the press and information department of the Political Committee of Hezb-i-Islami. Upon the request of Mr. Lee Shapiro and his friend, Mr. Jim

Lindelof, and upon the direction of the Political Committee, we went to Afghanistan for the purpose of observing and filming the northern fronts. After spending five months there, and while on the way back to Pakistan in Sanglakh Valley in Paghman District of Kabul Province, at around 11:30 AM on the 17th of Mizan in the year 1368, we faced an ambush in which four Russian helicopter gun-ships participated. As a result of the firing of rockets, which lasted about fifteen minutes, the two journalists, Mr. Lee and Mr. Jim, and two of the mujahedin were killed. Rahma Pullah, the horse-tender, and myself were injured. After firing from the four helicopters, two helicopters landed and fourteen to sixteen Russians came out. They were able to capture the film, equipment and other supplies. Later the bodies of Lee and Jim and the two mujahedin were taken by the mujahedin to another location on the way to Pakistan and were buried.

Malik apparently added to the sworn statement later, telling the consul that Lindelof had been severely ill with hepatitis and was on horseback, too sick to walk. Unable to escape when the gunships first appeared, Lindelof had been hit first with a rocket in the chest. Shapiro rushed back to his horse to save his camera and was hit in the leg by a rocket. He took two more bullets to the chest and died about four hours later. Malik claimed the Soviets made no attempt to take the bodies but insisted they had seized the cameras and film and took them on board the choppers.

On the afternoon of October 27, 1987, Pacho Lane heard the news of Shapiro's death as he was boarding his flight in New York for Moscow. Stunned and confused, he was nevertheless determined to continue his shoot as planned. In Moscow and then in Kabul he probed discreetly for more information on the alleged murders. The information he obtained did not mention a Soviet attack, only that the two American journalists had been killed somewhere south of Kabul. He could not confirm the cameras and film had been confiscated.

Strangely enough, Jan Goodwin told us in an interview in 1989 that an Aaton movie camera (what Shapiro had used) complete with

lenses, batteries, and a tripod had shown up in the Peshawar market-place several months after the reported murders. Had the Soviets turned the "seized" equipment over to scavengers? I doubt it.

# 11

# *Pacho in Kabul*

**In spite of how rattled he must have been after** hearing about Shapiro's and Lindelhof's murders, the footage Pacho Lane shot in Afghanistan was extraordinary. Perhaps along with his remorse he drew inspiration from Lee's and Jim's relentless pursuit of the truth in Afghanistan. Or maybe the professional drumbeat to which Pacho always marched was his muse. Whatever the source, his coverage was powerful and, above all, scrupulously honest. He filmed in both Kabul and Kandahar, where the Soviet Army was stationed. He photographed Soviet soldiers on patrol and elite troops engaged in hand-to-hand combat training. He filmed hardened Spetsnaz soldiers, who did their jobs at whatever the price, and the rank-and-file Soviet soldiers in hospitals who had already paid the price. He filmed officers who expressed themselves with little feeling and common grunts who cried, those who believed in their mission and those who had begun to doubt.

My overriding impression when I first viewed the footage was that he was a determined filmmaker who did his job without favoring any party or individual. It did not matter that in his heart Pacho Lane was then and is still today a committed socialist. For Pacho the facts were the facts. After he'd finished shooting in Afghanistan, he traveled back to Moscow with the "Black Tulips," which is what the Soviet soldiers called the body bags that transported their dead, and filmed the burials of the young men at local cemeteries. There he interviewed their family members and friends, who were more shocked and confused than they were angry about their loved ones' deaths. They shed tears but yet held the conviction these young men had gone to Afghanistan to do the right thing.

Many of those who survived, however, no longer believed this rationale. It was evident in a scene Pacho shot in an Afghan War veterans' club in Moscow, where a portrait of Mikhail Gorbachev hung prominently on the wall. Unlike the families of those who had died, the veterans Pacho filmed were sullen and bitter about what they had experienced in that hard land to the south. Perhaps they sensed this war had made travesty of those tightly held values of the October Revolution. Pacho might not agree, but I think it's there in the footage. Having seen it multiple times over the years and having walked many more miles in Afghanistan since that first screening, I remain convinced.

Regarding the horrors and atrocities the Soviets committed in Afghanistan that I (and many others) witnessed, the rank-and-file soldier was not the one responsible. The Spetsnaz and the gunship crews, however, were of a different breed and training. I often heard how the first Soviet foot soldiers in Afghanistan had been told by their superiors that they would be fighting Americans, British, Egyptians, and Israelis. They found to their dismay that they were fighting only poor, underequipped Afghans. By 1986, poor Afghans were still the enemy, but they were now being equipped with new deadly ordnance. No matter where a soldier's sympathies might lie, his heart had to harden if he wished to survive. And the beat went on.

Toward the end of the war in 1988, another course correction became apparent in the Soviet camp. Average soldiers, now completely disillusioned with their own increasingly brutal tactics and their growing realization that the war was unwinnable, settled into a kind of seething bitterness over the whole Afghan affair. Many, in fact, had become so burned out by what they'd seen or had been forced to do that they began tipping off the local Afghans about the Soviet military's next targets. Tours of duty in some areas were reduced to three months to prevent fraternization with the local Afghans.

So when some critics refer to a brutality inherent in the Russian nature, I remember the scores of sad, disillusioned, wounded soldiers in Pacho's footage who had nothing bad to say about their enemy and only expressed their desire to leave him to his hard lot and go home. I recall, in particular, one scene with soldiers who played guitar and sang about those Black Tulips and the wasted lives on both sides.

By the winter of 1987, the war had entered a yet grimmer stage. Soviet gunships appeared in villages to terrorize those suspected of supporting the mujahedin. Frequently, the Soviets would carry a suspect up in a chopper and drop him or her from such heights that their screams on the way down might be heard throughout the neighboring villages. But the Afghans spread the word that the ploy was ineffective if the victim remained silent, an act that took the same intense concentration and determination we had witnessed on that first shoot in the refugee children's hospital in 1986. Thus the Soviets abandoned that tactic in favor of others—brutalizing or killing children in front of their parents or, if a tank were handy, running over a suspect, beginning at his or her feet. In speaking with both mujahedin and former Soviet soldiers, I learned that these methods also backfired, but in a different way. Although the Spetsnaz might have little trouble with this kind of warfare, the Soviet foot soldier began to rebel. Drug and alcohol use, already heavy, skyrocketed.

But in spite of the Soviets' deteriorating morale, the mujahedin needed a new weapon to even the odds in their fight with the empire. The CIA had it, the Stinger surface-to-air missile (SAM). With this shoulder-held, heat-seeking ordnance, one man could bring down a gunship or even a MiG jet. We noted, however, that only the radical Islamic Afghan organizations received the bulk of the new weapons. Hekmatyar, as usual, got much more than the lion's share.

Let us not paint the mujahedin as innocents, for their response to the Soviet invasion was often brutal. In fact, several Soviet prisoners of war captured in Kandahar were skinned alive. Most of these horrors, however, occurred in the war's later stages, when the Saudi Arabs had joined the jihad in force. POWs' murders then served a Saudi (Wahhabi) ritual purpose as well.

# Postmortem

# 12

**In January 1988, Dan Devaney and I arrived** again in Peshawar. We stayed at the same dilapidated, one-story hotel near the business district where we had stayed before. Other budget-conscious independents chose Green's Hotel, an equally modest, two-story building in the center of the district. Green's had a small restaurant that served coffee, so Dan and I frequently went there for breakfast. On one chilly morning we sat with Dr. Gran and two other Afghans, going over plans to return to the front.

Dr. Gran was a trained Afghan surgeon who had forfeited his medical career to fight the Soviets. He once explained his decision to drop the healing arts in favor of killing. He had been running a field hospital near a small village south of Kabul that came under a surprise attack from a devastating Soviet artillery barrage. In a cloud of dust and debris a tiny finger landed on his foot, the finger of a child.

As we sipped our coffee and tea, he spoke of a woman carrying a movie camera whom he had met the day before. She was not Pakistani or Afghan or American but Guatemalan. And, he added, she said she was a medical doctor. I wondered what a doctor from Guatemala was doing here with a camera. Guatemala had enough problems of its own. Gran had heard that she was looking for her partner, an American cameraman who had disappeared inside Afghanistan. I remembered the day I'd heard about the deaths of Shapiro and Lindelof and began making the connections in my mind.

Three months after the report of Shapiro's death, Carmen had returned to Pakistan with a small crew to dig into the facts. Too many unanswered questions and parts of the official story, as reported by

Malik, didn't add up. And, of course, there were no bodies. Traveling through the refugee camps in and around Peshawar, Carmen hoped to stumble onto the truth or to meet someone from the Jalrez or Khost regions who may have seen or heard something.

She thought Hekmatyar's Hezb-i-Islami was somehow implicated, but it was only her hunch. When she approached his organization for an interview, she was refused. Then she sought out Abdul Malik and the other Hezbi warrior who had been injured in the attack, but they were nowhere to be found.

Even when she requested a meeting with officials at the U.S. consulate in Islamabad she ran into a blank wall. A subaltern gave her the overly friendly advice that she was becoming a known quantity and therefore a target herself. After a few more attempts back in Peshawar, another in Quetta, and a last visit to the Khyber villages of Landikotal and Torqam, Carmen had decided to call it quits. Though she had collected some curious information on film, she had found no one who knew directly of the incident or would speak of it. She was looking for the proverbial needle in the haystack, and she knew it.

She approached the American consulate in Islamabad a second time and requested a meeting with Abdul Malik. The Hezb-i-Islami spokesman showed up along with a German reporter. Carmen recorded the interview on film and audiotape. When questioned by the consul general, the spokesman replied in Pashto, and the reporter translated. Malik avoided Carmen's eyes, and his answers evaded many of her questions. The interview seemed not only a bust; Carmen also found the way in which it was conducted very suspicious.

A few days later, on Carmen's last evening in Peshawar, Abdul Malik showed up unannounced at her hotel room. According to Carmen, he spoke in halting English and said he was sorry but that there were things about Shapiro's death that he could never tell. Carmen took out her tape recorder, but in the blink of an eye, Malik was out the door to disappear again into the dust and chaos of war. After he left, Carmen replayed the audiotape of Malik's earlier interview at the American consulate, hoping to discover a new clue. She fell asleep over the sound equipment.

In the morning when she awoke, she was running late for the drive to Islamabad and her flight back to the States. In a hurry she threw the audiotapes in her carry-on bag instead of putting them back in the exposed film case where they'd been.

When she checked in at the PIA desk in Islamabad, the exposed film had disappeared from the case. Every roll and every frame had been stolen. But she still had the audiotapes in her carry-on bag.

# Refugees and the Taliban

<div align="right">13</div>

**Unaware of Carmen Zuniga's latest drama and** almost everything about her project with Lee Shapiro, Dan and I made arrangements to link up with a large group of refugees that had left the northern city of Badakhshan on foot and had traveled almost the entire length of Afghanistan. The UNHCR had learned that the caravan was now only about sixty miles from the Pakistani border and in a troubled area. As refugees were their mandate, the UNHCR folks would again help us with transportation, but they wanted us to wait a couple of days until the group was closer to the border. They also wanted to remain anonymous. We understood. The good news was that a warm snap had melted much of the snow and only rain was falling in the region.

Smuggling ourselves across the border with the UN was a more elaborate operation than we had endured with the Afghan organizations, but this time we were not forced to hide under sacks and carpets when we approached the checkpoints. The UN carried weight with Pakistan, and we were traveling under its auspices. I suspect, however, the traditional bribe must have been paid somewhere in the process.

Although I discussed the border's historical significance in chapter 7, to understand its political and fiscal significance to Pakistan, in particular, we have to return briefly to the years following Pakistan's creation in 1947. Within a decade, Jinnah's great vision of a democratic sanctuary crumbled after successive military coups. With its ongoing struggle against India over Kashmir and with civil strife between the muhajirs and the indigenous population draining an economy already in shambles, the Punjab military leaders took control of the country. In

1971 a brutal war against East Pakistan degenerated into genocide under the West Pakistani leadership. It led to the murder of more than a million people and the rape and torture of hundreds of thousands civilians. When India entered the war on the side of East Pakistan, it defeated the Pakistani Army and helped carve the new country of Bangladesh out of Pakistan, thus reducing Pakistan by more than half its original population and territory.

By the time General Zia overthrew Zulfiqar Ali Bhutto in 1976, Pakistan had a reputation for mass murder and as a failing outlaw state. His execution of Bhutto in 1979 together with the creation of Pakistan's nuclear program under Abdul Qadeer Khan only exacerbated the country's negative image. By the time the Soviets had invaded Afghanistan in 1979, U.S. president Jimmy Carter had cut off all aid to Pakistan. But in 1981, Carter was out and Ronald Reagan was in, and the CIA was searching for a way to support the Afghan struggle against America's Cold War enemy, the Soviet Union. Suddenly a cash cow arrived at Pakistan's door: financial aid channeled through Pakistan's government for the upkeep of 2.5 million Afghan refugees who had fled the Soviet takeover and were housed in camps in Pakistan. And then another miracle arrived: U.S. and Saudi funding for the mujahedin war effort would also be channeled to Zia's government and its notorious ISI, Pakistan's secret police.

Thus, with refugees and military aid making their way across the border in different directions, along with a burgeoning drug trade, the Pakistani government began monitoring more closely the gateways between Pakistan and Afghanistan to keep the dollars moving and prying journalists out.

I understood little about this political situation in January 1988 and viewed the Pakistani border policies as mean spirited. That the border agents were safeguarding ISI business and Pakistan's economy was not in my purview. After all Dan and I had only wanted to cover the war and document the plight of the refugees.

Free of the last Pakistani checkpoint, we made our way by Land Cruiser to a locale that had seen a great deal of fighting in recent weeks. On the second day we reached the refugees, around a hundred souls, with their belongings strapped to their backs and a few goats, camels,

and horses at their sides. After introducing us to the people in Dari our mujahedin escort left us to make our own way with them. At first, the people were uncomfortable with us, and we spent most of the day just hiking with them and smiling a lot. The caravan's leader, a wizened man in his fifties, attempted to befriend us, but I could read the concern in his face. I was disturbed in particular by one ten-year-old girl carrying a great bronze pot who kept her eyes on us all the time, eyes filled with such fear that I felt as if our faces must have matched a wanted poster. Then I noticed another member of the caravan who was carrying a musical instrument that I had never seen. When the group stopped for a brief meal, I asked the man if he would show it to me. He called it a rhubab, and it was outfitted with five principal strings with which to play melody and eleven sympathetic strings, much like the sitar. This distinctly Afghan instrument, as opposed to the fragile Indian or Pakistani sitar, was shaped out of a solid chunk of wood. It was so heavy and robustly constructed it could be used as a weapon if its music failed to soothe. Being a musician myself, I was taken with the instrument, so he showed me how it was played. Later when the group stopped for the night, the musician invited Dan and me to spend the night under his canvas and take dinner with him and his family.

The two candles in the old tent were barely enough light to make out the man's wife and three small children. It was fortunately not bright enough to inspect the food we were offered, which was served in a large bowl into which we dipped bread and hands. I ate with a smile, but Dan, with his weaker stomach, had a hard time of it. At first, the children were silent in the presence of the two foreigners, but after dinner and several cups of tea, they loosened up and began acting as children do anywhere. The musician and his wife put the kids to bed on an old carpet and tucked them in under a couple of worn blankets. While the temperature had not slipped below freezing, it was quite cold, and rain began to fall. Dan and I laid out our sleeping bags near the door and prepared for sleep with a sip each from our cough syrup bottles, which contained forbidden rum and scotch. I felt warm and comfortable in this tiny sanctuary and in the company of kind and simple people. I stretched out to listen to the rain against the tent.

Sometime during the night the rain was accompanied by thunderclaps. Then I heard the jets. Dan and I sat up and looked out the open tent flap. The horizon was lit up with multiple explosions no more than a couple miles away. Some target was being hit hard. We stared at the glow and wondered if the MiGs would find us. Then I heard the music and turned to watch as our friend sat next to his children, playing his rhubab and singing a gentle song, while his wife caressed their heads. The bombs fell for another ten minutes, but the music continued for half an hour, until the children had fallen asleep again. I wondered if mothers and fathers during the London Blitz had done likewise with other instruments when the Luftwaffe struck.

Before sunrise the refugees broke camp and headed south. Though no one said anything—and we wouldn't have understood if they had—they knew they were crossing the "badlands," or that area approaching the border that the Soviets bombed without mercy. At around noon the caravan came to an abrupt stop, not to take lunch but to deal with a crisis.

As a cameraman I like to think I'm observant, but I had not noticed that the leader had been sending out scouts to survey the route. I happened to be up front when two men, one carrying a World War I rifle, returned with news that was clearly bad. Something was wrong up ahead. I drew close and watched as one of the scouts pointed around us. Suddenly we realized we were in the middle of a minefield.

Dan and I had, of course, observed firsthand the devastating impact of land mines on soft human flesh, but we had never encountered a field of mines. Here we were squarely in the middle of one without a clue how to get out. I scanned the ground around us through my camera's zoom lens and found the tip of one mine. Then the caravan's leader gave instructions to the people, and within a minute, they brought their goats to him. These poor, dumb animals, we realized, were going to locate the lethal devices. I wondered how a mine set for a human weighing from one hundred to two hundred pounds would register a goat weighing fifty or sixty pounds. Then I remembered the children in the field hospital. These devices were designed for them as well.

I filmed in silence as the goats were prepared for sacrifice, hoping somehow they might be spared. It didn't seem right that dumb creatures were being sent to their slaughter to protect slightly less dumb creatures. There was a moment of silence during which many of the refugees must have prayed. Many a man, woman, and child must have been saved in Afghanistan and other unfortunate places in our world through the similar intercession of other goats, sheep, horses, or even dogs. I was simply seeing it for the first time.

The men sent the goats out on the path ahead, each with a rope tied around its neck to control it. Eight goats wanted to go in four different directions, and the men did their best with the reins to redirect them along the path. Half-horrified by what might appear in my viewfinder, I followed one goat, then another, and another. Which one, I wondered, might have the distinction of dying for us? Finally I told myself to get a grip. Animals are killed every day for food. I found the path again in my eyepiece and saw a goat sniffing at something. I zoomed in and caught a hint of dull gray paint. The goat began to lick at the flat metal surface and got ready to bite it. As goats are known to eat almost anything, I cringed and closed my eye behind the camera, not wanting to see what would follow. But then the rope leash was jerked back, pulling the goat away from the device. It had done its job. We now knew of one place not to step.

After another hour or so, the men discovered another device in much the same way. This mine was on the path ahead of us, and the queue moved forward a bit after it was discovered. If we were lucky, I thought, we would escape the minefield one mine and, perhaps, one goat at a time. I was relieved a bit later to see the headman give the order to move out again. If he thought we were safe, I'd trust his judgment. But another twenty yards along the path, each of us had to leap over a two-foot hole in the ground lined with ash and a few pieces of black metal.

Although we escaped the minefield, none of us could shake the experience. The caravan moved more slowly as everyone watched every step. I looked back at the location the Soviets had chosen to sow their explosives. It was so nondescript, a portion of a camel path through some scrubby flatland. It was not near any village, stream, or

curious geological formation that I could see. Who did they expect would be using this well-worn path? The mujahedin, refugees, or maybe locals visiting a neighboring village or carrying a sick child to a hospital in Pakistan?

Later that afternoon we began climbing the mountain range along the border. The temperature dipped quickly, and the wind kicked up as we approached the snow line. We passed the night again in the musician's tent, this time shivering in our sleeping bags. No amount of hot tea or sips from our medicine bottles helped. We awoke in the morning to snow falling. Our friend had already made a small fire and was heating water for more tea. As we sat on our haunches around the tiny flames and tried to warm our stiff bodies, I wondered how we would locate mines under the snow.

That thought tortured me so much that day that I shot no footage of our march. I was heavier than most of the Afghans in the caravan, and I figured if anyone was going to set off a mine, it would be me. Nevertheless, with the camels, horses, and goats leading the way, we traversed the mountain passes.

In a broad canyon far below us, we caught a glimpse of our destination. Although the camp must have housed several thousand people, it was one of the smaller camps in the heart of Pashtun tribal country. Generally speaking, visitors from the Tajik north would normally bypass these tough tribal areas with their harsher rules and religion, but the Soviet invasion had bonded both peoples. They were all members of the Afghan family now. Justice—or perhaps vengeance—is swift and brutal here, especially regarding family matters. Though the Pashtuns remained committed to the dream of an independent Pashtunistan, the war against the Soviets had indeed become a family affair.

Here in Parachinar and across the entire border to the southwest, the mujahedin had set up training camps alongside the refugee camps. With Saudi funding, U.S. weapons, and Pakistani military trainers assisted by ISI and Saudi advisers, Afghan boys learned the honorable arts of war as tough Pashtun warlords oversaw the operation. Such a triumvirate of foreigners would never have been welcomed

anywhere in this xenophobic region before, but the war had united all Muslims against the communist atheists from the north.

As we filmed young novices being taught how to fire an RPG or rig a booby trap, Dan and I had no idea where this knowledge would eventually take them. Neither could we imagine the long-term effect of the *madrasahs*, or Muslim schools, connected to the refugee camps. There, clerics taught a brand of fundamentalist Islam to the orphans. As we filmed these schools, we couldn't appreciate that we were witnessing the origins of a system that would initiate an entire generation of lost, motherless refugee boys into an organization that years later would become the Taliban. At that time I don't believe anyone could have envisioned this future: not President Zia, who funded the schools; not the ISI, which for the most part was oblivious to the madrasahs; and perhaps not even bin Laden himself, who had first arrived on the scene in 1981 with his Wahhabi petrodollars to support all Islamist training.

In this camp and elsewhere we filmed these orphans of terror as they played out their own war games in the camps or drew illustrations of prehistoric-looking gunships, tanks with eyes, and butchered corpses on the large tents that housed them. And in the Mundapul camp we witnessed an odd game, where teams of Afghan refugee boys struggled to bring each other to the ground while everyone held one of their legs up behind them with one hand. The simple message was clear: even a maimed Afghan could resist the invader.

# 14

## *Come Together*

**Back in the States in the spring of 1988,** I learned more about Lee Shapiro and Carmen Zuniga from my friends at DuArt Film Labs in New York. Along with nearly every other East Coast–based independent filmmaker, both the Afghan Documentary Movie Project— Shapiro and Carmen's company—and Seven League Productions, Suzanne Bauman's and my company, did all their film and video processing. Irwin Young, the much-loved owner of DuArt, gave me Carmen's contact numbers. Going through the numbers, I spoke with Ron Pacquette, a good friend of Carmen's. After our preliminary meeting in New York went well, Ron set up a meeting with Carmen that went equally well. The next step, we all agreed, was to screen our respective Afghan footage.

At this point I'd already begun playing with the idea of including Lee Shapiro's story as a part of our documentary, but I was still unfamiliar with this woman who had already returned to the front lines to uncover the facts surrounding her colleagues' deaths. After I'd heard about her efforts in Nicaragua and El Salvador, about her documenting those wars while treating the injured and sick, I realized that this soft-spoken filmmaker and medical doctor was every bit as important to Shapiro's story as Shapiro himself.

Carmen suggested that we join her at the ADMP's editing room in Hoboken, where it had been moved after Shapiro's death, to review each other's material. When I arrived at ADMP's rented two-story townhouse, I was taken immediately with the simplicity of the environment. A plain structure in a lower-middle-class area, it was clean and pleasant. I met Ellen Hori, Shapiro's associate producer. Ellen

had met Shapiro, Carmen, and Ron at a Unification Church meeting before they had made *Nicaragua Was Our Home*. I learned Carmen and Shapiro had mixed closely in church circles. Yet Jim Lindelof, Pacho Lane, and other major players in Shapiro's drama had no connection with that organization.

As Ellen escorted us into the small editing room, I saw a framed photo of Shapiro and Carmen taken when they had returned from Nicaragua in 1986. Though I did not yet know the story, I would discover it was the same photo that had unnerved Carmen the night Shapiro had been killed. During the screening I noticed Carmen often turned to the photo, almost as if she were seeking Shapiro's advice. We showed Carmen about an hour of our footage, and she showed us the same of Shapiro's. In particular, she highlighted a scene he had filmed in Narkh, a small village about a hundred miles across the border, where five kids played with a bombshell. They rolled it around on the ground as if it were a soccer ball.

Unlike the few network folks who covered the Soviet war from the relative safety of Pakistan, Shapiro and Carmen made a point of "going inside" for weeks at a time, wearing the native clothes, eating the native food, and trying to learn the languages. When Carmen revealed she and Shapiro used to pray with the people, I became more intrigued. Shapiro, a Jew, and Carmen, who was half-Jewish, were willing to put their lives on the line to tell the story of a Muslim people.

They found the inspiration to pursue this story from their affiliations with a religious group some critics had labeled New Age and worse. This Christian group emphasized the commonalities shared by world religions. It sounds pretty harmless today, of course, but in the mid eighties, such ecumenism was considered incorrect. The well-organized and well-funded Unification Church has a few unusual practices, such as arranged group marriages, in its global mission to bring the world's people closer together. I know little about this aspect of Shapiro's and Carmen's religious lives. I can only give my opinion of them as documentary filmmakers, and as such, they were real pros. Their moving film on Nicaragua had succeeded in making some sense of the mess in Central America. But could they do the same with Afghanistan? Maybe that was beyond any of us at the time.

At the end of the session, almost reluctantly, Carmen presented some of the footage she had shot herself of women in the refugee camps. The footage was startling, for she gave us our first intimate scenes of Afghan women "behind the veil." The women we saw in that footage did not wear the *burqa*, the light blue outer garment that covers a woman from head to toe. (After the rise of the Taliban, women would be required by law to wear burqas whenever they went out in public.) Instead, in Carmen's footage, the refugee women wore only the simple head scarf. There are many kinds of veils, of course, and not all of them are made of cloth, but the Afghan woman, we realized, was not quite the tragic creature we had assumed from our own limited study and experience. (In fact, as Jan Goodwin informed us later, women had traditionally controlled the family purse strings in Afghanistan.)

The status of women in the region would, of course, change in every way when the Taliban seized power. Many claim Afghan women were treated as inferiors from the start. While it was not so much the case in the northern Tajik provinces, in the Pashtun south, stonings for adultery were not uncommon before the Taliban assumed control. Several other sources suggest, however, that it was precisely because Afghan women were so revered that they were targeted for radical containment by extremist Muslims determined to silence the sirens.

After the screenings, Carmen, Ron, Suzanne, and I met again in New York to explore the possibility of producing a joint effort that would combine the best of both of our projects. My coproducers, Suzanne and Dan, began approaching the networks with a short promotional piece looking for money and broadcast commitment. Suzanne felt optimistic that the new concept would not only attract network attention but galvanize it. After all, we had produced shows for PBS, ABC, and others that had attracted both significant viewership and awards. If they liked what we'd done with those projects, why wouldn't they support this one?

How arrogant of us on one hand and how naïve on the other! The big decision makers passed on the project, Suzanne told us, with barely an acknowledgment. How utterly depressing! How could they reject this project, the only one of its kind, that featured the people who were fighting, dying, and actually winning the Cold War for the

West? We would ask ourselves this question again and again in the years to come.

So if we were going to continue covering the story, we would have to tap our own resources yet again, but at the moment we were tapped out. To complete the project, I knew we would have to go to Jalrez to investigate what really happened there to Shapiro and Lindelof and pick up where their film had left off. But the prospects for funding looked dim.

Then, we found help from unusual sources. In one unlikely scenario, a surgeon whom Dan had met near his home in New Jersey helped us. Dr. Mahmoud Bangash had grown up in Kabul and was horrified by the attrition rates in his homeland from land mines. He was determined to help and gave us $3,000, which bought our airline tickets. But we still needed another $4,000 to cover film and equipment costs.

Then an even more unlikely event occurred. The consul general of Pakistan in New York, Dr. Hadi Raza Ali, had become something of an adviser to me during the previous year. I sometimes stopped by the consulate to renew visas or to obtain the latest information on the state of the war. We would sit in his office, drink tea, and discuss the latest reports from the front in light of the greater world situation. Hadi had once been the ambassador to Moscow, and he offered insights into the Soviet political mind that always proved on target. Gradually over many more cups of tea, we discussed the personal aspects of our "crusade," as he called it, not without a touch of gentle sarcasm. He even began inviting me to ambassadorial functions.

On a cold December day in 1988, I sat in his office, sipping more tea than usual and feeling very sorry for both myself and the project. Hadi listened attentively to my story for some time and then suddenly leaped to his feet. "Grab your coat," he said as he reached for his Russian parka. "We have money to find."

We left the warmth of the consulate to enter the snow-piled, Upper East Side streets, where the temperature was in the twenties and the wind chill in the single digits. Without explanation he began walking south along Fifth Avenue. The wind was so strong that twice it sent me chasing the chitrali cap I'd become attached to.

"Maybe you need a string under your chin to keep it on," Hadi laughed, "like your Western heroes and their ten-gallon hats."

After hiking for six or seven blocks, Hadi suddenly turned without warning into a high-rise. Twenty floors up we exited the elevator and I followed him into a large office. He didn't knock, he just walked in. He said something in Urdu to the Pakistani lady behind the desk, who was clearly surprised by the intrusion but who nevertheless got on the intercom to announce our arrival to someone in the inner sanctum. Before long a well-dressed gentleman appeared and greeted Hadi in Urdu. After a quick exchange of pleasantries, the consul general switched the conversation to English.

"This is my friend, Mr. Burroughs," he said. "He's doing a film on the Afghan war and the refugee situation, and he needs money. How much do you have on you?"

This was Hadi's style—straight, fearless, and always to the point. The gentleman dug into his wallet and handed over about $1,000 and then went to several of his employees to collect another $500. After we offered our warm but quick thanks, we went back to the icy streets for another cold hike and another elevator ride. All in all we must have trekked about ten miles that day. We visited five of Hadi's acquaintances and collected just less than the $4,000 we needed. Then we returned to the consulate for more tea and to discuss power politics and dreams.

I honestly suspect that we would have abandoned our project had Hadi not helped us when he did. His actions confirmed to us that we had a story worth telling, and he encouraged us to do so to the best of our abilities. I have often wondered what Hadi would have thought about the story's evolution and the bizarre twists that would befall both Afghanistan and Pakistan in the years to follow because of the ISI and the Saudis. Sadly I'll never know. Hadi died of a heart attack while jogging on the streets of Karachi in May 1992. He had just been reassigned to a well-deserved, high-level position with the government in Islamabad, and I was about to join him in Pakistan for his "coronation," as I jokingly called it. A brilliant, passionate, and compassionate man who had seen the clouds from both sides and still loved their illusions, Hadi Raza Ali was a friend and an inspiration. I have never met anyone else like him. I'll never forget him.

# Jalrez or Bust

**Shortly after Christmas 1988, at our Grove Street** studio in Greenwich Village, Dan and I viewed and studied Lee Shapiro's 1987 footage of Jalrez, where the official U.S. government and media story said he and Jim Lindelof had been killed by soldiers from Soviet gunships. We looked at it several times, pumping Carmen for information.

I had an idea early on that I never shared with anyone, even Dan, until one night over multiple drinks at New York's Afghan Grill, where I laid out the groundwork for a shoot that would pick up Shapiro's story where it ended. The drinks did their job and, very much unlike him, Dan suddenly agreed wholeheartedly that we go to Jalrez and find out what really happened there. In fact we had to go if we wanted to pick up Lee's story. What a great dramatic plot twist for our film. Dan and I never mentioned this idea to anyone, lest they think we were crazy or had a death wish. But Jalrez, we decided, would be our next destination in completing the film. But, located south of Kabul, Jalrez would not be easy to reach and, if we were lucky enough to get there, might prove hazardous to our health.

For months before Gorbachev formally announced in Geneva, on April 14, 1988, that he would begin pulling Soviet troops out of Afghanistan, rumors flew that a pullout was imminent. Our contacts in broadcast television agreed that covering this event was a good hook for our film, but as usual they had no money for us. Still we believed we needed only to put this one last sortie in the can to prove we had *the* story for our time. Besides, we could also sell the footage to CBS or ABC as news, as we had done with the Cuban exodus story.

The town of Jalrez is about twenty-five miles southwest of Kabul near the road to Kandahar. The mujahedin refer to it as a lair of spies and bandits, and we'd sensed it in Lee's footage. We also heard from other commanders and journalists that it was a harsh and unfriendly place, where every male older than eleven or twelve years of age kept a rifle slung over his shoulder or at close reach. A dirt (or mud, depending on the season) road ran through the center of town, where shops and hucksters were crammed on top of each other. Donkeys, camels, and traders milled about, colliding with each other. Most of this activity was normal for an Afghan village during the war and as different factions began fighting with each other. The difference in Jalrez could be seen in the people's eyes. In Lee's footage they stared into his camera as if he were the ultimate intruder. People stopped their work to watch him pass. Some looked surprised, some smiled sarcastically, and a few seemed to snarl. We could also see that Lee's Jamiat escorts were nervous. They watched the villagers and kept their automatic weapons ready, continually glancing at each other for signals. Several escorts passed in front of Lee's camera as they cleared the way for him and Jim along the congested street. Shapiro had run out his full 400-foot magazine, or ten minutes of film, without cutting once. A cameraman doesn't usually do this. He must have thought he had something important in his sites that might never pass his way again.

With some idea of what we would face, Dan and I returned to Pakistan on December 8, 1988, with a loose plan for finding our way to Jalrez. People in Peshawar told us that our idea was foolish on many counts. Access from Kandahar and Paracinar was closed, for one, because of snow, and we would have to go by way of Jalalabad to Sorobi and on to Bagram Air Base outside of Kabul. Also, our trusted contacts—Wakil, General Wardak, and our other NIFA links—were inside Afghanistan and out of touch. I had to admit that our scheme sounded a little crazy, but I felt we had to give it a try.

When we arrived in Peshawar we paid a visit to Shah Zaman, Peshawar's minister of refugee affairs, who also decided which journalists were permitted to cross through the tribal areas along the border. We hoped he could suggest a way for us to reach Jalrez. Shah Zaman had been helpful before. As we sat in his office waiting room

and our turn for an audience, the small anteroom filled with petitioners grasping dirty, crumpled papers. Some were looking for missing relatives in the camps and others for authorization to set up concessions or services in them. The sunlight poured in from windows that had never known a squeegee, and the heat in the room became unbearable. So did the smells and the flies.

When Shah Zaman discovered we were waiting, he escorted Dan and me into his office as if we were long lost friends. All around us were other clients who sat in chairs and benches on the periphery of the room, waiting their moment to speak or to be addressed. Shah was always a multitasker, conducting several meetings at once and interrupting a conversation to answer the phone or make a call. Dan and I took the seats in front of his desk and began the meeting with the traditional ritual of tea and casual conversation before moving to more serious matters. There is no rushing a meeting anywhere in India or Pakistan. This day Shah Zaman held a beautiful rose in his hand, and at every break in the conversation he brought it gracefully to his nose. It reminded me of paintings I had seen of Suleyman the Magnificent, the great sixteenth-century Ottoman sultan of Turkey who was said to often hold a rose. The flower in his hand reminded me that beauty still existed in this world alongside the grit, grime, and crime of everyday life.

Shah suggested we approach Professor Burhanuddin Rabbani's Jamiat-i-Islami organization with our Jalrez travel request, and he arranged a meeting. We knew Jamiat was the political arm of Massoud's force in the north and the organization with which Shapiro and Lindelof had each traveled safely on their earlier trips.

Armed mujahedin in another Toyota Land Cruiser picked us up later that day at Deen's Hotel and took us to Rabbani's headquarters in the Defense Colony sector of Peshawar. We were escorted into a two-story colonial building, asked to take a seat, and, of course, offered tea. It was during the late-morning call to prayer, and our escorts stepped into the courtyard to pray with others. Dan and I glanced around the room and noted its bare walls. NIFA's offices at least had a few military maps and old photographs of famous landmarks confirming its more moderate stance. Jamiat abided by a more-or-less strict

interpretation of Sunni Islam, which does not allow photographs, but according to other journalists, its fair-minded constituents always behaved with integrity. We would be safe with Jamiat, they had assured us, as long as we played by their rules.

After prayers, we were invited to a second-floor office where the celebrated, grey-bearded scholar with intense, flashing Bette Davis eyes sat behind a simple desk. Professor Rabbani stood, shook our hands, and greeted us in halting English. He offered us tea, which we accepted, even though we had just had two cups down below. The tea ritual in the region is curious; first one spooned great gobs of sugar into the cup and then poured the tea quickly to mix with the sugar. No one uses utensils to stir the tea. Perhaps that way hosts can afford to offer a second, already sweetened cup without having to add more sugar, or perhaps it's considered bad taste to place a spoon in the tea. The bottom line is that visiting diabetics should be wary of that first cup!

As we sipped our tea, the professor said he understood we wanted to find a way to Jalrez. He wanted to know why we would want to visit such a no-account place filled with bandits and Soviet sympathizers and whether we had considered the danger. We explained the mysterious deaths of Lee Shapiro and Jim Lindelof and our desire to find out what had actually happened to them. Rabbani listened patiently to our story before commenting. He remembered hearing about the two unfortunate journalists, but he wondered why we needed to learn more about it. I was thrown by the question. I would have thought our inquiry would have spoken for itself in journalistic terms. The question shook something loose in my psyche that suggested there might be more to it. Of course, we were being the diligent documentary filmmakers following in Shapiro's footsteps, but perhaps other things had motivated us as well. For myself, was it simply the gratification of unraveling a mystery, or did I have another agenda? Was I trying to prove my male qualifications again, my relentless journalist nature in the face of big obstacles? Was I grandstanding? If so, I'd picked a dangerous way to do it.

Satisfied on some level with our sincerity, if not our intelligence, the professor asked one of his commanders, a tall, good-looking man in his early thirties, to join us. He was introduced to us as Muamar,

but because of his bearded, "revolutionary" appearance Dan and I have referred to him ever since as "Che." Rabbani and an English-speaking assistant continued to talk with us for another ten minutes, translating very little of it for the commander. Clearly Che understood only bits of our conversation, but he watched our every move, hand gesture, facial expression, and knee twitch. He never opened his mouth and at the end of the conversation simply nodded to Rabbani. Che had agreed to take us to Jalrez, if such a thing proved possible, the professor told us. When he stood to shake our hands good-bye, I remembered that decisions in this part of the world are often made with less information.

Che's route to Jalrez took us once again through the Khyber. As before, Dan and I hid from the Pakistani military beneath sacks of grain, blankets, and a dozen gas cans whose caps leaked. This time we also enjoyed the company of a raunchy goat, which we figured had been brought along for food or to find land mines or both. The trip was pretty much the same as our previous one through the Khyber, only this time at checkpoint number three, just before the cusp of the mountain and before the road begins its downward spiral, our vehicle ran out of gas. The three mujahedin jumped out to push the truck but couldn't get it moving. Che called Dan and me to get out and help push the vehicle to the checkpoint. As the truck approached the guards, Dan and I ducked back inside. Of course the two soldiers saw the whole maneuver, but the humor of the situation worked in our favor. With broad smiles the soldiers waved us through the checkpoint. They burst out laughing when one mujahid slipped and fell and had to run to catch the truck as it picked up speed going downhill.

We spent the remainder of the day on the infamous road to Jalalabad, listening for MiG fighter jets and ducking off the road and into cover whenever we thought we heard one. The night was a welcome relief. A mujahid who spoke a little English told us Che planned to get us from Jalalabad all the way to Kabul with the truck. He didn't want to switch to a camel or donkey. It would be rough going, but we would stay off the road and use the foothills and camel paths until we got to the Silk Gorge. The mujahid thought this Toyota could handle it, because it had "five wheels drive."

The next morning, Dan and I were dismayed to find someone had tied up the goat overnight next to the small gasoline generator we used to charge our camera batteries. The goat had eaten the cables, and when I discovered the critter in the morning, he had just begun chewing on the ignition system. I grabbed the generator and tried to pull it away from him, but he held tight. A goofy tug-of-war ensued, as the goat held on with its teeth while I spun in a circle with the machinery, trying to dislodge him. Che's men thought it was hilarious. Finally they joined in to extricate the beast. Dan believed he could repair the damage, but it would have to wait until we stopped again for the night. We would be without power for the cameras until he fixed it. This was not a good omen or a good way to begin a shoot.

We left the road around midday and skirted the Jalalabad suburbs, where we could hear the occasional pounding of artillery. Unable to shoot anything with dead camera batteries, Dan and I tried to get some sleep and nodded off in twisted positions in the backseat of the Land Cruiser. We awoke later that afternoon with numb limbs and saw the ice-bordered Kabul River on our right. As the sun set, we were still on the road, driving without lights or the benefit of a moon. When we finally stopped, I stumbled from the truck unable to move my legs. The wind had picked up and the temperature had dropped.

We started a tiny fire, and Dan fiddled with the generator but got nowhere. The situation began to unnerve me.

The morning found us leaving all excuses for roads and heading toward the mountains on a camel path. We were moving deeper into unknown territory without a clue where we were and, thanks to the goat, any way to document the escapade. I began to think nasty thoughts about this beast, which, given yet another opportunity for causing mayhem that day, had crapped all over our backpacks.

As we climbed into the mountains, light snow began falling. Soon the truck was slipping and sliding on stretches of ice. Off-roading in the California sun is one thing, but driving through snow-covered camel paths in Afghanistan is something else. The pitch of the paths in the foothills occasionally leveled out to allow us to drive the truck for a time, but the following day up harsher grades we made progress only after Che borrowed two camels from a village and harnessed

them with lengths of rope to each side of the Toyota's front bumper. Our trek was becoming an Afghan version of Werner Herzog's film *Fitzcarraldo*, only we were dragging a Land Cruiser instead of a steamboat. Dan swears the particular beast he was following up one slope purposely waited for him to approach his rear so that he could unload his bowels in Dan's face. Our escorts laughed louder than the Pakistani soldiers had at the checkpoint.

On our fourth day out, we lost all sense of where we were going and what we had set out to do. The whole idea was beginning to seem as crazy as some had told us. We didn't even have a map. With the bright sunlight reflecting off the snow in the clear mountain air, there was little with which we could identify in our semi-blinded state. But we could still hear the drone of a high-flying Soviet gunship headed in our direction.

In an instant Che and his men had unhooked the camels and sent them running, and they began throwing snow on top of the Land Cruiser. In a frantic burst, Dan and I joined in. After half a minute of scooping and heaving, we followed Che's lead and dived into a snowdrift as the gunship passed overhead. The terrifying chop of the main rotor drilled into my head. Apparently, the crew didn't see us or check their heat sensors. Waiting until the sound had disappeared, I was the last to crawl out of the drift, shaken and cold. Che and his men seemed to take it all in stride and took off after the camels. It was just another day on the slopes.

As the afternoon progressed, heavy cloud cover came in from the north. By the time we'd eaten and set up camp for the night, a blizzard was raging. We slept in the cramped Land Cruiser, five unwashed men and a flatulent goat. In the morning the storm was still going strong, and Che made the difficult decision to give up on the foothills and head back down to the plains and the road. There he would decide whether we could continue our journey. Clearly he felt bad about this turn of events, but we recognized the camel-led sleigh idea wasn't working. Besides, Dan was coming down with a nasty chest cough. If Jalrez was not in the cards this time, that was all right.

Four hours later, with the snow having turned to cold, pounding rain at the lower altitude, we came upon a small village, or what

was left of it. The bombing had been recent for much of the rubble was still smoking. A dozen or so Jamiat soldiers bivouacked there. They invited us into the remains of a building and gave us cups of steaming tea and warm naan. They were friendly guys who did their best to make us feel comfortable with little more to offer than their smiles. We spent the night in the place huddled next to a tiny fire. They brought the camels in to add their warmth to the space, and one of Che's men took the goat with him under his blanket. With a flashlight that he had to shake ever so often to make work, Dan worked on the generator late into the night and finally got it going. He hooked up two camera batteries to charge. I felt a little better.

We awoke the next morning to the sound of a MiG, not very close but close enough to send my stomach swirling. Then we heard the sound of bombing in the distance. The mujahid with the 100-word English vocabulary explained the Soviets were hitting a village of only women, children, and old men about twenty miles away. A little later he said Che and the local commander had decided to strike the Soviet encampment not far from the village. A military offensive en route to Jalrez? That was not part of the plan!

Around noon, the entire group, or about ten soldiers, set out on foot in the direction of the smoke. No one asked if we wanted to go along; they just assumed it. And they didn't take the Toyota or camels this time. We had heavy armaments and ammo to hump.

It always amazed me how the mujahedin would walk through rain, snow, and ice in sandals. Occasionally we saw someone wear socks, but for the most part, the men's feet were bare to the elements. Of course, sandals were easier to step out of when entering a mosque, home, or even a simple hut. While it was cumbersome for us to unlace our shoes or boots and to remove our socks every time we entered a building, out here in the cold outback wearing our Timberland boots had been the right choice. I even noticed a few soldiers' covetous glances.

The rains picked up again as we approached the smoking village. Che and the other commander chose to bypass it. I suspected they didn't want any of the survivors to compromise our element of

surprise. So instead we marched another hour and came upon a second village that had been wasted. We learned the Soviet encampment was close by, and Che gave the order to stop for the night.

The rains had paused briefly, and Dan and I decided to wander off for a sip of scotch from Dan's cough medicine bottle. We had to discuss this situation, which was slipping way out of control. What if these guys attacked the Soviets and were beaten or, worse, were captured or killed? What in the hell were we going to do out here on our own? This trip, we decided, was the dumbest thing we'd ever done.

We sat in the remains of a doorway and sipped at the scotch, which went down too easily. Then Dan sat forward and stared at something across from us. I followed his eyes and saw the corpse. It was not your typical corpse. We stood up and approached it nervously, as though it might harbor some kind of contagion. The remains of the head were connected to nothing more than the spinal column, which was mostly bare of its flesh. The head seemed to have been melted somewhat by a great heat, but the face, with its wide eye sockets and its lips stretched around the great gaping hole that was its mouth, held its final expression of shock and unfathomable horror. I had seen a number of victims of war through the years but never such an apparition as this. Clearly this man, Afghan or Soviet, had suffered hideously before he had died, conscious to the end. His silent scream still echoes in my head to remind me, should I forget, of the ghoulish nature of war.

# Dead Soldiers

<div align="right">

# 16

</div>

**The gray morning was cold and so was the tea** by the time I'd extricated my shivering body from the wet blanket that separated my sleeping bag from the frozen mud. As far as I knew we were still a considerable distance from the Soviet installation. How could the men have acted so casually if we weren't? I sipped my beverage, thankful for the hint of warmth, as we sat on our haunches in a circle around a small fire and discussed with Che and the others what Dan and I would do during the attack. The guy who spoke the bit of English translated. We could come along, Che and the other commander said, only if we followed their orders precisely. We would be in the second line of the offensive, and our biggest job would be to keep up with men in front of us and not fall behind. If we slowed and delayed the men behind us, he could not guarantee our safety. Dan and I nodded as though we understood.

We hoped we did understand everything and that we'd have enough time to work out our own drill on the situation before the engagement. Although both of us had been in contested environments before, neither of us had been a part of any frontal assault. We thought we'd get a chance to slip away from the group and discuss the situation over a cup of really hot tea and, in the light of sanity, make appropriate adjustments to our participation. All we wanted was to film the operation, not to take part in it. That way, we would be able to position ourselves at a spot—a distant one, we hoped—that afforded decent coverage. We needed synchronous picture and sound to film this raid successfully, and that meant getting occasional head or tail "slates" (the modern replacement for the old movie clapsticks) from a digital

readout that the soundman held up for the cameraman to shoot so that the editor could match up sound and picture. Complex maneuvers were not in the cards for synch film coverage. Others might shoot this "mit out sound" (MOS, or without sound), as a German director from the early thirties allegedly once barked, but we wanted synch whenever possible.

When the meeting was over, Che stood abruptly and the others followed. They presented their hands palms up to the heavens in brief prayer. Dan and I glanced at each other wondering if we should do the same and thought better of it. We were not Muslims and we were not warriors. After the prayer the men picked up their weapons and began jogging in the direction of the Soviet installation. Dan and I glanced at each other and began jogging with them. Che went to the side of the group to watch both ahead and behind. He gestured with his hand and the men in front began running faster; we had to sprint to keep up. The men leaped across a broad ditch obviously expecting us to follow. What was this, I wondered, a practice run to get our moves down? Dan leaped across the chasm with the thirty-pound Nagra and barely kept his balance. I slowed a bit, but hearing heavy footfalls and breathing behind me, jumped too. Then I heard gunfire from the contingent of our men who had stayed behind with the mortars and saw shells hitting up ahead of us in the wreckage of a compound. Our men began screaming war cries. We were closing fast. The defenders returned fire. I could make out the flash of large ordnance along with small flashes from AKs, and our men, running both in front and behind Dan and me, began firing wildly. A report sounded next to my right ear—the same ear that had been tested by the exploding land mine two years before—and a loud, high-pitched buzz replaced my hearing.

Obviously it was not a rehearsal. Dan and I were racing to keep up with the men ahead of us as Che had advised. I turned on the camera, threw the zoom into the widest possible angle, and held the eyepiece up to my eye. We were running at top speed across the rubble-strewn ground and toward men who were obviously firing at us. In Dan's expression I saw the reflection of my own terror as well as the determination to go along with the damn thing.

Somehow in the midst of this madness I began to fear not for my life but for my eye that was against the camera's eyepiece. If I tripped at this speed and hit the ground, the heavy camera would dig into my eye. It was somehow appropriate that my life's greatest fear—blindness—would at this moment distract me from the real and present danger. I could have brought the camera to waist level and aimed it with the wide-angle end of the zoom, as I had done so often before, but I didn't. I pushed the glass further toward my cornea and hoped that the wings of the Prophet's Gabriel would carry me across the ravaged turf and save my sight.

Through the lens the remains of a broad doorway swept past me. Suddenly I was inside the compound and part of the show. My adrenaline was pumping at max. This same hyped-up transformation has overtaken warriors since the beginning of recorded history and earlier, and whether it's a kind of physical or mental coping mechanism peculiar to males, it's very contagious among our gender. The shot was looking great through the camera, and I only hoped Dan's sound was as good. I was rocking and rolling, and somehow the Prophet's angel would have to look out for the rocks and the potholes beneath my feet. These kinds of shots were the ones a documentary cameraman lives for, or—as Shapiro did—dies trying to get. I surrendered to the moment.

Somehow, in retrospect, I can't imagine a woman, either a warrior or a journalist, seriously entertaining such an operation. The women I've met in my profession would have handled this situation differently from the start. They would have stopped, come up with another plan—a deception, a Trojan horse–style trick, or a clever siege. They would not have gone barreling in as we did, without serious consideration of the risks.

Maybe survival of the species is better left in the hands of women, but after what I've studied of Afghan history, I'm not necessarily adding compassion and benevolence to the proposition. The lines of the Kipling poem "The Young British Soldier" reflect the passion and madness of both Afghan genders as well, perhaps, as those of his own race:

*When you're wounded an' left on Afghanistan's plains*
*An' the women come out to cut up your remains*
*Just roll to your rifle an' blow out your brains*
*An' go to your Gawd like a soldier.*

From what I've seen and read about the Soviet-Afghan war, I doubt if the Soviets, as the British before them, ever knew what kind of enemy they faced. Communism dismisses religious and cultural pursuits as little more than "opiates" that spawn social illness and weakness, but the Marxist axiom appears to have been wrong in this case. The Afghans certainly weren't weak. The history of this fierce people was available for the Soviets to study and learn from, just as that of the Vietnamese was available to the Americans, if we'd chosen to look.

After the shooting stopped, Che and his men moved from room to room inside the roofless compound in a cleanup operation. Apparently, neither side suffered serious casualties, which amazed me given the firepower expended. The enemy had taken off over the back wall. If I had seen or heard these wild men coming at me, I'd have done the exact thing without hesitation. But then again, I'm not a warrior.

Dan and I sat in the smoky rubble and caught our breath while Che's men went after the Soviets. The gunfire grew distant and soon subsided. Meanwhile, Che went through the place and scoured it for arms, ammo, information, and clues. One of his sergeants urged us to come with him. He was a grizzled warrior in his sixties who, we'd been told, had once snuck into a Soviet camp and slit the throats of five Soviets in their sleep. We followed him through the compound to a courtyard in back where we encountered more dead soldiers than I'd ever seen in one place. No, not blood, guts, or body parts, only shards of glass with Stolichnaya labels. We saw heaps of empty beer bottles, too, but mostly drained vodka bottles. Hundreds? No, thousands! After a brief count we estimated about 2,500 empties.

Through our interpreter, I asked Che how many men had been stationed here. He held up ten fingers and then two more, so perhaps a dozen men. But there had been twice that number the month before,

our interpreter added, and a tank crew had come and gone before the Soviets began withdrawing their troops from the south in anticipation of Gorbachev's formal announcement, which would come four months later. So I wondered how many Soviet troops had actually passed through this place. Sensing where I was headed with the questions, Che thought the more important consideration regarding the bottles was the length of time the Soviets had held the location. They had been there three months, he said. Before then it had been in mujahedin hands. I calculated that in three months, or ninety days, an average of, say, twenty men per day would have had to consume 12.5 quarts of Stoli plus the beer.

Dan and I have met people who drank this much and more, but let's not forget that this compound was a military base. These men were in uniform and supposedly on duty around the clock. The bottles did not evidence great morale, nor did they say much for military discipline. The courtyard told me more about the mind-set of the rank-and-file Soviet regular in the last days of the war than anything I've seen or read since. Now I understand why the Soviets' tour of duty in those last years had been cut to only three months.

# 17

## *Smoke on the Border*

**After the engagement with the Soviets, Dan and I** managed to make it back to the border in two days. We hadn't reached Jalrez or gotten anywhere near it, and frankly, we were too tired to care. Besides, we had shot some extraordinary footage. Now we had to get it back into Pakistan. Returning from inside Afghanistan and crossing back at Torqam was always nerve racking. If we were caught at a checkpoint on the way in, we might have our equipment seized and find ourselves detained, but at least we'd be in Pakistan. If we were caught on the way back, it would be evident that we'd already exited illegally. Shah Zaman had no authority to issue formal permits to cross the border, only those to enter the tribal areas. So here we were, once again, hiding under carpets, blankets, and mujahedin butts. At least the goat was gone. Che had left it for the other soldiers to feast on.

It was late at night when we approached the big gate, Che with papers and money in hand. We managed to move through quickly. As usual we held our breath until we could feel the truck's engine turn over and begin the steep climb into the Khyber. Only three more checkpoints to go, but we were past the big one.

When we stopped at the next checkpoint, however, I could gather from the muffled conversation that all was not going well. The minutes passed, and we heard the truck door open and close several times as Che returned to gather more papers or money. After another ten minutes the rugs and bags were pulled off us, and we sat up as Che said something urgently in Dari. Our translator did his best to explain the problem: the guards knew we were hiding in the truck, and one of us would have to talk with them.

In my arrangement with Dan, negotiations usually fell to me while he handled the equipment. It was a good division of duties, as I guess I'm better with the diplomatic stuff and he with the machinery, but that night my leg cramped so badly I couldn't walk. With Che urging us to move quickly, Dan would have to do the schmoozing. I gave him my passport and papers, and he stepped nervously from the truck and headed for the guard post about a hundred feet away. Since they knew we were in the truck (how, I can't imagine), I saw no reason to keep hiding and decided to watch the scene through the windshield. In the light of a kerosene lamp that hung from the roof of the guard shack, I could see Dan, Che, and our translator talking with the two guards. Papers and passports changed hands in the shadows, but I couldn't get a sense of what was really happening. The only clue was a growing tension on the faces of the soldiers with me in the truck. Five minutes, then ten minutes passed. What the hell was going on? The mujahedin started groaning, and my mouth went dry.

I saw Dan light up a cigarette. Then I noticed that all the men were smoking. Their more relaxed body language indicated that they were now chatting instead of negotiating. Dan left the group and headed back to our truck. He wore a strange expression and handed me the cigarette through the open window. I didn't smoke and he knew it. The moment I looked down at the hand-rolled joint and sniffed the smoke I knew what it was. Dan just stood there and grinned nervously. I was speechless.

"Go on, take a drag," he said.

Was he mad? Was he already stoned? What had he said over there? What were they doing to us? I could see the headlines now: American journalists caught at Afghan border smuggling drugs thrown into Pakistani prison!

"What the hell are you doin'?" I shouted. "Are you crazy?"

"They said it was cool," he said lamely, "not to worry."

"Not to worry? Are you nuts?" I nearly screamed. "Now they've got us where they want us."

"But Che's smoking too. Everybody is." So here it was, I groaned inwardly, the Garden of Eden bit all over again, only this time the snake was at the guard shack, undoubtedly laughing nastily as

Devaney played the part of Eve. He even gave me the damn fruit to eat. Then I saw the whole crew walking over to the Land Cruiser: Che, our translator, and the two guards with their automatic weapons. The jig was up. I sat back in my seat, still holding the joint, and took a deep breath. When the group reached the truck, one of the guards poked his head through the window and smiled broadly. He pointed to the joint in my hand and took a puff from the one in his. "Good, yes?" he nodded and added a few more words in Pashto. Our guy translated with a big silly smile. "He ask if *charras* better than *charap?* Is *charras* better than American whiskey?"

I stared at the entire gang—all of whom were quite stoned—and then brought the joint up to my own lips. What the hell, I figured, if this was a setup we were already in trouble. As I blew the smoke back out in a ring, one of the guards cheered. Then the mujahedin sitting next to me plucked the joint out of my hand, took a long drag, and chuckled. Smoke began filling the truck.

So I had my introduction into the region's drug culture. In my future trips to the region, I observed that hashish was the inebriant of choice and could be found just about anywhere. A bottle of booze would land you in deep trouble, but a hash joint generally would not. Smoking hash was an accepted practice and quite often, especially among the mujahedin rank and file, a way of bonding, just as Westerners might share a beer at a bar. I've often wondered why the Prophet established an injunction specifically against alcohol and not drugs.

We couldn't foresee Afghanistan's future drug problem in 1988, but the stage was being set. By 1992, the U.S. government would withdraw all financial support to rebuild postwar Afghanistan, "compassion fatigue" would set in among the nongovernmental agencies (NGOs), and the drug trade would replace the refugee cash cow that had kept Pakistan in curry and kebabs. And when ultimately faced with this illicit, multibillion-dollar trade, which would grow by leaps and bounds in the mid-nineties, even the Taliban with its claimed adherence to strict Shariah law would eventually bow to the poppy. In the meantime, the Soviets had already become active consumers. It was becoming a bull market for Gulbuddin Hekmatyar, Pakistan's and America's favorite drug lord.

# 18

# Siege of Jalalabad

**It was one o'clock in the morning on June 9, 1989.** Dan and I were in a camouflaged tent camped about four miles from regime-controlled Jalalabad, where firefights crackled and bombs exploded throughout the night. I couldn't make out what was going on in the commander's tent, but I knew it had to be bad if NIFA had brought its commander in chief, Palawan, back from the front. The four voices speaking in Dari were very agitated, and it seemed one man was trying to defend himself. Someone slammed his fist on a table.

The "lights out" order had been given at its usual time, before sundown at seven o'clock that evening. But once the sun dropped, the adrenaline level rose throughout the camp. I think it was because we all felt more vulnerable in the dark. Using any light, even a little flashlight, could enable a regime Hind gunship or a MiG crew to spot us. A few guys made the rounds at night to ensure no one was cheating, so the likelihood of light leakage was small. Besides, we hadn't yet heard any engine noises overhead that night. But the activity in the commander's tent told us something was very wrong.

Plenty was going wrong during the siege of Jalalabad in the summer of 1989. By then the last of the Soviets had been out of Afghanistan for over six months, but Moscow was still supporting President Mohammad "the Ox" Najibullah, whose forces had held onto all the major cities in the country: Kabul, Jalalabad, Kandahar, Herat, and Mazar-i-Sharif. The mujahedin, however, controlled the countryside throughout the land. This strange standoff was reminiscent of the Middle Ages, when the castles might remain inviolate but

their governors were unable to ride safely across the immediate terrain to visit a neighboring fortress. The mujahedin had beaten the Soviets by deploying fierce guerrilla units and by adopting an overall strategy of harassment under the leadership of Jamiat's Ahmed Shah Massoud and NIFA's Gen. Rahim Wardak that simply wore down the enemy. This attrition kind of warfare had been part of the warrior fabric here since before Alexander's arrival, and the Afghans knew it well. But things had changed. With the countryside in their hands and the regime's forces having retreated to the cities, the mujahedin had to embrace a new strategy.

Now the "seven parties" (or fifteen if, unlike Pakistan's President Zia and the ISI, one considered the eight Shia parties of the Hazarajat as well) were determined to try something they'd never learned to do—work together as a team to surround the walled city of Jalalabad and storm its gates by sheer force. Not only did the parties not have that kind of force, but the very tribal, ethnic, and religious differences that always divided them scuttled any possibility of a unified and successful offensive. When we arrived in Jalalabad at the NIFA sector days before, soldiers told us the rules of engagement— not engagement with the enemy, but engagement with the allies, or the various organizational military forces that had encircled the city. Somehow in some *shura* (parliament of elders), its leaders had decided which party was to occupy which piece of turf during the siege. The different parties erected borders for each inviolate area to ensure that a soldier from one party did not inadvertently cross into another's terrain. If one party wanted to enter another organization's position, a meeting was arranged to determine if the reason was justified. Soldiers didn't snarl at each other across these borders, but the divisions were quite real.

When Dan and I had arrived at the NIFA sector without a translator, the mujahedin used sign language to give us specific instructions as to where we could and could not go, what we could film in NIFA's territory, and what we could not film in the Hezb-i-Islami sector on one side and that of Jamiat on the other. Because of our own failure to communicate, Wakil didn't even know we were in Peshawar. Perhaps he or one of his people might have been able to explain the

system to us but not the two guys NIFA headquarters had sent along with us. Hussain was bright enough and spoke a bit of English, but he was slow on the uptake. The other guy, Anwar, an arrogant kid of seventeen, never paid attention to anything or anybody. All he wanted was for us to take his picture with our Polaroid camera. And one snapshot was never enough. He always wanted two photos as he posed beside artillery pieces, rocket launchers, and other "manly" ordnances. We humored his requests at first, but the double-photo bit got old fast. The situation at Jalalabad was bringing out a less than impressive side of these fierce warriors.

During the next few days we filmed what we could from the outpost and went along on several sorties to the edge of no-man's-land, where repeated strikes had flattened the earth and vegetation and covered it with ash and twisted metal. The city's entire perimeter had been laced with land mines, and only an occasional tank driver would dare cross even a small section of it. It reminded me of archival footage I'd seen of the trench fighting in World War I, and undoubtedly any frontal attack by the mujahedin across this plain would meet with the same kind of withering fire that brought down millions of young men in the Great War. I wondered what the mujahedin's strategy was. They weren't likely to starve out the regime's defenders, given that Soviet cargo planes (though Moscow claimed otherwise to protect its new, so-called neutrality) made daily runs into the city with food and ammo. From Kabul, Najibullah was in constant radio contact with the garrisons in Jalalabad, and between his daily weight-lifting sessions, the Ox could talk with any of his commanders as well as his Soviet "advisers."

The regime forces had at their disposal MiG fighter jets after the Soviet occupation, and even though the Soviets told the world they were being flown by Afghans, everyone here knew most of the pilots were Soviets. These experienced fliers would often come in so low we couldn't see or hear them until they were on top of us. Whenever I heard a plane approaching, the blood would pump so loudly in my head my thoughts would scatter. And while the low fliers scared us, the ones armed with heat-seeking devices that flew high and out of

range of the Stinger missiles filled us with cold terror. The moment I heard one bomb in the distance and a second one closer, I knew I was in for a case of nerves. I found I couldn't think straight under this pressure, and Dan was making less sense than I was. He constantly played old song tapes on his tape recorder. He said he was just checking them, but I think he wanted to hear English-speaking voices. Once I even thought I caught him talking back to the recorder. His behavior was a bit weird, but then we were in a very weird situation.

After we'd arrived at the camp a week before, we wondered why we had felt so compelled to return to this graveyard. With the Soviets gone, what possible interest could American viewers (who had never shown any interest anyway) have in any ongoing accounts of the strange, chaotic people on the other side of the world who had fought the Soviets on their behalf and who were now at each others' throats? Maybe the American networks were right. Maybe Dan and I did not, in fact, have a rational reason to be here now, but only an emotional connection to the story. Still we hoped for a change of heart among our countrymen, believing that if they could only see what was going on in Afghanistan and come to know something of the Afghan people they might take an interest in their ongoing struggle for liberation. If what we filmed could elicit even a hint of that awareness, then our work would be worthwhile. That's what Lee Shapiro and Jim Lindelof as well as other journalists like Mike Thornton and Andy Skrzypkowiak, who was also allegedly murdered by Hezb-i-Islami, had come to believe, and it was up to us to complete the story these men died trying to tell.

While I am moved by the cyclical aspects of historical events, as they had been taught to me during my Georgetown University years through studies of Arnold Toynbee, Carroll Quigley, and others, Dan had been steeled by more concrete roots. As a Bronx street urchin he had learned to rely more on his gut feelings than on what he learned in school. Regarding the Afghans, he has said many times, "I just plain like these dudes." But in Dan's simple and spare language there was insight born of strong intuition. Dan has the gift of seeing the world around him for exactly what it is.

The nights in the encampment were spookier than the days. From a hill nearby I could watch the rockets bursting over Jalalabad a couple of miles away, evoking memories of Fourth of July celebrations. From a certain distance I have found I can deny that the carnage is real. Havoc can almost be beautiful in a Jackson Pollack sort of way. I have to be close up, seeing the eyes of the victims and hearing their screams of pain and their prayers for salvation. In the Jalalabad fireworks, people were dying on a regular basis. Reports said hands, arms, legs, intestines, and skulls were piling up in the rubble for the vultures and the few dogs that hadn't yet been eaten to pick apart. Ten thousand people would die in this foolish three-month siege. And of course, another 20,000 would be maimed for life, with only one leg or arm or an empty eye socket. Death cries were carried on the winds nightly, but I could barely make them out from where I was.

And the regime struck hard at the mujahedin outside Jalalabad. The chill would begin its slow climb up my spine the moment I heard the sound of one of its MiGs or Mi-24 Hinds. I would gaze out across the great, dark expanse and try to guess where it might be. I would learn how accurate I was when I saw the first flash of an air-to-ground missile and the subsequent explosion. Whenever I determined the flashes were moving in our direction, I would hurry back to the tent, as if its flimsy canvas would somehow protect me. The others around me generally retired to their tents as well. And then everything would fall silent as people prayed and listened for the whine of the jet engine. Cloudy nights were a gift from Allah and a reason to rejoice.

During a particular bombardment near the front, Dan and I found ourselves in a cave with another American journalist. Steve LeVine had been covering the war from the front lines for different weekly news magazines. He was a sharp guy who traveled alone and was always hyper about something, whether it was bombs, bugs, or bad tea. LeVine was ever on the lookout for the next opportunity, no matter how risky. When I expressed my surprise at seeing another American journalist out in the thick of things, he laughed. He was only here, he said, because as a photojournalist he could work alone. Traveling with a media news team was out of the question now in terms of network budgets, for Afghanistan was not a front-page war

anymore. I countered that it never had been. LeVine agreed, pointing out that some journalists had covered the war's earlier stages but from hotels in Peshawar and Islamabad and far away from the flak. Steve didn't care much for the hotel warriors, saying he liked the flak. In a few hours, LeVine had disappeared as quickly as he had come.

On the way back to camp we crossed a shallow stream that had enough water that we could almost say it was flowing. I found it curious that the soldiers with us chose to leap from rock to rock or walk across a fallen limb instead of wade through the water. They avoided getting their sandaled feet even a little wet, almost as though they feared the water itself. Perhaps, I speculated goofily, it was the reaction of a land-locked people who could never imagine our human origins in water. Water was for tea; outside of that it was an alien substance. I sat for a moment to take off my sandals and bathe my dry, aching feet in the cool water. One of the men bringing up the rear of our group started shouting at me in Dari. Clearly he wanted me to take my feet out of the stream, fast. When we returned to camp, Hussain explained that the Soviets had poisoned this stream before they left. I looked at my feet. There was a cut on one foot that had not yet healed. I dug into my backpack for a bottle of hydrogen peroxide and poured it over my feet and hands, as if it might be able to neutralize poison.

As no one spoke English, Dan and I were lonely at NIFA's Jalalabad camp. Besides that, the tea was drying up, for the other nearby stream, whose water had been deemed safe to drink, was now no more than a trickle of green slime. We had to boil its water at least twenty minutes. The food was equally slimy, so we chose to eat our dried, packaged stuff whenever our presence was not required on the communal carpet. The only relief Dan and I could look forward to was leaving the camp to take a leak. In reality, it was an excuse to partake of our "little guys," the small medicine bottles filled with liquor that we had managed to smuggle past the checkpoints and our escorts. Our ruse had never been detected until now. Though we hadn't realized it, they thought they'd caught us with our pants down: instead of suspecting us of drinking alcohol, they thought we were performing homosexual acts. Since Dan and I always left together in the evenings, spending considerable time out there in the dark, it was no great leap

for the sexually deprived Afghan males to imagine we were engaging in sex. They gradually made that clear to us through knowing smiles, gestures, and body language whenever we left camp or returned together.

We felt it was definitely time to split, but we didn't know how. The guys in charge hadn't received any orders from Wakil or from operational headquarters in Peshawar to relocate, and we were told that we would have to wait for such orders. God, I thought, those orders might never come, and Wakil might never know we were here. The whole situation began to depress me. That night Dan and I slugged down the last of the little guys in our tent and climbed under the blankets early, passing up a gracious dinner of donkey's head stew. Dan fell asleep immediately.

When the ruckus began after midnight on June 9, I still had not dozed off. My unconscious and conscious worked hand in hand to scribble grotesque graffiti on the inner surfaces of my eyelids. Dan was still sleeping when I got to my feet and sought out the anxious voices coming from the command tent. As I approached, in the dark I could make out only forms. Then I saw that one of the men was the radio operator. He was trying to defend his actions, whatever they were, but was losing the battle. The man with the dominant voice was Commander Palawan himself.

Other soldiers had gathered in the dark, including Hussain and "Two Photo." I asked Hussain what was going on. With charade-like gestures, he pointed to the radio transmitter and then to his ears and mouth, and I gradually connected the dots. The trouble had something to do with a transmission from the field that the operator had received. When Hussain created a triangle with his two thumbs and forefingers, I got the picture. Our radio guy had responded to a call that he thought had come from another mujahedin operator, and by the time he realized the call was bogus, the caller had kept him on the horn long enough to triangulate our position. Or so said Palawan.

The commander was still haranguing the radio operator when Dan joined us at the tent. I explained what I thought had happened. When I finished, Hussain added the final touch, pointing to his watch and then raising two and then three fingers. I assumed he meant hours.

"All right," Dan said, "if I've got this right, Bozo here gave away our position to the regime, and Hussain here thinks they'll bomb us in two or three hours. Right?"

"Ne, ne," Hussain interrupted when he had heard the word *bomb*. He proceeded to demonstrate with his hands an airplane dropping a bomb, which he then waved away. "Ne, ne bombarge," he added, creating a long trajectory in the air with his hand. "Ne bombarge. Scud!"

Back in our own tent, Dan and I discussed our predicament over what we were told was the last of the tea, since the stream had dried up altogether. Whatever we could or would do would have to wait until daylight. Stumbling across the tribal borders in the dark, surprising Hezbi guards, and bumping into assorted camels and land mines would do us in quicker than any Soviet missile. We resolved to leave in the morning in whatever way possible, but for the night we'd stay put and pray that Palawan was wrong about the triangulation. Dan climbed back into his sleeping bag and was snoring in seconds. I wished I could have done the same.

I'm not sure what came first, the colossal crash or the violent wrenching of the earth. I tried to stand up, but the ground was still rolling and I fell back on top of Dan. Face to face with him I looked at his closed eyelids. I shouted at him and pulled myself up, grabbing the camera. I even kicked him, but he still didn't move.

Struggling through the tent flap, I saw a ghoulish, red plume that rose from the earth like vaporized blood not fifty yards away. I turned on the camera and pointed the lens just as another shock wave hit. I tried to keep my balance but finally fell on my side, clutching the lens to my chest to protect it. The second Scud—they were always launched in pairs, I learned—had struck even closer than the first had. I turned to look back at our tent, which had been knocked down by the force of the blast. I ran the camera a bit longer on the red smoke and then rushed back to the tent, scrambling through the folds to find the doorway. I finally located Dan, uninjured and just waking up. Outside I could hear excited voices. When I extricated myself from the tent again, men were running with medical kits toward the fading clouds to search for the dead and the injured.

_____ 19

# *"Two Photo"*

By noon the next day, I had arranged a ride for Dan and me in a large van that was returning to Peshawar for supplies. Palawan had left the command post before I could get new orders from him authorizing us to leave, thus making our departure rather sticky. Given the previous night's missile attack, which had almost hit us, I could not understand why the NIFA crew wasn't moving its command post as well. I reminded them the next Scud might take them all out. And the good stream had dried up, leaving them only the poison stuff. When I asked what they were going to do, the officers said they wouldn't leave that spot until they received orders to do so. They said God would provide. I shook my head but bowed in respect for their decision.

As we put the last of our gear in the truck, "Two Photo" demanded we take more snapshots of him at the command tent before we left. After Dan took the photos, the kid asked for another one with him posing in the tent's doorway, as if he were the commander.

The truck was covered with the traditional netting that held various bushes and branches in place to camouflage it. I sat in front with Hussain, who drove, while Dan rode in the back of the van with Two Photo. Negotiating the various organizations' territories without Palawan's written orders proved to be the nightmare we expected, but by 3:00 p.m. we were on the road and headed for the border. And we still hadn't had anything to drink since the day before to slake our growing, crazy thirst.

We hadn't traveled far out of town when I heard Kalashnikov fire from the back of the truck. Hussain slammed on the brakes, and we rushed to the back.

"It was nothing," said Dan, barely restraining his rage. His face was as tight as a drum. "Just asshole here," he gestured to Two Photo, "wanted to shoot at some birds in a tree."

I did my best to explain to Hussain that we had to keep a low profile and asked him to tell Two Photo. Hussain nodded and spoke to the kid in his typical lethargic way.

Back on the road we continued toward the border and had to pull over one more time to hide in a small village when we heard the sound of a plane. As it passed overhead, a group of boys playing in a fetid stream nearby hardly noticed. Two other boys on the little bridge that crossed the stream were selling big glass bottles of orange soda from a three-legged chair, somewhat reminiscent of the lemonade stands I saw when I was a kid. My thirst was so over the top now, I would have gladly drunk the green slime tea from NIFA camp had it been offered to me, and here was a thirst quencher beyond my wildest fantasies. I rushed over to the kids, threw money at them, and grabbed one of the big bottles. I unscrewed the cap on the spot and raised the big jug above my head as the sun illuminated the little wet drops of condensation on the bottle. Anticipating pleasure straight out of a child-hood summer, I took a huge gulp. The liquid oozed into my mouth and throat and hung there. I gagged, floundered about, and pounded on my chest, trying to get air to my windpipe. This drink was not orange soda, of course, but the thick orange syrup used to make it. The kids stopped their game and stared at me. Two Photo laughed so hard at me that he had to hold his stomach. Dan rushed over and forced me to sit down and to try to relax my throat. Then he shot a sharp look at the laughing teenager, and I could see Dan's eyes narrow to slits. I was beginning to feel the same way.

That the local kids found it all so funny didn't bother me. After all, I must have been quite a sight, a big, gagging, orange-mouthed alien whirling like an out-of-control dervish. After coughing and spitting out the rest of the goop, I offered the bottle back to them. They ran over, grabbed it, and returned to the others, who were playing a game beside the bridge, some kind of target practice. I sat down on the edge of the bridge to compose myself and watched them. They were throwing rocks at something in the water. I looked to see what it was but

couldn't spot it. Then one of the kids to whom I'd given the orange syrup ran up to me, smiling, and gave me a handful of stones. It was his way of thanking me, I guessed, for giving back the syrup so they could sell it again. I suppose my bewildered expression as I took the stones made it clear I didn't understand their game. He smiled again and pointed to a small piece of metal barely visible above the green water. Then he threw up his hands to effect an explosion and yelled, "Boom!" The other kids observed the primitive explanation and made the same gestures, laughing happily and shouting, "Boom!"

Two Photo suddenly came up behind me, grabbed the stones from my open hand, and began throwing them at the land mine. One of the stones hit the shore and bounced up, striking one of the kids in the head. The boy's hands flew up to where the rock had hit him and he began moaning. Two Photo thought the boy's reaction was funny too. I walked over to Two Photo and wrenched the rest of the stones from his grip. As I walked back to the truck, I could still hear him laughing.

Back on the road about twenty minutes later, we passed another small village. I heard a ruckus in the back of the van. It sounded as if the big, empty water barrels had gotten loose and were rolling around on the floor, slamming into the walls. Hussain stopped again, and we rushed to the back. Instead of the empty barrels, it was Dan making all that noise. He had Two Photo by the neck with both of his hands, strangling him and slamming his head against the floor. The kid was flailing in his grip and trying to breathe. He looked terrified. I shouted at Dan to stop and leaped into the van to wrestle him off. After a bit, he released his grip, and Two Photo crawled away to a corner, where he rolled up in a fetal position.

"This time the little fuck was gonna shoot a goat," he growled, "right back there at that house we just passed. Can you believe it? Shoot a goat in the middle of a fuckin' town?"

"C'mon, buddy," I said, "if anybody hears about this we'll be in deep shit."

"Deep shit, huh? I'll rip the shit outta his ass and stuff it down his goddamn throat if he touches that gun again!"

Dan had lost his sense of humor, something I could never have imagined happening. Even when things went sour on a shoot and

people grew weird and nasty, I could always count on Dan Devaney to come up with the great joke or the perfect line to get everybody back on track. In fact, he'd become rather famous for it in our small documentary film world. I looked into his angry eyes and saw that my resident stand-up comic had become a dangerous man, pushed miles beyond his limit. Was he another Afghan war casualty? I hoped not, at least I hoped he wouldn't be for long. His sleeping through the Scud attack should have been my first warning, but there wasn't much I could have done.

Dan had cut his head in the fight with Two Photo, and blood dripped into his eyes. He tried to rub it away, but it began mixing with his tears. I put my arm around him and walked him to the front of the truck. "You ride up front with Hussain now," I offered, "and I'll ride in back with the kid."

Dan stared at me for a moment, seeming not to comprehend. Then the light returned slowly to his eyes as if on a rheostat. "Yeah," he agreed, "that's probably a good idea. The kid's a fuckin' casualty of war!"

# 20

# *Jalalabad Roadshow*

**The scene in Jalalabad had taken its toll on both of us.** We needed rest when we reached Peshawar. Dan slept for about forty-eight hours straight, woke up just long enough to take a sleeping pill with a slug of scotch, and fell back on his pillow. The cut on my foot that I had washed with the allegedly poisoned water needed medical attention. I visited the doctor in the refugee hospital every day. It wasn't healing, but I began to live with it as if it were a wart.

On the third day Dan and I switched from the funky but reliable Deen's Hotel to the Hyatt, where we could have air-conditioning and booze that we didn't have to sip from medicine bottles. Of course we still had to sign a form that stated we were not and never would become Muslims before a man would come to the room, carrying a cloth bundle and glancing nervously over his shoulder as if he were delivering heroin. He would unwrap the bottles, place them on the table, and leave without opening his mouth, afraid, perhaps, that he might become contaminated by the airborne sleaze in the room. We learned to deal with different behavior out in the notorious Northwest Frontier Province. But at least at the Hyatt we could actually get our hands on Murree beer and spirits. Unfortunately, Murree is made in Pakistan by folks who detest consumers of alcohol. It's not premium stuff.

As it turned out, neither was the air-conditioning and ventilation system at the Hyatt. It had to be shut down for several days because fun-gus or airborne bacterial sleaze was supposedly being carried through the vents. A person had to be really beat to rest here. We were beat.

Dan stayed in bed with a fever, and even though I was dealing with a low-grade fever myself, I needed a diversion. I'd already bought carpets until they were piling up on my floors back home. And while I found good deals on jewelry here, I had already purchased enough pieces for birthday and Christmas presents a year in advance. And my eyes were too tired to read a book, even if I was lucky enough to find one in English. Suddenly I had an inspiration. As a musician I'd always been fascinated by the sitar, the Indian stringed wonder with five lead strings and fifteen sympathetic ones. When a player plucked a note on the lead strings, the sympathetic strings would ring out in harmonics all on their own. It was wild! Spending a couple hours in a shop looking through scores of instruments of every kind was a joy. Then I found the one that had my name written on it, made in Lahore on Chand Rattan Road. What a sweet sound it had. Those resounding strings must have buzzed for minutes.

I stopped on the way back to the Hyatt and showed my local musician friend, Iqbal, what I had just bought. He strummed it a few times, smiled broadly, and pronounced it a good instrument. I suggested he get his sitar, and we headed to my hotel room for a lesson. We climbed the stairs (the lift was out as usual) and found Dan still in bed, moaning about his illness. I'd soon fix that, I laughed, and sat down with Iqbal on the beds for my first lesson. I was in heaven.

But apparently Dan sank deeper into hell with every new note of the strange musical scale I played. He ordered a few more Murree beers through room service, but even these, he said later, did nothing to ease his great headache. He was aggravated by the noise of the two sitars, which he claimed sounded "like cats mating in an echo chamber." Even if I was not making legitimate music, Iqbal and I were having fun. When I thought I had a handle on the weird instrument, I suddenly played it for all my worth and hit as many sour notes as good ones. I, of course, heard only the latter. I'm generally more aware of my environment than this episode demonstrates, and I am not by nature a selfish and uncaring person, especially with regard to sick friends, but that day the great giver of gifts had come down the minaret with the best toy a music-loving boy could imagine.

Suddenly, Dan had had enough. He leaped from his bed and began shouting, "Do you have any fucking idea how horrible this sounds? You should be staked out in a minefield and forced to listen to it yourself."

Dan stood there in his underwear, looking goofy, with his hair twisted in a thousand cowlicks from fever sweats. I laughed, thinking he was joking. Then I made a crack about the big banyan tree in front of the hotel. "You could join Iqbal and me with the water drums you bought in the shade of that tree. We'll be just like those Mughal paintings or like Ravi Shankar, Ali Akbar Khan, and George Harrison."

"Ravi Shankar?" Dan raved. "Ravi shitcar!" He stomped out of the room in his underwear and slammed the door.

I was stunned. Was it that bad? I turned to Iqbal for support, but he was gazing at the ceiling, obviously wishing he were somewhere else.

Later, when I'd packed my sitar away and got sane and serious, I spent the time reviewing our project. I pondered what possible visual metaphors might explain the David-and-Goliath drama that had been acted out in Afghanistan. After all, no one had told the whole story of 17 million people (5 million of whom were now refugees) confronting the 200 million-plus of the Soviet Union. After the debacle of Jalalabad, I looked for a visual that would represent better than words what the ill-equipped Afghans had been up against since day one. We needed an image to symbolize the overwhelming odds they faced and, even though the Ox's regime was still in power, to serve as a powerful reminder of what was involved in forcing the Soviets to take flight.

Then it came to me—the Soviet tank! It was the most common weapon with which the Soviets terrorized the people. When a tank rolled into a village, all the locals could do was run. A few brave souls might try to stuff a grenade down the barrel of the turret gun, but if they were caught alive, they would be dispatched in the most unpleasant fashion. Imagine those great metal treads as mobile meat grinders creeping up your body. Yes, a tank was the answer, but we'd need a captured tank, of course. We'd need to find one that was still functional so we could arrange the kinds of menacing, low-angle shots to represent Goliath.

NIFA said it had several tanks and drivers it could put at our disposal. They were across the border, it said, but not far. Sufficiently recovered from the nightmares of the Jalalabad siege, Dan and I decided to take NIFA up on the offer. One more under-the-sacks-and-carpets ride with the mujahedin through the Khyber we could just barely manage. But after the Torqam gate, when our driver kept going for another hour on the road to Jalalabad, we became concerned. Then we smiled and reassured each other that we weren't really heading for the dreaded siege. We laughed and agreed we'd shoot the driver before we'd let that happen. Just as last time, no one with us spoke English. When we attempted to ask where we were headed, the guys smiled and said, "Tank, tank, yes." Then, hours later as we passed under the long, treed archway leading into the ancient city, we knew we were in trouble.

Our driver, whom we chose not to assassinate, seemed to know exactly where he was going. We twisted and turned casually through active combat areas as though heading for the local shopping mall. We wanted tanks in situations we could control, not tanks in the thick of things shooting at people. How could we explain this to him? Suddenly he pointed up ahead to a broad field where we could see several large armored vehicles. Our escorts began chattering excitedly and smiling at us. As we approached the field I could see the vehicles were indeed tanks, but they had been hit with everything but the kitchen sink. One was split practically in two, and the others were in various stages of disintegration with twisted treads, dislodged turrets, and broken 50 mm guns hanging from them as if they were tripe in a Mexican market. Worse, we saw explosive blasts and puffs of smoke at opposite ends of the field.

Not looking or seeming to care who was shooting at whom, our driver drove across the muddy field, right up to the tanks, and stopped. He and the others were now psyched beyond containment. They leaped from the Toyota and ran to the steel skeletons. Each sought out his own photographic frame as they scurried up the sides of the broken machines. Then they posed with their arms stretched casually along gun barrels, chests puffed out, and eyes staring heroically into the distance as in the painting of George Washington crossing the Delaware River. Two Photo was apparently not an anomaly.

Dumbfounded, Dan and I looked at each other. Then a mortar round hit near the periphery of the field. I could imagine regime officers at that very moment studying us with binoculars and redirecting their artillery. The driver snapped me from this unpleasant reverie, tugging at my arm and pointing to his heroic boys who still posed motionless and waited for the big snap.

"We've gotta hurry up an' shoot these idiots," Dan shouted above the next mortar, "or we'll become part of the landscape!"

"But I don't get it," I said, confused.

"You don't have to get it, dimwit, just turn on the camera!"

I raised the Aaton and began isolating images of our holy warriors. In tight they looked even more ridiculous. One had taken the wilted rose from the barrel of his Kalashnikov and placed it in the tank gun's broad barrel. As I zoomed in on him, he turned to smile at me briefly, seeming to know the exact moment at which I had focused on him, and then returned to his George Washington stare.

Then I heard the whistle of a shell that sounded as if it had our name on it. Our driver shouted for his pals, and they all leaped from the tanks in a dead heat for the truck. The engine growled, and we sped out of the place, leaving a mist of mud in the air for a hundred yards. We had left none too soon. One of the boys pointed to a hit just a few feet from one of the tanks. They all thought this close call was great fun and began laughing joyously, swatting Dan and me lovingly on our backs and shoulders. The guy who'd put his rose in the tank barrel now stuck the flower in the microphone holder above the lens of my camera. He smiled from ear to ear and raised his thumb way up.

It was just another day in Jalalabad. I wasn't smiling at the driver when I pointed to the accelerator and slammed my foot on the floor. "Ah," he said with a broad smile. He took the opportunity to use what was undoubtedly the only English phrase he knew: "Pedal to metal, yes?"

Back in Peshawar with several more bad-tasting Murrees under our belts, Dan and I struggled to decompress from yet another visit to Jalalabad. Dan swore he'd had it with both the city and with Soviet tanks and vowed nothing could ever get him back on that damn road again, not even a Heineken. "Well, maybe for a cold Heineken,"

he added nastily, which was, of course, impossible to find in this part of the world.

The next day, after Ittehad-i-Islami's local commander assured me he had access to a functioning tank, I visited the Dutch consulate and appealed for a couple of brews. When I approached Dan later that day with the little green bottles smothered in ice, he knew he'd been had.

"But," he asked as he opened the first bottle with his army knife, "what are we doing with Abdul Rasul Sayyaf's team? Isn't he another one of the dudes who hangs out with Gulbuddin Hekmatyar?" Were we going to follow in Shapiro's footsteps if we went with Ittehad, the way he'd done with Hekmatyar?

"Look," I said, "a tank is just a tank. We're not visiting Massoud or Rabbani or doing anything political that'll piss 'em off. If they've got a tank for us just over the hill, let's go.

Dan eyed me suspiciously and then opened his second bottle.

"On the road again," per Willie Nelson's anthem, we headed back across our favorite pass and hid as usual under sacks of grain and warrior butts. This mode of travel was getting old. Ittehad had assured us the tank was only a few miles from Torqam, but as we began hitting the potholes on the Jalalabad road at 35 miles per hour, I began to have reservations. Dan's eyes were beginning to narrow again. As before, no one spoke any English. We were with guys who just smiled at us warmly and said, "Tanks."

Four hours later with one leg twisted and numb under the other on the floor of the crowded truck, I gazed up at that green, cathedral-like archway. Back in siege mode again, Dan was sound asleep and refusing to wake up to the good news.

And there it was ahead of us, just the way we'd left it—the muddy soccer field and the three slammed tanks! As if reading from the same script, our driver barreled across the mud and slammed to a stop next to the wreckage as our Ittehad guys piled out and raced for their positions. Just as our NIFA boys had, they climbed through the twisted metal to find that perfect spot to immortalize their warrior image. And I was once again seeing in my mind's eye the same regime guys with the binoculars shaking their heads in disbelief and redirecting their artillery.

Dan shoved the camera in my face. "Dammit, just shoot the bastards!"

I half-wished I'd had a gun instead of a camera. Once again, through the lens, I saw the men strike classic poses. They were definitely shots to send home to Mom. Then we heard a blast and saw a puff of white smoke and listened to more whistles. We raced back to the truck and dived inside. The men landed on top of us, laughing crazily as the Toyota dug its way through the mud and out of the earlier smoke puffs. Fooled 'em again, didn't we?

On the trip back from Jalalabad, we were forced to take cover at the sound of an approaching plane. Our driver drove the Toyota right into an old barnlike structure, chasing out two spindly chickens and an old man with one leg who'd been sleeping on the dried hay. The plane flew over without incident, and Dan and I rested on the prickly straw as the men said their afternoon prayers. It had been another intense day on the road to Jalalabad, and Devaney was not happy. Not even a case of cold Heineken would make up for this fiasco.

As we pulled the truck out of the chicken coop and back onto the road, a hint of camouflage paint caught my eye across the field. It was the turret of a tank! I pointed to the apparition and grabbed Dan's arm.

Dan was quite low on the happy meter and only mumbled to himself as we drove into the village where the tank sat. The villagers gathered to meet us. One spoke a little English. He assured us the tank still ran, but the man who could operate it was away in another village. I rushed up to the vehicle and circled it several times as if it were the Kaaba. It appeared to be in good shape, without any apparent damage, and its treads were intact. I climbed up the side and poked my head into the open turret. It was fate!

I shouted for Dan to join me, and he moved as if he were a slug in snow. "This is a working tank," I insisted, "an' you're just the guy to get it moving!"

Dan stared at me for a good fifteen seconds. He thought I'd finally lost those screws that had been rattling around for a while. "Are you nuts? I don't know how to run a Russian tank!"

"A Soviet tank can't be all that different from an American one," I countered. "You were in the Marines, for crissake!"

"Marines don't drive tanks!" he growled.

"But what can be the big problem, I mean, just to get it running? You're an ace mechanic. You've taken broken cameras apart an' fixed them with bombs exploding all around you."

Dan stared at me in another long silence and then glanced over at the tank. I was maybe finding his weakness.

"C'mon, you can fix anything," I added greasily. "You can get this thing going, and you know it."

After shrugging and kvetching, he agreed to give it a try, but he insisted that I help in case something went wrong. Of course, I agreed. We scouted up a couple of flashlights from our packs and climbed down into the turret. It was dark and eerie, even with the lights, and reminded me of the old World War II submarines I'd seen in the movies. Dan began messing with buttons, switches, and wires. Several kids had climbed up on the tank and were watching us from the open hatch.

"You're gonna be a local hero!" I assured him. "You'll be able to pose on this thing just like the guys on the soccer field."

"Do me a favor," he grumbled, "don't take me to Jalalabad with you anymore, OK? And keep the goddamn Heinekens."

"Gosh, 'tanks' a lot," I chuckled.

Suddenly, we heard an electrical whine, similar to that of a generator. Then something whined again, followed by stuttering from what sounded as if it could have been the engine. Shit, I said to myself, he just might do it. Then it whined again and made some kind of cranking sound. I know nothing about engines, but I knew some of the mechanical parts were moving. I could hear cheers from outside the tank and the kids up top going crazy.

"Now to find whatever they use for gears," said Dan, flirting with self-congratulation.

"How do you steer the thing?" I cautioned. "Don't they have a periscope or something?"

"Hey, dude, let's first see if I can actually get it moving. Maybe it'll coast."

"That won't work. We need to shoot it while it's moving, from different angles."

Dan fiddled with some item that must have been connected to a gear, because I could feel the vehicle lurch backward. "Sonofabitch!" I shouted. "You're a genius!"

Outside I could still hear the crowd, louder now, but the cheers had changed to something more cautionary. The kids screamed at us from the top of the turret and then disappeared. Dan kept fiddling with things, and the noise of the metal monster became deafening. I poked my head up from the turret to escape the rattle and to see what was happening. The villagers shouted and pointed in the direction that the tank was crawling backward. It was the edge of a cliff.

I ducked back down, grabbed Dan by the arm, and yanked him away from the gears and switches. I tried to explain, but the racket was too loud. Finally he got the idea. We pulled ourselves up and out of the turret just before the tank approached the lip of the cliff. I jumped off, dragging Dan with me. We hit the ground hard and turned in time to see the great metal monster disappear without a sound. Then, in delay, we heard a series of crashes as the tank made contact with the earth again. By the time I got to the edge, the beast was lying on its side about thirty feet below us, with its engine sputtering and its treads still turning like a windup toy. Then it coughed and stopped.

Dan joined me at the edge of the cliff as the villagers scampered down the side. Wait a minute, I thought to myself, this can't be! It's not possible! Not again?

I retrieved the Polaroid camera to do my duty. When I returned, two dozen villagers had struck poses on the tank. Some smiled as if they were big game hunters with their dead trophy while others stared off into the distance like George Washington on the Delaware.

If anyone was upset about our little caper, we set it right. The men went home with the timeless image of their person standing on the vanquished Soviet tank to hang on their walls (in defiance, of course, of the Shariah law that forbids photography).

# 21

## *Lost in Space*

**I had been back in the States only a few days** when it hit me. I remember sitting at a tiny desk in a grade school classroom attending some session. My thigh just above the knee was swollen and throbbing with pain. My head was hot, and everything around me was taking on a distant, white-light aspect. What was I doing here? And why was the guy at the front of the room putting on and taking off those silly clown masks? When everybody else in the room began laughing, I remembered I was in traffic school to clean up a ticket I'd been issued before I'd left for Afghanistan the last time. I tried to laugh out of courtesy with everyone else, but the sound that came up from my throat was so hollow it scared me. I needed air. I struggled to my feet, gestured toward the door as though heading for the restroom, and hoped I wouldn't disrupt the comedic mood as I stumbled through the aisles of desks.

I remember making a call from a pay phone somewhere outside the building, and then everything blurred. I'm told that one of my kids came and took me to the emergency room, but I only recall fleeting images of doctors and nurses hovering over me, sticking thermometers into my mouth and needles in my arms. I knew I had to be very ill, but the realization didn't bother me. A high fever can really mellow one out.

Days later when my temperature had dropped somewhat, I became aware of words, phrases, and a few complete sentences. I heard talk of "the infection," which was apparently still spreading upward from my knee toward my innards. Then I recall conversations with several different doctors. My wife and kids tried to translate my fuzzy

responses in order to piece together events and to help the doctors come up with a diagnosis. I told them about the poisoned stream near Jalalabad, the cut on my foot that had refused to heal, and the quick detour on the way home to Qumran, Israel, where we'd been shooting in caves for another film. That's when I first began feeling pain higher up the leg.

When Dan and I left Peshawar after the tank episodes, we flew to Israel by way of London. As we expected, there were no direct flights from Pakistan to Israel. Besides, it would not have been smart to arrive at Ben Gurion Airport directly from a Muslim country that didn't recognize Israel as an independent state. In Qumran we wanted to finish shooting another film we'd started the year before about Vendyl Jones, who had been searching for the long-lost Ark of the Covenant in the region since 1975. It wasn't going to be a long shoot, and with summer temperatures spiking to 120 degrees Fahrenheit, we wouldn't last long anyway. Thankfully we did most of the filming inside the Cave of the Dome, which was once inhabited by the mysterious Essene sect, where the direct sun could not reach us. But the cave's bats could, and their presence might have caused my problem.

So the doctors were trying to determine if I'd been afflicted from bacteria in the Afghan stream or if I had been infected in Israel with a rare disease commonly called "cave fever." This illness was said to have killed explorers in the party that unearthed King Tut's tomb in Egypt in the twenties. Allegedly they had incurred the curse warning all to keep out that was written above the tomb's entryway. Several of the men, including the leader of the expedition, Lord Carnarvon himself, had died not long after the expedition from a mysterious fever.

Do curses really exist? When I had interviewed Lord Carnarvon's aged son in his castle outside London years before, he spoke of the night his father had died in Egypt. The son had been startled by his dogs' howling at the very moment his father was said to have succumbed to the curse.

Well, I didn't believe I'd been cursed by anything but bad luck, Soviet poison, or busy bats, but the implications of the illness, if not contained, were disturbing. The hushed talk of amputation brought me out of my mellow mood. The doctors finally reached a diagnosis

of pyogenic osteomyelitis and put me on a blitz regimen of intrave-
nous antibiotics, which I continued on my own for several months
after being released from the hospital.

In a way, the illness had relieved me from my myopic focus on
Afghanistan and my constant stress over a story about which Ameri-
cans didn't give a damn. For a brief time I was free of this obsession,
and it felt good. But as the weeks and then months of rehabilitation
wore on, I began having flashbacks. And when I began watching the
evening news again, the old anger began to resurface. I'd grab the
telephone and call Dan across the country in New Jersey late at night
to share something I'd just seen on the tube. I think he humored me,
knowing I was recovering from more than a nasty infection, but on
occasion he too would rant about some gross misinformation from the
Afghan front.

The big problem during the fall of 1989 was not the media's
distortion of coverage but their total lack of coverage. As everyone
knew, Gorbachev had ostensibly pulled the Soviet military out of the
country, and for most Americans, especially those in George H. W.
Bush's administration, the Cold War fight for Afghanistan was over.
All eyes were now on Baghdad's Saddam Hussein, who had invaded
oil-wealthy Kuwait, a tiny emirate that had once been a part of Iraq
before Britain redrew the borders of the Middle East at the end of the
Second World War. The massive fighting and dying in and around
Kabul, Jalalabad, and other major Afghan cities that Dan and I had
witnessed firsthand were irrelevant to the administration's interests.

> My mind just wouldn't stop, it kept running on. Beneath it
> all was a rage that burned out of control: at the injustice of
> the war itself, at the fact that no one in America seemed to
> want to hear about it, and beyond that a general, free-form,
> omni-directional rage, tangled with gloom. I felt as if a great
> secret had been entrusted to me in Afghanistan, but that I
> had no one to tell it to. I felt estranged, alienated; my old life
> in America didn't make sense anymore, I couldn't connect
> with it. To my surprise, I found myself thinking of going
> back, wanting to go back to the war. I began to feel as if I

belonged there, where there were things worth dying for, worth living for, great men, grand causes.

No, I didn't write this passage. Rob Schultheis did in his acclaimed report on the Afghan-Soviet war *Night Letters: Inside Wartime Afghanistan.* He exactly expressed my own sentiments and those of other journalists who had delved into the story of Afghanistan. Schultheis spoke for us all.

While I went about my slow rehabilitation, Suzanne continued to pitch the project to the television networks. Because we had seen significant success at PBS with earlier projects, she felt that outlet was our best bet, even though they had failed so far to come up with any funding for this project. Still, our friends at PBS in Alexandria, Virginia—Barry, Gail, and Susan—seemed enthusiastic and copied us on internal memos that indicated their support. I guess Suzanne, Dan, and I felt it was just a matter of time before they committed cash along with kind words.

We were aware of the ongoing feud between the Corporation for Public Broadcasting (CPB)—a funding arm of Public Broadcasting Service—and PBS, but we had no idea that their skirmishes had heated to the boiling point and that CPB had targeted our friends for the chopping block. PBS had a liberal bias and CPB a conservative one. In theory it seemed to have been set up as a reasonable system of checks and balances similar to that of the U.S. government itself. Each side should have enough input into the PBS system to ensure reasonable impartiality and guarantee important facts and events were not stricken from the record or twisted so that the truth was lost. Such issues are, of course, at the very core of journalism. But it didn't work that way at PBS and CPB in the summer of 1989. As a friend at CPB told me in private, it was the earlier projects we'd done for PBS on Central America and Cuba that cost us their support. Consequently, she said, CPB had earmarked our Afghanistan project, without reviewing it thoroughly, as too liberal, even though the Afghan struggle against the Soviets had been a priority of both Presidents Reagan and Bush.

And even though the CPB guillotine sent liberal heads rolling in the late eighties and early nineties, Jennifer Lawson, a liberal,

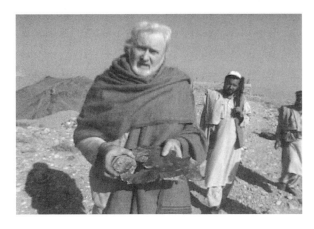

*AUTHOR JIM BURROUGHS IN NOVEMBER 2001 IN THE TORA BORA REGION OF EASTERN AFGHANISTAN, NEAR THE PAKISTAN BORDER. HE HOLDS A FRAGMENT OF AN AMERICAN BOMB.*

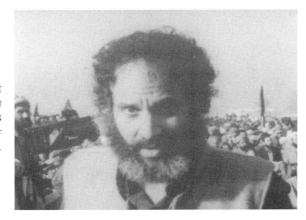

*DOCUMENTARY FILMMAKER LEE SHAPIRO IN AFGHANISTAN IN 1987, THE YEAR THAT HE AND HIS SOUNDMAN JIM LINDELOF DISAPPEARED.*

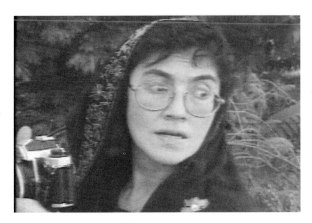

*DR. CARMEN ZUNIGA KARTACHOV, WHOSE FRIENDSHIP WITH SHAPIRO BROUGHT HER BACK TO AFGHANISTAN WITH BURROUGHS IN 1998 AND 2002. COURTESY OF THE AFGHAN DOCUMENTARY MOVIE PROJECT COMPANY.*

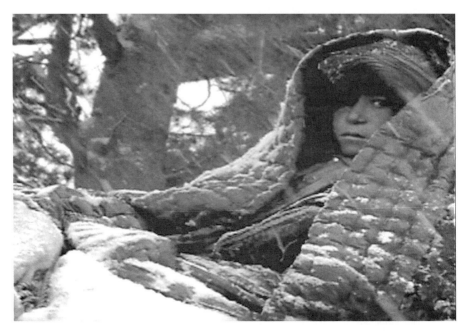

*From chapter 2, the dying boy on the camel crossing snow-covered mountains in Paktika Province on the way to Pakistan for medical treatment.*

*Because Soviet land mines took the limbs of so many friends and neighbors, the Afghans devised a game for their children. The message: Even a crippled Afghan can fight the invaders.*

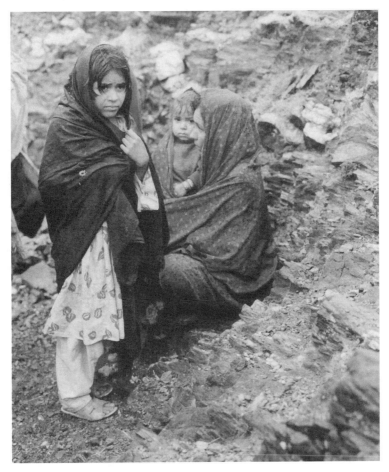

*An Afghan refugee family near Torkham, 1987.*

*Fundamentalist populist and drug lord, Gulbuddin Hekmatyar, whose Hezb-i-Islami forces escorted Shapiro and Lindelof on their final assignment.*

*In 1987, mujahedin commanders gather at night near Sorobi to plan
an attack on the Soviets.*

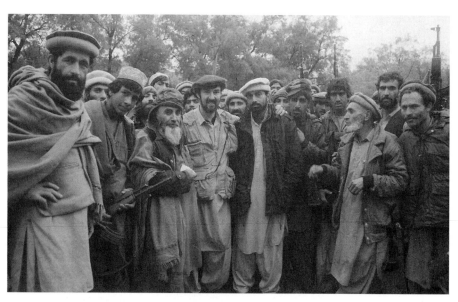

*The author's soundman and partner, Dan Devaney, with members of
Jamiat-i-Islami, Ahmed Shah Massoud's military force. Jalalabad, 1988.
Courtesy of the Afghan Documentary Movie Project Company.*

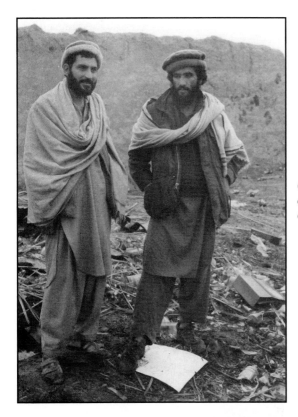

*On the right, Jamiat commander "Che." North of Jalalabad, 1988.*

*The aged Jamiat commander fond of sneaking into the tents of Soviet soldiers and slitting their throats. North of Jalalabad, 1988.*

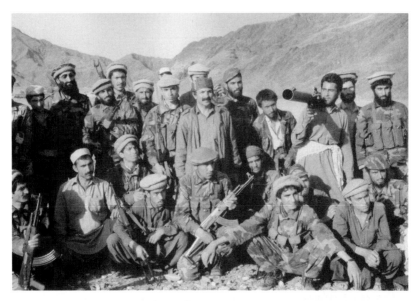

*TROOPS OF MODERATE PIR GAILANI'S NATIONAL ISLAMIC FRONT OF AFGHANISTAN (NIFA) IN 1989. TWO PHOTO IS IN THE FRONT ROW TYPICALLY TRYING TO TAKE UP AS MUCH SPACE AS POSSIBLE IN THE PICTURE.*

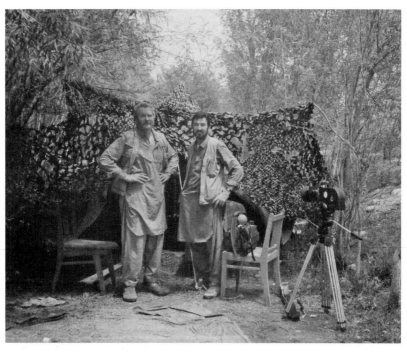

*BURROUGHS (LEFT) AND DEVANEY IN FRONT OF A CAMOUFLAGED TENT DURING THE SIEGE OF JALALABAD IN THE SUMMER OF 1989.*

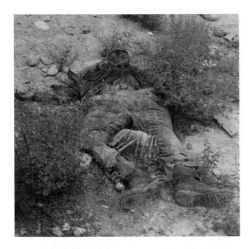

*RENEGADE NIFA COMMANDER NOOR MOHAMMED TOOK TO DECORATING REGIME CORPSES. JALALABAD, 1989.*

*COMMANDER WAKIL AKBARZAI, THE AUTHOR'S LONGTIME FRIEND AND GUIDE, HAVING RETURNED TO HIS FAMILY'S PROPERTY OUTSIDE JALALABAD IN 1992. HE IS UNABLE TO ENTER THEIR COMPOUND BECAUSE IT IS COVERED WITH LAND MINES.*

*A POSTER OF AHMED SHAH MASSOUD, THE CHARISMATIC MUJAHEDIN COMMANDER WHOSE ASSASSINATION BY AL-QAEDA AGENTS ONE DAY BEFORE 9/11 MADE HIM A NATIONAL MARTYR.*

طریق خدمت به مردم افغانستان اینست که شما بروید طرف
یک وحدت‌ملی.در طول تاریخ‌ثابت‌شده‌که‌فقط‌وحدت ملی‌بوده
که از افغانستان در برابر تجاوز دفاع کرده و کشور را به صلح
و ثبات رسانده است.
(از سخنان پیشوای شهید احمد شاه مسعود(ره))

*TRANSLATOR AND GUIDE LAL AGHA POINTS OUT AMERICAN BOMB DAMAGE IN BALOCH VILLAGE IN LATE 2001.*

*COFFINS OF THE FOUR JOURNALISTS MURDERED ON THE ROAD BETWEEN KABUL AND JALALABAD IN NOVEMBER 2001.*

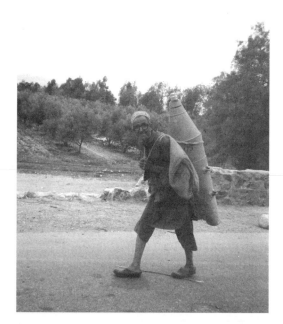

*THE PEOPLE ENDURE. AN OLD MAN CARRIES A BOMB FROM JALALABAD TO PESHAWAR—A TREK OF 140 MILES—TO SELL THE METAL.*

became head of PBS programming in late 1989. In 1992, Ms. Lawson told Suzanne and me on the same conference call that two projects on which we were then working—one embracing world religions and the other great art—did not fit her vision for PBS. Both subjects, she said, were of interest only to the "elite." Under her tenure, programs on social and minority issues would get preferential treatment. And when I asked where such a great series as *The Civil War* (1990) fit in, she labeled it as "racist" and claimed her administration would never have supported it.

Throughout the nineties, casualties on both sides were many, and to the interim victor went all the spoils. But after 9/11, the political struggle erupted again between political forces at PBS and CPB. In 2003, CPB came under the control of Kenneth Tomlinson, who wreaked such havoc to the system that, in the opinion of many, it may never recover as a voice of true, American grassroots journalism.

So yet again the die seemed to be cast for us. Without funding from PBS, I knew we'd have to dig into our own pockets one more time, as I felt compelled to return to Jalalabad and to complete the story of that monstrous siege, which the U.S. media rarely mentioned. I couldn't talk about it with my family for they would know for sure that my fever had caused brain damage. I was even hesitant to tell Dan, but I finally did in another one of those late-night calls that woke him up. He listened to me for about fifteen minutes, without saying a word, but he didn't hang up. A week later I was on a plane and Dan was with me.

Why focus on Afghanistan anyway? It may sound a bit simplistic in our post-9/11 era, but in the eighties, after we'd covered the machinations and deceit in both U.S. and Soviet dealings with the Caribbean region and Central America, the Afghan people's candidness and honesty were too refreshing to ignore. I remember when I witnessed for the first time a dishonest act among the mujahedin: when one of the NIFA men with whom I shared a tent stole my chitrali hat. It seems silly in retrospect, but back then I was stunned by the incident. Until that moment I had never seen an Afghan lie or steal or fail to stand up for his values. I believe my earlier naïveté derived more from a utopian sixties consciousness than it did from any failure in journalistic training.

I awoke from this innocent sleep not during my travels in Cuba, Nicaragua, or Costa Rica, where one might have expected it, but in Afghanistan, where the struggle laid bare things that could not be hidden. Most of those situations south of the U.S. border were more indigenously homegrown in their revolutionary origins than we citizens were ever led to believe. I can still sympathize with some of the peoples' socialist agendas and feel disdain for the many occasions when America adopted Soviet-style tactics in the name of fighting communism. But the rarified air of Afghanistan makes even murky situations clear. The Soviet Empire, I would discover in its political conflicts with Afghan leaders, had little compassion for the Afghan people. It strikes me that they had even less compassion than America had for the Southeast Asians during the Vietnam War. During that contested conflict, at least, the media did its best to keep the American people informed, and people who felt strongly against the war could at least march, protest, and sing peace songs. Later, when the Soviets invaded Afghanistan, the U.S. government expressed outrage over communist aggression against a sovereign state and sent aid and munitions to various Afghan organizations to fight the Soviets.

But in Afghanistan, when the Soviets began retreating, I would discover that America was also capable of reneging on its most basic promises to a trusting people, to help rebuild their nation after it had sacrificed itself in the name of the Cold War. My eyes were finally beginning to open wide. Afghanistan was an unusual place to come of age.

# 22

# *The Arab Afghans*

**On August 23, 1989, Wakil met us at the Peshawar airport.** He told us the "siege" was winding down as the body count rose, and he wasn't terribly happy that we had planned to return to this graveyard. Wakil knew about the trouble we'd had on our last trip to Jalalabad as well as about my medical problems. He knew we had come this time to get a handle on the fallout from the disastrous siege and to learn what the deteriorating situation might mean for the entire region. The night we arrived we sat around the samovar at his compound and drank tea until midnight. Wakil was not happy. At that moment, he felt Afghanistan was at a critical turning point in its struggle for liberation. Various unseen forces were already at work, he said, to take up the slack left by the Soviets and the Americans. Since Moscow's departure, Afghanistan had seen a clear reduction in interest and support from the States, the UNHCR, and the NGOs. Wakil had been appointed head of a new refugee repatriation program, but he could do little without money. Various Afghan supporters in the U.S. government, such as Senator Hank Brown, had said it was only a matter of time before the home troops rallied around Afghanistan again. They felt the declining interest only represented a bit of "compassion fatigue," which would disappear as soon as the mujahedin took Jalalabad and Kabul from Najibullah. But a mujahedin victory might take a while as the regime was still receiving daily, covert supplies from Moscow while the mujahedin ran on empty. Eden Naby writes that Afghanistan was then in the process of becoming a "pariah" to the international community. With the Soviets out of Afghanistan, the U.S. government's focus switched to the Middle East, where oil-rich Iraq was making big waves

in Kuwait. Just as we'd see again thirteen-and-a-half years later, Afghanistan would take second billing to Iraq.

The next morning Wakil sent us off through the Khyber in his own Land Cruiser with two drivers (in case one fell asleep) and two of his best young lieutenants, Abbas and Mirwais. As usual they had camouflaged the Toyota with netting and assorted vegetation. We stopped every ten minutes and turned off the engine to listen for sounds of jets or choppers. During those moments, the men would smoke or fiddle with their prayer beads while Dan recorded more "world tone," that ambient sound of the environment that helps fill sound gaps in the editing process. These moments were pleasant enough, even if sun shone in a cloudless sky, making any vehicle along the road an easy target for regime pilots.

As usual, the four NIFA men with us didn't speak English, but Wakil had explained our mission to them in detail. The Jalalabad offensive had turned so sour at this point that a bad joke circulated among the commanders that there were more wounded men than healthy men at the front. When they returned from the battlefield at night they checked into field hospitals. Morale was deteriorating fast.

Dan and I had experienced much grief along this road and had developed an aversion to it. Yet it did seem so clear, so bright, so stark, and so calm on the plains of Jalalabad that day that Afghanistan almost appeared at peace with the world. Our rose-colored perspective would change with each mile we advanced toward the city, as echoes from the past began to greet us. Still it was a beautiful day, a perfect day for plane spotting or whatever a filmmaker was inclined to do.

We passed a number of trucks and buses that transported the wounded out of Jalalabad, and I thought it would be smart to get a few shots of the exodus. Looking for a good place to set up the camera, we came upon a large personnel carrier that had been hit by an air-to-ground missile. It lay on its side, half buried in an artful way, and the angle looked good through the camera lens. A big wheel of the vehicle framed the road on the right, and the great expanse of the plains and the mountains filled the left. The empty road ahead disappeared into the shimmering heat. All we needed was a subject, a cooperative truck driver with wounded leaving the front. It was not long in coming.

The pickup manifested slowly in the wavering heat as it approached. It was moving at a crawl, and I began worrying about all the film I could hear running through the camera. Unlike video or digital footage, which is cheap, dollars tick off with every foot of exposed 16 mm film. I stopped and started the camera several times, waiting for the pickup to get close enough to isolate the passengers with the telephoto end of the zoom. I could make out about a dozen guys standing on the back bumper and along the side runners. At fifty yards I could make out their faces, and the red-and-white checkered scarves that many of them wore instead of traditional chitrali caps. The men glared at us, and some adjusted their Kalashnikovs with their free hands. I panned down to the cracked windshield, where I could barely make out the forms of the driver and a tall guy riding shotgun.

With my eye following the action through the lens, I heard shouting from the pickup and then our guys shouting back. I panned back up to the men riding the runners, their long-bearded faces now animated with anger. Suddenly the sun flared on the edges of the frame in the eyepiece, and I knew I was about to run out of film. The shouting grew louder along with the whining sound of my camera's motor driving empty sprockets. I saw the truck had stopped in a cloud of dust and heard the word *Americans* in the jumble of other languages.

I withdrew my eye from the viewer and reentered the real world. Abbas and Mirwais had their weapons up and trained on the pickup. What was happening?

"I'm outta film," I shouted to Dan, who was recording the scene with his shotgun mike. "Quick, get me another mag!"

"What the hell's going on?" he asked with a quiver in his voice. As he ran to the Land Cruiser for a fresh film magazine, I released the one on the camera and set it down. The voice of Abbas, our chief escort, suddenly became loud and threatening toward the men in the truck. I looked up as he trained his Kalashnikov on the pickup's passengers, who lowered their weapons. Abbas gestured brusquely with his weapon, and the driver behind the broken windshield shouted back at him before throwing his shift into reverse. The truck began backing up.

"What the fuck's happening?" Dan asked as he handed me the new magazine.

"I think he's telling 'em to do it again. You know, to back up for take two, the way they saw us shooting that one-legged kid on the bicycle back there."

"Shit, man, we don't wanna piss these guys off. They look mad as hell."

"Go tell Abbas. Make him understand we don't need 'em to do anything more. Tell him we got it."

Dan rushed over to Abbas and tried to explain. The soldier nodded as though he understood, but he clearly didn't. He finally turned to me to see if I was ready to shoot the next take. "OK, OK?" he shouted.

"Yeah," I said, "dammit, let's go!"

He gestured for the truck to come forward again. I put my eye back to the camera and flipped the switch. The truck came into the frame, but I didn't hear the camera motor. I flipped the on-off switch again. Damn, it had no power! I put down the camera and traced the cable to find it had come unhooked from the battery on the ground. Abbas shouted something that I did not understand. With shaky hands I reconnected the battery and looked up. Abbas was making the truck with the angry men stop yet again. The pickup slammed to a halt. God, no! I thought to myself. He's gonna keep this up until these guys go ballistic!

The men in the truckbed, wearing assorted bandages, were now on their feet along with the men on the runners. They were all shouting and waving their fists in rage. The man riding shotgun opened his door and placed one foot on the ground as if he was going to get out of the truck. He was a tall, wiry man with a beard wearing a red-checkered scarf on his head and a Banana Republic vest. He pointed a finger at Abbas and then at the road ahead, speaking loudly but calmly in what I would learn was an Arabic accent. I noticed that when he spoke, the others in the truck stopped shouting. The tall guy returned to the truck, and I glanced over at Dan, who had his sound up and running again.

"OK," I shouted and gestured to Abbas, "let's get the damn shot this time so these guys can go home."

Abbas seemed to understand and signaled the truck to advance again. I put my eye back to the viewer and shot as the vehicle passed us. The men in the truck were silent, but I could feel their anger. Mirwais

shouted something to our two drivers, who for some reason ran along-side the truck as it picked up speed. The men in the pickup sat back down, seeming to relax. Dan and I slumped as the truck disappeared down the road into the dust.

It was a disconcerting experience. The truck with the Arabs—or Arab Afghans, as they referred to themselves—seemed to have come out of nowhere and left for parts unknown. I didn't fathom their rage because it didn't make any sense to me. And I had never heard of "Ben" Laden, the guy whom Wakil said ran the Arab Afghan show. There was no immediate experience I could draw on to explain this incident between soldiers supposedly on the same side, but I had heard a few stories about the way the Afghans felt about the Arabs. One story in particular shed some light.

During dinner at Wakil's Peshawar compound with several other NIFA officers a few months before, one told us of an incident that had occurred in 1988. A friend of his, also a commander, had cap-tured several Soviet soldiers and held them prisoner in a compound not far from Kandahar. Three Saudi Arabs approached him and asked to buy the prisoners at whatever price he wanted. The commander disliked the Arabs, as did everyone in the region because of their alien religious rituals, but their offer of easy money was seductive. He agreed to sell them one of the prisoners and to think about the other two. The next day one of his own men told him the Arabs had executed the Soviet soldier in the village square. After tying the man's arms and legs behind him, they hung him from a pole as if he were an animal about to be slaughtered. They had slit him with a knife, from neck to groin, and released his intestines on the ground before his own eyes. When the same Arabs reappeared the next day to buy the other two prisoners, the commander had the Arabs shot. The Saudi Wahhabis were not liked in Afghanistan, the officer reaffirmed, but their money could not be ignored.

The Arabs who had arrived in Afghanistan in the mid-eighties came mostly from Saudi Arabia. They belonged to the Wahhabi sect, named for its founder, Mullah Muhammad Abdul Wahhab, who in the seventeenth century established a fundamentalist order in response to a new wave of Sufi mysticism spreading through the desert. Of late,

these strict Wahhabis had caused trouble in Saudi Arabia by accusing the royal family of complicity with the various oil-hungry satans of the West. Perhaps even then, in 1989, they were looking for a more accommodating environment than their homeland offered. They had joined the mujahedin in the struggle against the Soviet infidels and cloaked themselves in the glories of the first successful Islamic military jihad since the Mahdi had driven the British out of the Sudan in the late 1800s. Along the way the Arabs must have noticed Afghanistan's potential as an alternative homeland.

They came, as Wakil said, outfitted with designer camouflage clothing and the most advanced weaponry. And they brought money, a great deal of it. They earmarked much of it personally for the war effort, while Pakistan's ISI, as we now know, was brokering the traditional Saudi aid and U.S. undercover support. Those funds, of course, went to those organizations most aligned with Wahhabi fundamentalist beliefs, such as Gulbuddin Hekmatyar's Hezb-i-Islami, Abdul Rasul Sayyaf's Ittehad-i-Islami, and the Deobandi madrasahs in Pashtun land. In retrospect we can see how little it mattered to the Saudis, the Wahhabis, the Pakistanis, and the Americans that the majority of Afghans were not religious extremists but of historically moderate Sunni and Sufi heritage.

The mujahedin found the Arabs' arrogance offensive and felt that these foreigners were only looking for a free ride to Islamic glory. But the Saudis with bin Laden spent great sums of money on roads, wells, and hospitals as well as on guns and ammunition. These things the Afghans could not ignore. As alien as they felt the Wahhabis were, they gradually came to accept the wealthy Muslim foreigners, if not as their own kind then at least as more preferable to the smooth-talking Americans who promised big and delivered little. The Americans didn't know it then, and neither did the vast majority of Afghans, but the Arabs had come to stay.

# 23

## *Noor Mohammed*

**On the morning of September 11, 1989, Wakil sent** Dan and me back to Nangarhar in the company of the same two lieutenants, Abbas and Mirwais. We wanted to get establishing shots of the entire war theater from the heights above Jalalabad, and Wakil knew of a particular NIFA commander whom he thought could take us where we needed to go. The man, Noor Mohammed, had been one of NIFA's finest commanders, but on the first leg of our drive, accompanied by an English-speaking commander, we learned that Noor Mohammed had become something of a problem. He no longer played by the rules, the soldier said, and was often in trouble with his superiors. Nevertheless, he agreed, Noor was the man to get us the shots we needed, if he cared enough to help.

The commander bade us good-bye at a NIFA station just outside Jalalabad, and we were sorry to see him go. An English-speaking Afghan comrade with whom we could share our shooting plans would have been welcome, but by then I knew a linguistic-friendly comrade was quite rare among the mujahedin. His near flawless English was certainly one of the reasons Wakil was in such demand with journalists and other Westerners on the scene in Afghanistan. Once again as we approached the city we could hear the sounds of artillery in the distance while the bright sunlight we'd enjoyed along the open road succumbed to an eerie orange haze from all the bombings and raging fires. I began to feel that this trip was as ill advised as our attempt to reach Jalrez had been. Something felt wrong about it that I couldn't explain. I shared my fears with Dan, who said he felt the same way. On all our other journeys inside, neither of us had ever experienced such a strong impulse to turn around.

We reached the city's outskirts and took one side road after another. Then Abbas and Mirwais began arguing with the driver. We didn't know why, but I felt it had something to do with Noor Mohammed. When we stopped along the way to ask different soldiers for directions, I noticed they often grew wary when asked about the commander. After an hour of bouncing through the back alleys, the argument in the front seat began to turn ugly. The driver slammed on the brakes, turned off the engine, and got out. The other two jumped out after him and a shoving match ensued. Suddenly a mortar hit the remains of a house a few hundred yards away, sending a goat and several chickens running past the three men. Mirwais turned abruptly, took off after the chickens, and caught one. An old man appeared from the ruins and shouted at him. Mirwais yelled back, probably something about the spoils of war. He wasn't going to release the chicken for anybody. Then another mortar hit down the road where the other chickens and the goat had fled, and the old man ran after them into the smoke and dust. The five of us dived back into the car. We took off in the opposite direction with the chicken squawking and fluttering about in the front seat. The scene bordered on the surreal.

After another hour of asking directions, we finally found a mujahid who knew where Noor Mohammed was based, and we took off in the direction of the nearby hill he'd pointed to, which stood out from the flat surroundings. Winding our way to the top we encountered another mortar. This time our driver went right through the smoke and dust only to slam into a mud wall. No big deal, he threw the vehicle into reverse and winged another wall before escaping the area. Near the crest of the hill, we passed several disemboweled personnel carriers and the smell of death enveloped us. The smell worsened as we approached the crest of a hill and made a sharp turn onto another road shrouded with trees. We were in what had once been a wealthy part of the city.

The stench became unbearable as we turned into a devastated compound. Though there was no evidence of shelling, pieces of broken furniture, toys, trash, twisted bicycle parts, and discarded clothing lay scattered across what had once been a great lawn.

A dirty, disheveled guard, his Kalashnikov trained on us, leaped in front of our car and shouted in Pashto. Our driver stuck his head out the window and spoke back. The guard turned and pointed with his weapon to the second floor of the large house. We parked next to another personnel carrier riddled with more (bullet) holes than a genuine Swiss cheese. Nearby sat a Soviet tank with its machinery spilling out on the ground along with the guts of the men who had once operated it. The weeks-old corpses, wearing remnants of regime uniforms, had been strung out over the wreck like jack-o'-lanterns on Halloween.

We stepped from the Land Cruiser and headed for the stairway to the second floor. Lying across the first step, another corpse blocked our way. This one was missing half its head, and every kind of bug imaginable was eating away at the open cavity. As we gazed at the ghoulish thing, the guard shouted again and pointed to a second stairway behind the first. We stepped around the corpse and proceeded up the other steps. At this point the smell from the decaying bodies was so bad I had to breathe through my mouth. Even our escorts seemed appalled by the smell and the surroundings. As we climbed the steps, we encountered several broken chairs and mirrors and a dead cat.

We walked to the commander's door and were about to knock when we heard a large dog growling on the other side. To knock or not to knock was the question. The decision was made for us when a thirteen- or fourteen-year-old boy opened the door, gripping the leash of the big, growling canine with both hands. He was a handsome kid with an effeminate manner. He spoke in a gentle voice that we could barely hear over the dog's growls. After Abbas explained our reason for being there, the boy gestured over his shoulder to a near naked form sprawled across a bed in the shadows. Noor Mohammed was asleep. The boy said something else, and Mirwais turned to me and pointed to his watch. We were to come back in an hour. I thanked the boy in English. He smiled in a seductive way, still grasping the taut leash of the growling monster. We descended the stairs. When Dan tripped over the debris and stumbled down the last ten steps, the guard with the AK47 laughed.

Another soldier approached us from inside the house and called to us. He spoke a little English and asked who we were. I explained as best I could, and Abbas filled in the gaps in Pashto. The soldier

explained that Noor Mohammed was very tired because he had spent the whole morning trapped in an alley by a tank that he'd finally outwitted. "Commander hates tanks," said the man, "and tanks hate him."

With an hour to kill, we walked around to the back of the compound, trying to escape the smell of the dead bodies that no one had chosen to bury. Obviously this decision had been Noor Mohammed's, to heap in death even more shame upon the regime soldiers' heads. Dan pointed out another tank about a half block away. We walked to it, stepping carefully around more burned corpses. As Muslim law dictates immediate burial, I assumed all the dead here were either regime or Soviet soldiers. The smell overwhelmed me and even breathing through my mouth was not helping. Once again the corpses were rigged around the dead tank in Halloween style. A severed head stuck on the turret's twisted barrel glared at us through eyeless sockets.

"Where are we?" wheezed Dan, "on the set of *Apocalypse Now*? Where's Dennis Hopper?"

"Probably one of the heads," I said as I jockeyed around the funereal mess with my camera, searching for a shot that would do it justice. I stopped at one point where flowers were blooming amid the twisted metal. I put down my camera and reached out with a stick to move a hand on one of the corpses a bit closer to the flowers. Yes, I was thinking about that last shot in *All Quiet on the Western Front* in which the young soldier who has managed to survive the trenches is killed in the end by a sniper as he leans from his foxhole to reach for that flower. I was about to arrange this shot in that same manner without even realizing what I was doing (for obvious reasons, journalists do not stage such moments)—but I did not succeed with this unconscious staging as Mirwais knocked the stick from my hand with the barrel of his Kalashnikov. He shouted at me and pointed to the almost invisible black string that led from the hand into the earth. When I realized what I had almost done, I froze. I feared that even my breathing might set the thing off. The whole damned mess had been booby-trapped to zap some unsuspecting enemy grunt who might have wanted to give his comrades a proper burial. I glanced around at the entire grizzly scene in the compound where Noor Mohammed had chosen to live while he fought the evil atheists on behalf of Allah and Afghanistan.

We heard a high-pitched shout from the house and turned to see the effete boy beckoning us. Apparently, the commander was awake and wanted to see the Americans. We walked back quickly to the compound and climbed the steps again to the commander's room. When we reached the second floor, we saw this Afghan "Kurtz" (Marlon Brando's character in *Apocalypse*) leaning against the doorjamb with his arms folded across his chest and his lips twisted in a snarl. His clothes were filthy, which was understandable as he spent his days dodging tanks in narrow alleys. His long, black hair hung down greasily from under his chitrali hat; his beard was clotted with layers of dirt and sweat; and his face, hands, and broken fingernails were encrusted with dirt.

Our escorts were clearly as intimidated as we were by this apparition, and they attempted to placate him, explaining again (I suppose) why Dan and I had come seeking his help. He responded to Abbas and Mirwais with brusque words and crude gestures and then turned to Dan and me. We smiled weakly. He began laughing. Abbas said something else in a solicitous manner and the commander laughed louder. Then he spat on the floor, turned, and slammed the door in our faces. On the other side of it, his raucous laughter was joined by that of the pretty young man and the barking of the dog. Abbas, Mirwais, Dan, and I stood staring at the door a moment longer, not knowing what to do. When we heard the two guards down below laughing, we looked to see one of them pointing his Kalashnikov at us. He made a loud popping sound with his mouth and laughed louder.

Trying not to look scared, we hurried back down the front stairs and leaped over the stinking corpse. A little way from the house, Abbas—the warrior who only weeks before had faced down the Arab Afghans without a flinch—began running for the truck. We were right behind him.

# 24

# *The Saddam Connection*

**I thought of Noor Mohammed as the chopper lifted up** and over the thousand shabby tents that carpeted the canyon floor. The refugee camp below reminded me of the camps along the Pakistani-Afghan border—it had the same feel—but I was a good two years and 1,000 miles away from there. At the tiny Turkish border station that guarded the path from Iraq, one of the Turkish soldiers watched us through binoculars as if the U.S. insignias plastered all over the fuselage might be phony. How typically paranoid the Turks were.

I sat back in my seat with my film camera as we flew among the mountains of Kurdistan. This trip was to be my last into Iraq before I returned to the States, and I was off to film what I'd been told was an innovation in UNHCR refugee relief. I had been covering the First Gulf War along the Turkish-Iraqi border, gathering footage of the Kurdish exodus. Now the great sprawl of refugees from the air did indeed remind me of those huge Afghan refugee camps. On the surface it all appeared the same, with people running for their lives, living under torn canvas, eating first-world leftovers, wearing someone else's old clothes, and being glad about it. Refugees had it much the same the world over, whether they were Jewish, Muslim, or Christian, and even were they Kurds.

The story wasn't pretty in northern Iraq in August 1991, but at least it didn't feature burned-out Afghan commanders or Arab Afghans who wanted to kill me. Those last Afghan experiences had left me deeply shaken. While in my heart I was still caught up with that struggle, I was glad to be anywhere but Afghanistan, even if it meant covering the meat market of Baghdad's "butcher." At this point

in the conflict, Saddam Hussein was said to have agreed to U.S. demands to withdraw from Kuwait as well as to UN demands for protection of the Kurds. The shooting war had officially ended in February, but there was still plenty of shooting.

The chopper pilot was in his late thirties, seemed a bit edgy, and resembled Ted Turner a little. I listened through the headset static as he talked to his navigator.

"So you think we should just hop over this range here into the next valley and follow it down to Zakho?"

"Affirmative," replied the younger man with an Hispanic accent. "I made the loop with Command yesterday. It's been cleared."

"But didn't you cut through the mountains south of Çukurca, near Saddam's airstrip?"

"It's the same valley, sir," replied the junior officer. "It skirts the range all the way to Zakho."

"But you guys had five birds!"

"Affirmative again," countered the navigator, "but the problem is that we haven't got enough fuel to get back to base if we don't cut through here, right sir? We'll have to overnight at Yüksecova."

The pilot screwed up his face at that idea. "'Yuk' is right," he replied, "so it's over the mountains and through the peaks to Saddam's house we go."

I had no desire to go back to Yüksecova either, since I'd just been stuck there for two days while waiting to hitch a ride on this chopper. Yüksecova was just a fuel depot with bad food and no booze.

I looked out the window as the pilot maneuvered the Black Hawk through the mountains and searched out the lowest passes. Ten or eleven thousand feet, I'd been told, was the maximum height for these birds. Some of the permanently iced peaks here rose to 13,000 or 14,000 feet, and only the Chinook helicopters were able to fly above them. A week or so before, I'd made several trips on a Chinook that dropped food supplies to those Kurds who had climbed the highest peaks to escape Saddam. They had to be running from some serious shit to do a thing like that. Once the pilot located a group of Kurds, he'd hang the chopper about thirty feet above them as we dropped out boxes and plastic barrels of food and water for the crowds who swarmed below the spinning prop. If we'd tried such a tactic in Afghanistan, the

people would have run, expecting booby traps, toy bombs, and other lethal devices. Saddam had relied more on gassing people, so food drops were considered safe.

On the return journeys, I would sit on the back deck of the Chinook, with the bay doors wide open with my feet dangling on the edge of infinity, and stare out at the silent, awesome, snow-covered landscape. At such times I would reflect on the sad state of mankind, which continually found itself at the mercy of power mongers. I wondered how Wakil and other friends were doing in Afghanistan and if they were even still alive. And I wondered about "Ben" and his Arab mercenaries and what they were doing now. Some reports had it they were digging in along the Pashtun southern border with Pakistan while others said bin Laden had returned to Saudi Arabia to help run his late father's business. At a bar in Ankara I'd also heard some scuttlebutt from an NGO staffer, who'd just returned from Kabul, that tensions were rising between the forces of Rabbani's right arm, Massoud, who was now in power in Kabul and his archrival, Hekmatyar.

I'd learned one of the U.S. officers at Zakho had just returned from a fact-finding tour of Afghanistan, Pakistan, and Saudi Arabia. This was fortuitous as I hoped for the chance to learn from firsthand observers what was really going on in the region since I'd left.

Sharp turbulence jolted me back to the present as the Black Hawk burst from the mountains into a broad Iraqi valley. Suddenly the snow was gone, and we could see the color green below. Then the pilot's voice crackled through the earphones. "What's that down there?" he asked the navigator with some urgency. "Is that an Iraqi base?"

"We're in Iraq, sir."

"Let me have another look at that map," growled "Ted Turner." The pilot studied the map and turned to look out the window. It was an Iraqi military base, all right, and it was a big one. There were plenty of tin-roofed buildings, personnel carriers, and jeeps but no aircraft. Ted tossed the charts back to the copilot. "It's not that I don't have complete faith in your navigational skills, Romero, but this shortcut of yours is making me nervous."

Even the starboard gunner, who'd been dozing with a bad hangover, woke up on that note. Alert and watching all along, the port

gunner opened his window and panned the M60 machine gun across the base below.

"The route's been cleared," repeated the navigator. "There's no problem."

"Yeah, no problem for five Hawks flying fifty miles farther south, but we're just one lonely sparrow out here in nowhere." Something caught the pilot's eye. "What's that at 7 o'clock?"

There was a short pause while the copilot studied whatever it was. When he finally responded, the chopper hit an air pocket, and static in the headphones blurred his words. The port gunner released the safety on his big M60 and gripped it tightly. I craned my neck around to see what was out there and finally caught a glimpse of two metallic reflections.

"They're splitting up to surround us, sir!"

"Fuck 'em, we're ducking down that canyon," said the pilot. "I'm not gonna become a goddamn statistic."

I raised my camera to get a shot of the two Iraqi jets, but our chopper dipped into the canyon before I could push the button. I looked out my window at the sheer rock face of the wall as we dived deeply and quickly. The sunlight began disappearing and the pass began closing in all around, with its rock walls only about thirty feet away from the prop on each side. I closed my eyes and hoped—no, prayed—as Ted maneuvered without speaking. The tension in the crackling headphones was so thick I could cut it. The icy peaks were far above us, and the dark pass was closing in below. The minutes ticked off—three, four, five.

What if we were forced down out here? I asked myself. What if our lone U.S. helicopter a hundred miles inside Iraq was too much for some disgraced Iraqi pilot to resist? Yeah, I agreed with the pilot, it was better to risk the pass than deal with the jets.

Suddenly we were climbing again and climbing rapidly. Then I felt another jolt as the Hawk lifted above the mountains. We reentered the broad valley. Judging from the more relaxed mood of the pilots, I figured they'd ditched the Iraqi planes.

"That's it, sir, right on target."

"Target?" replied Ted, confused. "What target?"

"Saddam's vacation home! At 11 o'clock, on that ridge, it's the thing that looks like a castle."

My eyes panned along the ridge until I saw it—a huge, dark, medieval fortress silhouetted against the sky and perched right on top of the mountain. No, really, it was part of the mountain, cold and lethal looking. I had no trouble imagining dungeons and torture chambers inside. The big problem with stereotypes is that sometimes they're accurate.

"Would you look at that thing," crackled Ted through the 'phones. "I'll bet the sonofabitch throws some weird parties there, whips an' chains an' shit."

Romero pointed to the bomb-pocked runway ahead of us. "Saddam's private airstrip, the one we hit on Thursday."

I looked at the craters in the runway. The butcher wasn't going to be flying in any weekend guests for a while. I grabbed one last look at the mountain compound. It resembled one of those megabuck mansions you'd find in the Hollywood Hills, except it took up an entire small mountain, mostly from the inside. Mr. Hussein, I thought, was much inclined toward life on a grand scale—big homes, big lies, big slaughters.

Thirty minutes later, we began our descent into Zakho, and I caught my first glimpse of the grand new refugee experiment—6,000 spanking new, but still empty, tents the U.S. Marines had set up for Iraqi refugees in this abandoned village twenty miles across the border inside Iraq. It was a strange idea, I thought, putting a Kurdish refugee camp in Iraq itself. What if all those Afghan refugee camps in Pakistan had been set up inside Afghanistan instead of in Pakistan? Would those 2.5 million people have been safe there from the Soviets? Armchair analysts hanging around the hotel bars back in Turkey thought that Zakho was the cat's meow, a breakthrough concept in refugee aid. Others, mostly military men, thought it was a disaster waiting to happen. The United States had apparently exacted some kind of promise from Hussein not to interfere with Zakho. So far that promise hadn't carried much weight with the Kurds. It appeared they'd rather deal with Turkey's conflicted policies than come back here.

I spent the night in the empty tent city of Zakho. The few Marines still in the camp built a fire, and the U.S. commander in charge offered good Western whiskey—to the only inhabitants of Zakho: four high-ranking military men, four NGO staffers (two men and two women), three Marines, and another journalist beside myself.

"Build it and they will come," quipped the commander, "we hope."

"Insh'Allah," added one of the Marines who had learned a few words of Arabic.

The conversation went late into the night under a star-filled sky with a near full moon. The military men, the NGO representatives, and the other journalist were all predictable in their points of view, to a point, that is. We heard plenty of good-natured ribbing from the military guys about the blind, bleeding-heart idealism of the NGO folks, who in turn had fun drubbing the military's tendency to reduce life to the lowest common, violent, greed-ridden denominator. And all expressed general agreement about the Machiavellian, self-serving streak evident in media folk. I smiled as my colleague defended our profession. But from beneath the studied exteriors came real insights, for these were not ordinary men and women in their professions but those nearing the top. In essence the NGO types agreed with the military men that Zakho was most likely doomed to fail since people running for their lives are not psychologically geared to trust their oppressors. And from beneath their progressive exteriors, the NGO staffers revealed they'd seen enough grand schemes die at the hands of knee-jerk idealism. As for us journalists, they felt we were a bright, hearty lot, though of late they thought we displayed a penchant for sensation over fact unless we saw some personal, material advantage in the facts.

I stared at the fire and took another sip of Jack Daniels. I wondered what Afghanistan had been all about for me. Was my motivation really just the chance to get a big scoop? If so, the possibility was still there and even bigger, perhaps, because of all the time that had passed while the story had been ignored. The glory of it would be delicious, but the relief of putting it behind me would be even more so. Listening to the group I realized that for whatever reasons I was still hooked on the story and on the people of Afghanistan. And if the

world ever chose to listen to the Afghans' story, I'd have the gratification of having picked the right horse in the race. The Afghan story was probably as relevant as it ever was and still had not been told. But what was I going to do about it? I was in Iraq, not Afghanistan, and I was damn glad of it.

The conversation finally turned from Afghanistan to Saudi Arabia. I took the opportunity to ask the general, who had just come from Riyadh, what was happening with bin Laden and his jihad-stealing colleagues.

The general smiled. "Bin Laden had his comeuppance," he said, "and is now on King Fahd's and Crown Prince Abdullah's shit list. Or maybe it's the other way around," he chuckled. "In any case," he said, "when Hussein invaded Kuwait, bin Laden suggested to the royal family that he be commissioned to gather the 5,000 Arab-Afghan veterans who were then living in Saudi Arabia, along with the same number still in Afghanistan, and another 4,000 from other North African countries to create a Muslim brigade to invade Baghdad. Bin Laden felt Saddam Hussein should pay for his ties with the Soviet Union and his crimes against Islam. And given his own personal experience in Afghanistan fighting the godless Soviets, bin Laden added, he was the one to dispense justice."

We knew that on the other side of the great desert to the east of Saudi Arabia, in another nation built on oil, just as Saudi Arabia was, Hussein shared a similar opinion of that spoiled, messianic Wahhabi prince who had condemned him for his pragmatic use of Islam. Meanwhile, Saudi royalty, bin Laden's bosses, feigned piety and continued to revel in Western materialism every bit as much as Hussein did.

"If these two guys ever met on the street face to face it would be a gunfight in Dodge City," the senior officer added. "Hell knows no fury like the way these two guys hate each other!"

As we all knew, the king had rejected bin Laden's offer and had instead invited U.S. troops onto sacred Saudi soil to dispense the needed justice. Until then, bin Laden had looked on this Iraq-Kuwait issue as a family feud between Muslim Arabs. If Saddam Hussein were to pay for his crimes, bin Laden had maintained, justice had to be dealt from the hand of Shariah and not by U.S. missiles. In the long run, he felt,

the Saudi king's decision was bound to backfire. Favoring bin Laden, the Wahhabis went on the stump again, demanding a return to strict Islamic purity and a renunciation of the royal family's Western ways. The Saudi people were beginning to listen.

If we fast forward to over a dozen years later, we find that, in spite of all the evidence revealing the contempt Hussein and bin Laden had for each other, the U.S. government would insist on fictionalizing their friendship.

# 25

## *Going Home*

**In August 1992, Dan and I took up an offer** from the World Bank to document one of its community health projects in Karachi. Perhaps I'd been away from the region for too long and needed to touch base again. But no one was offering to pay our way to visit the great "pariah" to the north, and I was not about to ask. I only worked for cash these days, so visiting Afghanistan was probably out of the question. Nevertheless, I contacted Wakil before we left the States.

The World Bank wanted us to document a grassroots sanitation project in Karachi. It was considered grassroots because the villagers were digging their own sewer systems instead of waiting for the government to do it for them. The shoot was a worthy project, and Dan and I enjoyed working with people who were committed to getting what they needed and not accepting any bureaucratic excuses. But when we accepted the job, we never thought we'd be shooting at the height of the hottest summer in recent Karachi history. My then-twenty-year-old son, Shane, joined us on this shoot. I believe he thought it would be a cakewalk and an excuse for him to acquire a sitar of his own, for Shane was and is a musician first. To téll the truth, we all thought it would be an easy shoot, but 128 degrees Fahrenheit and open sewage do not mix.

It was the hottest day of our trip in the suburbs of Karachi when we filmed a meeting of local women's organizations that were rallying to join the sewer project. The meeting was almost called off, because the heat was making everyone crazy. It's hard just to think and function in such temperatures let alone deal with a controversial political issue, which the independent sewer system was proving to be.

The government suddenly decided midstream it, and not the local folk, should dig the sewers. It's funny how a little activism can shake up bureaucrats. The meeting took place in a small, half-open court-yard, where the heat was awful. To balance the intense, smoggy sun-light with the shadows, I sent Shane aloft to place two-by-fours across the space and hang blankets and carpets from them to block out the direct sun. I set up the camera for the opening shot and then looked through the eyepiece. Drops of water hit the lens. How could it be raining? I looked up from the camera at the hot blue sky and saw my son sweating like a pig.

Out of the blue one evening, Wakil called from Peshawar with some breaking news: the first Afghan refugees in Pakistan had been officially allowed to return to their homeland. (Consistent with Paki-stani border policies already noted in chapters 7 and 13, Pakistan had not yet permitted any refugees to go home "legally.") For the first time in thirteen years, the Pakistani government declared it would open the gate at Torqam for all who wanted to leave. Although we had not planned to visit Afghanistan, the thought of the cooler, highland tem-peratures north of the border turned our heads. And, of course, we were anxious to see Wakil.

The next morning we flew to Islamabad, where we were picked up by Wakil's men and driven straight through the Khyber Pass. This time Dan and I were able to sit up and look out the window. We didn't have to put up with sacks of flour, carpets, or goats on our heads. It was unbelievable! We arrived at Torqam with less than an hour to set up our cameras to record the historic event. The refugees, tens of thou-sands of them, were lined up at the gate. Hundreds of trucks and buses were filled with men, women, children, goats, sewing machines, bi-cycles, small potted trees, and old Afghan flags. The long line backed up for miles into the Khyber. It seemed as if the Pakistani guards, who were smiling for the first time ever, were actually waiting for me and Dan to find our camera angles before giving the signal. And when they opened the gate, the cheers went up, the loudest I've ever heard. The moment was a mind-sticker.

The trek home began for tens of thousands of the 2.5 million refugees who had been living for years in the camps in Pakistan. Their

decision to return was a bold one for, in fact, they were making a great leap of faith. Would the people on the land where they (if not their children) had been born and raised welcome them back? Were there enough resources available to keep them alive? Would their kids become victims of the estimated 10 million land mines, toy bombs, and booby traps left about? And would the hostility between the leaders of the victorious mujahedin groups in Kabul kill the dream before it had a chance to blossom?

Once we'd filmed this stirring scene, Wakil drove us to Jalalabad, the city of his childhood dreams and the one of our nightmares. Its long, beautiful, tree-lined approach still sent shivers up my spine though I knew the MiGs and gunships were gone. Wakil had been in Jalalabad for the past week, scouting the terrain of his family compound. It seemed to be in fine shape, but as we filmed the great earthen building from the long path leading to the entrance, he warned us to go no closer. Not counting those they couldn't see, his people had detected more than twenty mines on the property. After fighting the war against the Soviets for thirteen years and driving them out of his country, he had finally returned to his childhood home unable to enter. It would take a year to clear the mines so that the women and children could return.

Wakil asked if he could borrow our camera and look at the old homestead through its lens. Dan and I stood with him for a good fifteen minutes as our escort, guide, and friend of many years panned and zoomed across the structure, from window to window and from doorway to patio. In his mind he heard the voices of his father and mother, long dead, and the laughter of his sisters and brothers, one of whom had been a casualty of the war. Those innocent, carefree days of childhood disappear for all of us, but in Afghanistan the process has been harsh indeed.

Wakil then took us to visit the family graveyard, which was already cleared of mines. In a neighbor's graveyard, a mine had been sown beside one of the grave markers. As we stood there, gazing down at the carved stones identifying long-gone Akbarzai family members, I wondered what thoughts might have passed through the mind of the man who had laid that mine in the graveyard. A soldier's trained body

does what it's ordered to do, but his mind is still his own. We would never know the private thoughts of the mine setter, and he would never know if his handiwork still awaited a victim or had already detonated and perhaps killed a child visiting his grandfather's grave.

Later that night we were treated to big news: Wakil had finally decided to marry. He had once told me years before that he'd never marry until he helped drive the Soviets from Afghanistan. Now that the Soviets were gone, Wakil had decided that, in spite of sinister forces at work in Kabul, the time had come. Afghans are guarded about personal matters, so I knew little about Wakil's lady of choice other than her name was Alya and she came from a fine, old family in Kabul. Perhaps I knew more than most ferangi about such events, and I felt privileged that Wakil shared what he did of his private life. In the States we would have called for beers all around, but in Jalalabad we toasted Wakil with Sprite and orange juice.

Despite his decision, I sensed from Wakil that all was not right with the country. I knew the Naqshbandiyya Sufi leader, Sibghatullah Mojaddedi, had been elected interim president by the Afghan Interim Government (AIG), and Pir Sayed Gailani, NIFA's commander in chief and leader of the Qadiriyya Sufis, had decided it was the moment to reestablish Afghanistan as a functioning, quasi-democratic republic. But the fundamentalist Pashtun Hekmatyar and his Saudi and Pakistani secret intelligence backers resented both men as well as the then-current Afghan president, Rabbani (a Tajik from the north). Hekmatyar also felt Massoud, another Tajik and master militarist with whom he had come of age fifteen years earlier, had betrayed Islam, while Massoud believed the demagogue–drug lord Hekmatyar had betrayed the liberation movement. The stage was set for another bloodbath, and this time the United States and the West would sit on the sidelines completely disinterested.

<div align="right">

# 26

</div>

# *The Civil War*

**In April 1993, as our old DC-10 circled Bagram Air Base,** flares flashed all around us in the twilight sky. I'd heard about the maneuver from others, but now I was experiencing it firsthand. I pressed my camera against the window and tried to shoot the light show with shaky hands. Then I saw the flash and felt the concussion as the flares drew off the first of the heat-seeking missiles Hekmatyar's forces fired from their defenses outside Kabul. The lights were out in the cabin of the old prop, and only during the flashes could I see the faces of the others on the flight. I figured I was luckier than most; at least with my camera I had something to do (never mind that I was so spooked I had forgotten to load it). I've often heard the phrase *like shooting fish in a barrel* without really understanding it. Well, I did now, except I was in no ordinary barrel. It was an electric, neon, Fourth of July–fireworks kind of aquarium, where they shot at the big flying fish in the sky with missiles that had once belonged to the U.S. government. I was again reminded of *Apocalypse Now* and the scene in which a tripping Timothy Bottoms strolls through the multicolored explosions at the firebase. We passengers had no acid or heavy metal music, but the strobing, smoky light show was the same.

Just a few days before, I had been in Jalalabad again in search of Wakil. The place reminded me then of America's Old West, as tough hombres belonging to various factions paraded the streets in Soviet tanks, jeeps, and pickup trucks as well as on horseback. They carried more hardware, though, than Wild Bill Hickock could have imagined. A man with only a six-gun in his hip holster would have looked naked on those mean streets. Most, in fact, carried a Kalashnikov in their

hands and a rocket-propelled grenade launcher over the shoulder, bandoliers crisscrossed across their chests à la Pancho Villa, a few grenades hanging from their vests, and a Soviet automatic pistol and several knives stuck in a leather belt tied across their shalwars. Any women we saw on the streets were usually running from one doorway to another. Angry shouting matches erupted in cafés and fistfights in teahouses. On one occasion I encountered two men wrestling in the street who kicked up so much dust that the entire street disappeared from view.

Sadly, I was observing firsthand what happens when men have lost their incomes, lost their ability to feed their wives and children, and lost their life's compass after struggling fourteen years for a cause that embraced all their beliefs, dreams, and commitment. And much worse, these unemployed and bitter men had once been soldiers and still had all their weapons. The Soviets, as we know, had left by March 1989, and American support for rebuilding the country slackened at the moment the CIA saw the tailpipe of the last Soviet personnel carrier disappear into the Salang Tunnel. The U.S. and other Western governments had promised ongoing financial support to help rebuild Afghanistan's infrastructure, which had been devastated just as Dresden's had been in World War II. But while the United States and Western powers did rebuild their former enemies Germany and Japan, in Afghanistan, these pledges were conveniently forgotten. The Afghan people remembered the CIA's Bill Casey, Secretary of State George Shultz, Presidents Reagan and George H. W. Bush, and all the others who made promises. Their vague allusions to eternal friendship were never put to paper, true, but to a largely illiterate people who believed in personal honor, the integrity of the Americans' spoken word was enough. To warriors who throughout their history had gone to war or made peace on a handshake, these promises were as real as if they'd been signed into a constitution. It was simply unthinkable to them that the Americans would drop all support of the friends they had encouraged to take on the Great Bear, the Soviet Union.

And now in the spring of 1993, once more Hekmatyar was whipping up the emotions of these out-of-work soldiers with promises of a

glorious jihad. Only this time he planned a jihad against fellow Muslims. In his master work, *Taliban: Militant Islam, Oil, and Fundamentalism in Central Asia*, Ahmed Rashid presents a strong argument that Hekmatyar's machinations may have ripped the Afghan fabric beyond repair. His long-brewing rage at Massoud, whom he saw as the ultimate threat to his Pashtun-Wahhabi version of Islam, triggered the split among the mujahedin forces. But without the enormous cache of American arms and Saudi money that had been channeled to him over the past decade, Hekmatyar could not have taken the field to effect the damage he did. During that same decade, Massoud and Rabbani claimed to have received only occasional CIA financial support and token shipments of Stingers (only eight Stingers, in fact, according to Steve Coll's *Ghost Wars*) while Hekmatyar and other fundamentalists received the rest of the 2,000 to 2,500 missiles America supplied to the mujahedin. Only Hekmatyar and his fellow travelers Sayyaf and Khalis were the West's real beneficiaries, and now Hekmatyar was using these same weapons against his fellow Muslims down below me in Kabul.

This duel between Massoud and Hekmatyar seemed almost preordained. Not only was Massoud a Tajik who spoke a bit of French and English as well as his native Dari—the language of the so-called Shia "heretics" in Iran—he stood firmly against the Wahhabi Islam to which Hekmatyar had been exposed while visiting Saudi Arabia. Massoud bowed to Mecca five times a day, just as Hekmatyar did, but he refused to kneel to the extremist beliefs and politics of the relatively new, oil-rich Saudi nation that had only begun taking political shape at the end of World War I when Abd al-Aziz ibn Saud waged war to reimpose Wahhabism on the land. In September 1932, he declared it "the Kingdom of Saudi Arabia," having christened it with the blood of Shias, Sufis, and other Sunni dissenters who were executed publicly whenever the opportunity presented itself. The Arab historian Said K. Aburish writes in *The Rise, Corruption, and Coming Fall of the House of Saud* that 400,000 Muslims of other than the Wahhabi persuasion were massacred over the fifteen years during which the Saudi kingdom was consolidated. Massoud wanted no part of this extremist ideology, which Pakistan's ISI had adopted. From his small homeland

base far to the north in the rugged Panjshir Valley, the dashing commander fought his own war against the Soviets with a brilliance that Hekmatyar could only envy.

But Massoud was not without fault. After his forces had taken Kabul in 1994, some saw the Lion as having been an integral part of the disaster that followed when the new interim government was set up in that city. After all, it was his colleague Rabbani who had arbitrarily (supposedly by a vote) extended his AIG presidency from six months to two years, angering all the other parties. And whether Massoud ordered it or not, some of his men joined Sayyaf's group in attacking the Shias in Kabul in what most describe as massacres, beheading men, women, children, and even dogs. Massoud and Professor Rabbani were not above playing politics as well, and war politics in post-Soviet Afghanistan revealed a quagmire of betrayal unknown even in Afghanistan's previous intrigue-ridden history. Consider, for one, the Uzbek warlord Rashid Dostum, who switched allegiances as often as some warlords fought battles. But let us not forget that Hekmatyar initiated this grim civil war that some estimate claimed the lives of 40,000 Kabul residents, mostly civilians. Many analysts have also suggested that Hekmatyar's political ambitions, in concert with his interest in the drug trade, extended far beyond Afghanistan's borders.

It is not my purpose to present a blow-by-blow history of the grim period from 1992 to 1996. For that one should read Ahmed Rashid's *Taliban,* among other books. From my perspective, the important thing is how the blowback came about—that is, how it resulted directly from an American-Saudi agenda that was administered by Pakistan's ISI with its eyes fixed on establishing a government in Kabul that would be controlled by Islamabad.

And here I was circling Kabul and being targeted by none other than the hit man himself, the same Hekmatyar who had ambushed Massoud's soldiers during the war against the Soviets; the same warlord whose men had escorted Lee Shapiro and Jim Lindelof on their last trip inside; the same misogynist who has been accused of complicity in the murder of Meena (the only name she used), the founder of the Revolutionary Association of the Women of Afghanistan

(RAWA); and the same thug who had issued a *fatwa*, or declaration, to kill Save the Children's Jan Goodwin, even after she had retired from her position in Peshawar and returned to New York.

True to his word, Wakil had waited until the last Soviet soldier had left Afghanistan before he chose to marry and have a family. He had returned home to Jalalabad the year before to build a new life only to find his family compound rigged to kill. But that had not deterred him from his determination to raise himself and his country up from the ashes, even though he sensed the shadowy movement of foreign interests working against this goal. And if some of those shades would be revealed for who they were a year later, others in the wings were waiting for them to blow their lines. By the summer of 1994, the curtain would rise on the next act, the Taliban.

When one of the rocket interceptions rattled the fuselage of our old plane, sending the flight attendants crashing down the aisle, the pilot decided he'd had enough and headed back to Lahore, Pakistan. I did not get to see firsthand the bloodbath that would be called Afghanistan's civil war, but my imagination and RAWA's website would fill in the gaps.

# 27

# *Back Through the Looking Glass*

**In 1994, we approached Channel 4 of London** to fund the completion of our Afghanistan project. We had a good track record with the network, having produced the pilot for one of their premier series the year before. But the 4 editor commissioned to work with us felt we needed to define the focus in our material, which could be done only by returning to Afghanistan with Carmen one more time. We felt this request was valid, given that the story needed closure, and we were ready to do whatever was needed. But when we approached Channel 4 again, along with its insurance division, they felt the project too costly and too risky. Afghanistan was not a location they were prepared to insure, and their refusal meant another red light for the project.

Two years later, in the summer of 1996, Carmen and I joined Wakil and his two nephews, Hamid and Wahid, for lunch at the Afghan Grill on Ninth Avenue in New York City. Hamid had just taken a position with the United Nations, and Wahid was enrolled at the University of Bridgeport in Connecticut. Wakil visited the States at least once every year to check on the exiled contingent of his family no matter what was going on in Afghanistan.

And what was happening there was indeed disturbing. The "students" had been on the march for two years and at that moment were at the very gates of Kabul. During the relentless push from Kandahar across the south and west of the country, the Taliban had revealed its extremist face and its total commitment to Saudi-style Shariah law, which was alien to the bulk of Afghanistan's traditional Sunni and Sufi population. But given that they were putting the rabid, raping,

unemployed mujahedin commanders out of business, most Afghans felt the Taliban (or, in Arabic, students of Islamic knowledge) was the better choice. The civil war had already cost Kabul more than it could pay, and the people were still caught between warring factions. On one hand, there was Hekmatyar, who was not prepared to leave the field willingly. Instead, he'd keep lobbing rockets at the city until he got his way or leveled the place. Massoud, on the other hand, manned the barricades in Kabul and would not give an inch to his arch foe. "For many Afghans," Wakil said, "the Taliban seems to offer the only hope of an end to the civil war."

"But what's the cost?" Carmen asked.

Wakil shrugged. He did not know. "It depends on whether the Taliban makes good on its promise to turn over power to a *loya jirga* (grand council of elders) once it brings down all the walls."

"Will Hekmatyar and Massoud ever submit?" I asked.

Wakil sat back in his chair, nibbled on the fresh naan, and reflected. We were asking him to read from a crystal ball for a land and a people that usually busted such balls. Finally he leaned forward. "With Hekmatyar it all depends on Pakistan, on whether Islamabad and the secret police keep supporting this warlord, and keep channeling CIA and Saudi funds to him as their Afghan solution." But perhaps, he added, Hekmatyar would find himself out of the new loop.

As for Massoud, Wakil felt he was a different story. If the Taliban proved amenable to negotiation, Massoud might bend a bit. But if it continued to pursue Wahhabi fundamentalist goals, allowing no quarter for legitimate dissent, Massoud would prove a great obstacle to any unification of the country under the Taliban. Wakil was not happy with his appraisal, but he stood by it. "It's good," he joked, "that my nephews are now doing their battles in New York and not Kabul."

Wakil's vision proved prophetic. Within the month the Taliban had sent Hekmatyar packing from his base at Charisyab and forced him to leave behind all the weaponry he had accumulated over the years from the CIA, the ISI, and the Saudis. Denied further support from Pakistan, Hekmatyar didn't stop running until he had reached safe haven in Iran, the land of the Shia "heretics" on whom he and his Wahhabi friends had sworn unconditional vengeance. Why did they accept him and not hang him? Who knows for sure, but drug money

talks everywhere in the Middle East. As for Massoud, he and his army began an orderly retreat from the city to return to his natural fortress in the Panjshir Valley.

On September 26, 1996, Taliban forces under Mullah Abdul Razak broke into the UN compound where Najibullah had sought sanctuary from Massoud for the last four years and dragged the former Communist regime president out into the streets. They took him to a nearby jail, where they tortured him for hours and were rumored to have hacked off his manhood. When they hung up his dead, twisted body from a lamppost in the center of the city, there was evidence of severe bleeding around his groin. The news photos flashed around the world. The message was clear to all, even to the Unocal negotiators who had been prepared to work with the Taliban to build a trans-Afghan gas pipeline from Turkmenistan to Pakistan. All deals were on hold until Unocal could determine whether the Taliban was prepared to moderate its behavior. But moderation was not in the Taliban vocabulary.

Carmen called me out of the blue a year and a half later. She planned on returning to Afghanistan. She'd decided to keep her promise to her dead colleague and finish the story—Channel 4 and the Taliban be damned! Such declarations are, of course, easier to issue than to realize. It would take some time for Wakil to arrange a new shoot in Afghanistan, where 90 percent of the country was now in the hands of the Taliban and Massoud was holding onto his 10 percent by his fingernails. So I asked Carmen the big question, why now?

Her answer was clear. Shapiro and Lindelof had given their lives for the cause of Afghanistan and its struggle to expel the Soviets, and Carmen had devoted many of her own prime years to tell the story she'd promised Shapiro she would finish. But her motivation was also personal. In 1991 she had married a Russian defector with whom she'd had a child, a little girl they'd named Katiana Lee. So Carmen, the doctor-journalist who had covered the Russian invasion of Afghanistan and who had lost her dearest friend in the process, had come full circle. Carmen had married a former Soviet! That was startling. And the sad fact was her marriage was now, so soon, on the rocks. At this

point Carmen needed clarification and closure on several levels. Her life and the lives of those she loved had been dictated one way or another by the conflict in Central Asia. Now she needed hard answers.

How had Shapiro and Lindelof died, really? Who was responsible? Where were they buried? Only a candid statement from the Hezb-i-Islami warriors who had been expected to protect them, together with finding their graves, would provide even a modicum of closure for Carmen. Her colleagues had sacrificed their lives for a cause that had since been betrayed over and over again. Looking back on Lee's journey, she wondered if it had been worth it, or if promising young lives had simply been wasted? Had it been worth it for any of us to bring our cameras to bear witness to a failed struggle for liberation in a place where photography itself was now punishable by the taking of an eye?

Wakil set the shoot for May 1998, a time when he felt he could be reasonably sure of our safety. He knew when the Muslim holidays would soften the Taliban border forces in the south. And he knew that when the snows began to melt in the north, the warriors of the Panjshir would leave their icy caves and head for the plains north of Kabul to challenge the intruder, whoever it was, from the British and the Soviets to Hekmatyar and Mullah Mohammed Omar. Wakil was a diplomat, but he was also a master military strategist.

"Have you ever seen Wakil use a gun?" Jan Goodwin had once asked me. "He's scary!" No, I hadn't, and I'd never seen him pick up a Land Cruiser either, but jocular myth has it that his powerful physique once enabled him to do just that on the battlefield. No, I'd only seen the master planner and negotiator at work, and he was at it again. By December, Wakil informed me by e-mail that everything was set for our May arrival. He never went into specifics for obvious reasons. We had to arrange for our crew, equipment, film stock, and air travel. We also wanted to film Carmen at her home in New York as she packed her bags and kissed her little girl good-bye for another trip into that strange land to the east. Perhaps it is true, as Kipling once wrote, our Eastern and Western cultures can never truly meet, but we were determined to return to Afghanistan—as visitors, of course, and always as guests.

A few days before our Afghan trip, our crew showed up at Carmen's house in Riverside, New York, with camera and sound. Carmen, now with an established medical practice in Manhattan, was packing the instruments that she'd laid out on her bed. Her four-year-old daughter watched as her mother added the blood pressure gauge, the stethoscope, and an assortment of drugs and syringes. Seeing these items elicited the first expression of fear from little Katiana Lee Kartachov. "There are lots of sick people in New York," she told her mother. "Why do you have to go so far away to find sick people?"

Carmen stopped her packing for a moment and looked across the bed at her daughter. "Because the sick people there—lots of them, kids like you—have no doctors to help them."

Katiana climbed onto the bed and crawled across it through the medical supplies to her mother's arms. She began to cry. "I don't want you to go," she sobbed.

"But I have to go," said Carmen, "to finish making a film we started a long, long time ago. We have to finish the things we start, don't we?"

Katiana scrambled higher up into Carmen's arms until she stared directly into her mother's eyes. "Then I'm going with you," she said in a determined, little voice, without even a hint of her mom's thick accent. "But you can't," said Carmen.

How do you tell a child you're going to Afghanistan when, as Katiana did, she knows what the word means? My youngest was four years old when I first traveled there, and I think only because I kept coming back more or less healthy from successive trips—that is, until the siege—he always expected I'd be OK. I never discussed these trips with my older kids and just kinda slipped out the door with my backpack. But Katiana Lee no doubt knew things on an intuitive level. I'm sure she often asked about the photo of the handsome bearded man on her mom's bedside table and noticed that his name and her middle name were the same.

Carmen's estranged husband drove Carmen, Katiana, and our crew to JFK airport. We passed over the bridge to Queens and saw the Twin Towers, standing tall, with their peaks disappearing into the low-lying clouds as if they'd been ripped away by some sky giant. There

was little conversation during that hour-long drive, and at one point Katiana fell asleep on her mother's lap. Carmen stared out the window, seeing things that were not there. Her Russian husband rarely spoke, and when he did, he had the thick guttural accent that I remembered hearing in Afghanistan from Soviet soldiers who had defected. Kartachov had defected too, to the United States, he told us once, not as a soldier but as a psychiatrist. In his country, the practice of that medical art was a sham. The Soviets even refused to acknowledge the seminal work of the likes of Sigmund Freud and Carl Jung. Only "work therapy" was acceptable. I thought about how much this communist view of psychology had in common with that of the close-minded Taliban, an aberration, which the Soviets helped create.

At JFK Airport, Carmen got out of the vehicle, grabbed her bags, and knelt to give her daughter a quick, warm embrace. Then she turned and walked down the long corridor. Katiana Lee lowered her head and cried.

On the long flights to Frankfurt and on to Islamabad, Carmen gazed out the window into the darkness and then back down at Shapiro's diary, a worn red journal with hand-scribbled pages, that she held in her lap. When we arrived in Peshawar, it was still night-time but twenty-two hours later. We had entered this dark tunnel prepared to step back in time to a place where we had once felt appreciated and protected. But it had changed.

As we descended the ramp, we could hear a chanting crowd beating drums on the streets outside the airport even though we were a good distance from the city proper. It was not Ashura (remembrance), when the Shiites of the world march, chant, and flagellate themselves in atonement for the murder of the Prophet's grandson. Instead, the Shia community was out in force to protest the Taliban's anti-Shia policies. And on another street closer to town we encountered women marching against the gender policies of the Taliban. But why all this ferment in the middle of the night? Perhaps the people were aware of something we were not: bin Laden was in town, preparing for a second press conference to clarify the one he had given here in February.

# 28

## *Talibanistan*

**My new crew, headed by cameraman Peter Brown,** had arrived a week earlier to begin an ancillary shoot in Pakistan, in which we would track the flow of the Indus River from its source high in the Karakoram Mountains in the northeast all the way to the Arabian Sea in the south. Consequently, the crew was primed for action.

On the morning of May 25, we left Wakil's Peshawar compound in two Toyota trucks and headed west to Parachinar on the road that parallels the border inside Pakistan. Wakil had brought along three former mujahedin with whom he'd worked during the war against the Soviets. Omar sat in the back of the pickup with Peter. A giant at 6 foot 7 with shoulders to match, Omar sported a deeply furrowed brow and a Kalashnikov that looked like a toy in his hands. The man's presence alone could be intimidating, but his broad, fun-loving smile revealed the trickster inside the rough exterior. Omar was so fierce and at the same time so friendly that former king Mohammed Zahir Shah chose him as his bodyguard whenever he came to Peshawar to consult with the mujahedin commanders. The day before, when filming in a Peshawar hotel where Shapiro, Carmen, and Lindelof had stayed on that last trip in 1987, we left Omar outside to look after the vehicles. When we'd finished shooting and returned to the street, we saw our giant holding two local merchants, one in each hand, up off the ground by their necks. No exaggeration! He explained to Wakil they were arrogant men who'd threatened to enter the hotel while we were filming. For such lack of respect he wanted permission to slam their heads together.

Our second bodyguard, Khawanee, sat beside Carmen in the backseat of Wakil's Land Cruiser. Wakil once said that Khawanee's eyes could see through walls to probe the very heart of a situation. An intelligent and handsome man in his late fifties, he had been a loved and respected commander during the Soviet war. On our trip he spent a great deal of time with Wakil every day, undoubtedly discussing the political situation. Though I never understood exactly what they talked about, I believe it included their part in a full-scale offensive (probably with Abdul Haq) against the Taliban planned for the coming months. Although ever alert, Khawanee would always put his Kalashnikov in front of him on the floor of the car so as not to appear hostile. On one occasion we heard gunfire as we drove into a truck stop, and he was out of the truck and in the café with his weapon drawn before we had come to a full stop. He moved with the singular ease of a hawk gliding with effortless power above its prey. He wore his six decades well.

Our third soldier was Wakil's nephew Wahid, whom I had met many times over the years both in Afghanistan and in New York while he attended college in nearby Connecticut. Wahid was about thirty years old, and his English sounded as if he'd been born in the States. I often thought about his schizoid life. During the school year in New England, he attended graduate classes, dressed in corduroy pants and tweed jackets, and chatted with his classmates about movies or an upcoming party, and during the summers, he returned to his embattled homeland to don the local garb and oil his trusty Kalashnikov.

The journey to Paktia would take ten hours. We stopped overnight at the Pakistani Military Headquarters just outside of Sadda. The guards opened the big gate revealing a hundred or more new recruits leaving to patrol the porous border, where the drug trade was rumored to have stepped up again. I wondered if this increase was in response to the Taliban's encouragement or simply the result of a good harvest. When the Taliban moved north from Kandahar in 1994 and 1995, the men burned the poppy fields along the way. There's no question that in its early days, the Taliban seriously upheld its mandate against drugs, for after all, it wanted to carry out the Qur'anic code with all the commitment of true Wahhabi crusaders. But as "absolute power corrupts absolutely," missions change. It makes men quest for

more power, especially when older, more clever, and greedier men are
there to whisper in their ears.

The Pakistani commander of the military headquarters was most
courteous and offered us lodging for the night. Wakil warned us to
say nothing to him of our intention to cross into Afghanistan. Our story
was that we had come simply to film the two large refugee camps in
the area, which was typical of the few UNHCR and NGO camera crews
that occasionally strayed this far from Islamabad.

Parachinar Province is a small, narrow finger of land that juts
some fifty miles into the Afghan mainland. At the southwest end of the
province, Wakil planned to cross the Kabul River. Then we'd have to
travel only another seventy miles to reach the place where Abdul Malik
claimed Shapiro and Lindelof had been buried. Our destination was
the smaller villages just south of Jalrez where we would learn about
life under the Taliban. Wakil had planned the entire journey as a mili-
tary operation and had worked out all the kinks. We had the firepower,
if needed in a clutch, but that prospect appeared unlikely since we were
sneaking in when the Taliban regulars patrolling this sector had been
called north to deal with Massoud's new spring offensive. If Wakil was
correct and his plan worked without a hitch, we might not encounter a
single armed Talib. But if clever strategy was part of the operation, so
were speed and luck. Sooner or later the Taliban would be alerted to
our presence in Paktia, and we would have to leave before a patrol
arrived in the area. No flat tires or broken fuel pumps, please!

We sat cross-legged on the army compound lawn, drank tea,
and talked with the commander and his assistant, who both spoke
good English. Somehow, although I tried, I was unable to coax either
one to talk about the troubled nation that lay only twenty miles north.
It seemed they had chosen for political reasons to pretend it didn't
exist. Wakil chatted up the commander, filling his head with the kinds
of things army lifers like hearing. I have often observed Wakil's or-
chestration of the diplomatic arts. He always got what he wanted from
a discussion, but he never resorted to outright fiction, or lying, as a
means to an end, no matter how worthy the end. He always studied
the words people used and did his best to remain honest.

The sun was setting over the mountain corridor to Afghanistan with some of the most glorious colors I'd ever seen. Wakil must have noticed the glint in my eye because he begged our host for his leave so he could drive us to a point where the majesty could be recorded by our camera without compromise from wires and buildings. We were back in the Land Cruiser and out the gate within seconds with Wakil at the wheel hitting the macadam as if he were a NASCAR driver. He had studied business and economics, not documentary filmmaking, but after so many years working with my crew and others, he had developed a keen sense of the imagery we wanted to capture. We barreled through the small suburb in a race with the sun until Wakil found a place where the great disk, now diminished by half, was framed for our camera by only mountains and trees. Switching the camera speed to sixty-four frames per second (slow motion), we prolonged its final, pastel descent with only seconds to spare. Wakil smiled. As usual, he had delivered, and he knew it.

We'd finished shooting a few other scenes in and around the barracks at about 9:00 p.m. No one had thought about food until the commander insisted we have dinner. He offered to have his personal cook rustle up something healthy for us. At a little before 10:00 p.m., I carried a tray of food to Carmen's room and was about to knock, when I noticed her door was ajar. I could see her sitting on the edge of an army cot, reading Lee's journal by candlelight. Though she was reading out loud to herself, I could not make out the words, only the soft, wet sobs filling the spaces between them. I stood at the door for a time, trying to decide whether I should interrupt her or observe her private moment in secret. After all, I was making a film about the entire story, and perhaps, I should be aware of such moments. But I had to remind myself that without a camera in my hands, I could not justify my eavesdropping as being work related.

Carmen finally relieved me of my indecision by closing the journal. She dropped her chin to her chest and continued to sob quietly, much as an anguished widow might do at her husband's wake. But Carmen and Shapiro were friends and colleagues, not romantic partners, and the depth of that friendship was powerful and revealing to witness. From near the barracks outside, a mullah began the evening

call to prayer. Their two voices, Carmen's and the mullah's, blended together as though in the same musical key. This awesome, disturbing sound set off harmonics in my head similar to the sounds of the sitar's sympathetic strings. At that moment I knew for certain why I had joined Shapiro's and Carmen's quest.

A sadness came over me far greater than my empathy for Carmen's profound loss and her endless struggle, a struggle I could plainly see was as real for her at that moment as it had been the day eleven years before when she had learned Shapiro had been killed. Added to her pain of losing this mentor and best friend, were the staggering losses in Afghanistan itself, losses that increased exponentially at which the number of deaths and mutilations only hinted. Now the great sacrifices of these worthy people seemed doomed to oblivion by a group of zealots whose system of religious thought was alien to Afghanistan's tradition and condemned us all as infidels for even caring about them or their traditions. Perhaps my deep remorse was for the human race and the dramatic horrors it must endure over and over again. Do we ever learn from history? I thought probably not. Where had God been hiding when bad things began happening here? Of what great sin were the Afghans guilty for Allah to have meted out such punishment? What unspoken agenda did God have in mind when he permitted such wrath to be inflicted upon his loyal followers? Maybe as some had speculated, the Afghans were indeed the lost tribe of Israel.

We were up at sunrise the next morning and took our leave of the commander, who, as a good mother, insisted we carry breakfast along with us in the trucks. After all, he reminded us with that enigmatic sideways nod that the cooks in the refugee camps were not that well trained. But of course there would be no refugee camps for us, and once outside the town, Wakil turned onto the road that led to the border. Still, the packed breakfast was good.

An hour later, at a point skirting the Kabul River, Carmen asked Wakil to stop the car. This place was where she had last seen Shapiro. She had waved good-bye to him as he glanced back over his shoulder from the long caravan that snaked up the snow-covered peaks into Afghanistan. Carmen stepped out of the Land Cruiser and stood staring at the peaks in silence. Then minutes later, without comment, she stepped back into the car.

The weather up until now had been sunny and warm, but as we drew near the border, it turned gray and cold. From a high point along the road, we caught our first glimpse of the bridge that would take us inside the land of the Taliban. From that distance, it was hard to tell if the guard posts were empty or not. Ten minutes later we parked near the Pakistani side of the bridge while Omar and Khawanee sought information from the locals. Waiting in the car with Wakil, we were suddenly surrounded by a group of Afghan women playing musical instruments and singing. They were cheerful and outgoing, without a burqa among them, and wore only simple scarves tied around their heads. When the performance was over, we each gave them some money. They thanked us and did not ask for more. I chose to look upon the event as a good omen. Across the bridge we would need all the good luck we could get.

Omar and Khawanee returned with word that the border was indeed unguarded. We prepared to cross. Omar's pickup with the heavier weaponry went first, ready for a possible confrontation. But as Wakil had anticipated, we did not encounter any Taliban sentries; instead, we saw only two Pakistani guards, who for some unknown reason were at the far end of the bridge on Afghan turf. As we passed them, they smiled and saluted us as if we were on our way to a picnic. Wakil gave them no recognition whatsoever, but he found their presence on the wrong side very funny.

If nothing else had told us we'd arrived in Afghanistan, the road would have done so. Craters, cracks, torn pieces of tarmac, tank carcasses—everything I had grown accustomed to finding here over the years—littered the road. And as if on cue, came dark skies, wind, and cold rain. I could see through the camera lens that Wakil's demeanor had changed. His mouth tightened as we hit the potholes to the rhythm of the wiper blades. We passed a turnoff that headed directly into the city of Khost, which was not more than five miles away. I remembered Khost had always been a beehive of fundamentalist activity, known for its eternal unrest. I was glad we were not turning here.

What we did not know at that moment about Khost could have gotten us all killed. Wakil had planned everything for this trip, but even a military mind as astute as his had no way of tracking the inner

workings of al-Qaeda. Even he was not privy to the fact that bin Laden had arrived in Khost the day before to prepare his declaration of war "against Jews and Crusaders" for his handpicked press. While he had issued a preliminary statement from Jalalabad back in February, here in Khost on May 26, 27, and 28, he gathered those journalists and camera crews from organizations he trusted. A few miles down the turnoff we had just passed he would deliver a statement to the entire world promising new strikes "in a few weeks." The coincidence still haunts me.

Up ahead of us, two trucks had pulled off the road to let Omar's truck pass. The vibe Omar sent out must have been clear, because the men sitting in the cabs and those standing in the beds just stared at us. I could almost see their jaws drop. I was glad cellphones had not yet arrived in Afghanistan.

Before long, with the rain coming down harder, the dirt road morphed to mud, making traveling even more difficult and slow. Wakil did not like this; the clock was not our friend. Between the wiper blades sweeping across the windshield, I saw two women run across the road and head for their houses, their multicolored clothes (not blue burqas) as striking as neon in the stark, gray landscape. From the safety of their mud huts, they turned to watch our mini-caravan with its guns and cameras pass by. Then the rain began in earnest, obscuring our view of the road and the obstructions. While I knew getting bogged down was potentially dangerous, I comforted myself with thinking that most folks would now be indoors and might not observe our passage.

A couple of hours later, with the rain slowing a bit, we pulled into a small village and stopped at the largest mud house. Wakil got out but cautioned us to stay in the car. Omar, Khawanee, and Wahid took off in different directions to scout the situation as a number of locals stepped from their doors, startled. We sat and watched nervously. Finally Omar returned and pointed to the house with the barrel of his Kalashnikov, and Wakil started up the stairs. Then Wahid appeared from the side and opened the car door. He instructed us to follow his uncle as the villagers wanted to meet us. In fact, he added, they were already boiling water for tea.

There were about twenty men in the room and Carmen. In traditional fashion, everyone shook our hands as we entered. There was no

hint of concern at our sudden and unexpected appearance, but I knew Afghans were cool under pressure. The head man was in his mid-forties and looked tough, but his smile seemed as broad as his torso. Kids scurried about outside and stared through the windows at the visiting aliens. The head man insisted from the start on using the few English words he'd learned before the Taliban arrived. I tried to accommodate him with my limited Dari vocabulary. Thankfully, Wakil interrupted us. He had taken his seat on the carpet at the head of the table, lounging casually on his side, and began translating the villagers' questions. Who were we? Why had we come? What did we want from them? What was this about, a death in the family? They listened in silence to the story of Shapiro and Lindelof's journey through their country.

They wanted to know who Carmen was, this adventurous yet quiet woman who had arrived out of nowhere with a group of Americans. Wakil wasted no time explaining that Carmen was a medical doctor from a land far south of the United States who had come to Afghanistan with her colleagues in the mid-eighties to film the Soviet atrocities. He explained in detail the official story of how Soviet Spetsnaz in gunships had killed her film partner and his soundman. The headman and, indeed, all the men were moved by this tale and stole glances at Carmen. The more they heard the more involved they became. They asked Carmen questions in reverential tones that Wakil translated and Carmen answered. Was she a Muslim? Did she love Afghanistan as much as Shapiro and Lindelof had? Did she support the Taliban?

I don't know how Wakil translated her response to this last question, but Carmen answered it with a definite negative, though, as she said, she understood the need to bring peace to the country at— almost—any price. That the men were having this discussion with a Western woman in Taliban-dominated times should not be considered startling, as once outside the jurisdiction of the Taliban's vice and virtue police, Afghans were prepared to discuss most subjects with anyone, Muslim or not. The gender part of the equation was stretching the bounds of safety, however, only because someone might inadvertently leak news of the event. We must not forget the Taliban's version of Islam had little to do with the history of Afghanistan and

everything to do with the Saudi Wahhabism that had arrived with Saudi petrodollars. Thus, Carmen not wearing a burqa meant nothing to these humble Afghans. They had originally come from the north near Balkh, not far from the birthplace of the great Sufi mystic, Rumi, and their women had not worn burqas until 1996. I'm sure they would have found one of those faceless, blue body shrouds for Carmen to wear in case of a surprise visit.

But were these men apologetic about the changes the Taliban had instituted, such as reigning in the commanders, taking their weapons, and demanding accountability for criminal actions? Absolutely not! They felt the Taliban had improved a terrible situation.

Toward the end of the conversation, after the tea and snacks, Carmen asked about the location of the village where Abdul Malik's mujahedin had supposedly buried Shapiro and Lindelof. She described it, and they discussed it among themselves. Finally the head man turned to us; he knew of a village fitting the description about twenty-five miles away. If we stayed the night, in the morning he would take us there himself. Wakil thanked the head man for all his kindnesses but explained that we would have to leave. When the head man pointed out it was still raining, Wakil stood and began embracing each man in the room. He made it clear in his diplomatic way that it was time for us to be on our way, alone. The head man understood. He pressed his right hand against his chest and bowed.

We spent the rainy evening in a small canyon just off the road about ten miles from the head man's village. All of us were talked out after the village roundtable, and before night fell we had disappeared under our blankets. As I nodded off, listening to the rain, I heard a wolf howling in the distance. How had any wild animal managed to escape the bullets, bombs, and land mines of the last nineteen years? The region had once been known for wolves and for its lions, tigers and bears, and the thought that a few of these creatures might still be hiding in caves high in the mountains once reserved for Gurdjieff's "remarkable men" calmed me. I wondered what his Sufis would have thought about the tall Wahhabi alien who was about to issue his fatwa in Khost, swearing vengeance upon all nonbelievers and even "people of the Book."

# 29

## *The Searchers*

**We were up long before dawn the next morning** and on our way to the village where the head man had directed us. The rain had stopped, leaving huge puddles on the road. Wakil told us we'd have to pass through another village on the way where local policemen, perhaps carrying sidearms, might be patrolling the streets. Omar and Peter would have to travel inside the pickup truck instead of in its open bed. If we were going to film anything there, we'd have to hide the cameras. Khawanee hung curtains on the truck's windows, and I arranged a small hole in them on each side for the cameras. Wakil cautioned us to move fast, noting, "The sun is not on our side."

Indeed, the sun continued to rise, and the road, with its obstacles and detours, had other plans for us. When we approached the outskirts of town, daylight had arrived before us. People were already up and on the muddy streets with their donkey carts and bicycles. I glanced at Wakil and observed once again the tension around his mouth that belied his cool countenance. He calmly instructed us to pull the curtains. With the bumps and potholes in the road, I had no way to stabilize the camera in any reasonable fashion and I tried to divine a rhythm in the truck's movement that would afford me a few moments of stable footage.

I wondered what would happen if we were discovered. A high-speed race for that bridge back through the same potholes? A shoot-out with the Taliban police? I remembered other moments when I had to film undercover. It was a bit easier on the fishing boat in Mariel Harbor during the big Cuban exodus in 1980. Traveling at slow speed in the bay's flat waters, we were able to set the camera on a tripod in

the cabin and poke the lens through a hole in a black curtain. The hot tropical sun overhead and the blinding reflection off the water created harsh contrasts and deep shadows, allowing us to pass right under the barrel of the guard's machine gun without being noticed. Of course, we took the additional precaution of waiting for him to leave his post to take a leak. In this instance, however, the sunlight was muted. We did not have any hard contrasts or deep shadows to hide behind, and calls of nature were not part of the drill.

Carmen grabbed a few shots with her still camera. She knew the Taliban had severely punished Afghan women for far less. As we approached the center of town, blue, the proscribed color of all burqas now worn by Afghan women, began to fill the frame. Burqa-covered women were everywhere, faceless and ghostly, moving about the streets from stall to stall buying food and other items. Women of the same family walked together, and many carried babies. A man always accompanied them, unless the women were old. At one corner an old woman in blue sat in squalor with her wrinkled hand extended to passersby for alms. On another street we saw several more old women on their knees digging through garbage.

And then we noticed the men, most with longish beards and the turbans demanded by the Wahhabi interpretation of Islam. Their heads had to be shaved and, as I was told on occasion, so must their pubic areas. Wakil's nephew, Mirwais, once revealed how he was received by the Taliban on a trip to his homeland the year before. A beardless young man who had lived in the States for many years, he had returned to visit his mother-in-law in Jalalabad. Crossing the border at Torqam, the Taliban authorities noticed his scraggly two-week growth, and soldiers with whips beat him for all to see until he fell unconscious. Then they carried him back to the gate and threw him over it so he landed hard on the Pakistani side of the border.

Two policemen were directing traffic at one crowded intersection, but they did not appear armed. They blew their whistles, waved their hands, and took no particular notice of us. The Land Cruiser slowed and pulled to a stop in heavy foot traffic at the next corner. A woman in a burqa holding a small child by the hand suddenly approached the window with her other hand extended. By her

movements we could see that she was old. She walked right up to the curtain and peered inside at the camera lens. Wakil noticed her right away and gunned the engine. Swerving quickly to the opposite side of the street, he almost hit several stalls to get through the pedestrian traffic. A few men stopped what they were doing to watch. Another leaped across a puddle to avoid the splash from our front wheels. He raised his fist. A donkey pushed aside by the bumper brayed at the intrusion. More men turned to eyeball us.

Clear of the town center, Wakil leaned on the pedal and hit the potholes hard as the town slipped behind us. We were now in a race with the clock. A half-hour later, Wakil pointed up ahead to what looked like the remains of a small, bombed-out village. Carmen looked out the window in every direction and then opened her notebook to consult Abdul Malik's location and description of the village where his men had supposedly buried Shapiro's and Lindelof's bodies. Wakil pulled the Land Cruiser off the road and headed for the cover of a large wall that was still standing. Omar's truck was right behind us, and he and Wahid were on the ground checking out the place before we got out of our vehicle. I glanced at Carmen. She seemed deep in thought as she reread Malik's notes and then surveyed the ruins. I said something to her, but she didn't hear me. I flashed to the final scenes of one of Shapiro's favorite films, *The Searchers*, in which John Wayne's Ethan discovers his own soul after searching five long years for his niece, who had been captured by rogue Indians. After eleven years, Carmen was—one way or another—about to unearth the truth of Shapiro's and Lindelof's deaths.

Peter and I followed Carmen's sandaled feet through the eyepieces of our cameras as she walked slowly and carefully through the rubble. The sunlight was bright and high overhead by now, casting little shadow on the ground. She stepped around broken pieces of mud and thatched wall, chards from bowls and plates, a comb that had once run through someone's hair. Then her feet stopped, and her hand reached down to pick up a small rock. Peter panned up to her face as she studied it. Then she looked away as though she heard something, perhaps something that had happened here at this spot years before. The rock seemed indistinguishable from any other she might have

picked up. Peter pulled back to a wide shot of the village ruins. What had hit it? Bombs, mortar, heavy artillery? Wakil stood some hundred feet away from Carmen, respectful of these final few footsteps in her long journey. Khawanee sat on a rock not far away, resting his Kalashnikov across his knees and fingering his prayer beads. He watched Carmen closely. Omar stood off to the side, his weapon small in his hands, his eyes moving back and forth across the landscape looking for trouble. Then Wahid pointed to a distant cliff, and Wakil followed his finger. I tilted my camera up to find what they were looking at, a small group of local women moving along the ridge. They moved in somber fashion one after the other in the heat shimmer as though in a funeral procession, the faint breeze blowing the folds of their clothing in slow motion.

"Like ghosts," said Wakil, breaking the silence. Khawanee turned to watch the procession as well and flipped off the safety on his Kalashnikov. Then he turned back to Carmen as she continued through the rubble.

The ruins were about thirty miles from the village where we had been received so graciously. The place seemed to fit the description that Malik had passed on, but then so did many other places on the map. More important, why had Malik and the survivors chosen to carry the bodies so far from where they had fallen? This part of Malik's story had always seemed strange to me. And added to the struggle of transporting the remains of four men—Shapiro, Lindelof, and the two fallen mujahedin—was the Muslim mandate that the dead must be buried within twenty-four hours of passing. There was no way, in my opinion, that the distance from Jalrez to any point along the border here could have been traversed on foot, horse, or camel within that time. The story never made sense to me. But perhaps logistics had nothing to do with Carmen's search.

Peter and I walked alongside Carmen with our camera as she passed the remains of walls that supported only sky, stairs that disappeared into the ether, and the wreckage of one house after another. And then we saw the startling appearance of green, the color of the Muslim heaven. Grass had grown up anew between the half-standing walls of a small room, amid the dust and dirt all around. Something

that had once lived lay buried here, where long ago it had been re-turned to its elemental ingredients and was now nourishing life in the form of grass. Was it a dog? A donkey? A man in his mid-thirties?

Carmen stopped. She looked down at the grass. Peter and I moved in closer to get better angles with our cameras while trying hard to be quiet. There was only the sound of the breeze and of the stones crunching beneath my own feet. Carmen stepped into the roofless room and sat on what was left of a windowsill. She reached down to touch the grass, caressing it as though petting the fur of a kitten. She lowered her head, and I saw the tears once again in the corners of her eyes. The breeze blew the chadra about her handsome face.

The place was as good as any for Shapiro to be buried, she said; it might not be his grave—probably wasn't—but then that wasn't what she'd been looking for anyway. It was closure, of course, closure on a life and on a personal crusade—both his and hers. And what was left of that crusade for her now or for any of us? What could she carry away from this moment, more than a decade later, in a land strewn with the ruins of three wars, ruled by a force opposed to everything she, Lee Shapiro, and Jim Lindelof had thought worth dying for?

For one thing, she would carry with her the memories of prayer. Five times as day she prayed with the women while Shapiro prayed with the men. These moments became important to each of them, and they shared with each other the thoughts and experiences they had while praying. These moments spent with the Afghan people seemed so pure to her, so unencumbered with the demands of creed and dogma, so universal. Though he had joined the Unification Church, Shapiro was still a Jew, she reminded us again, a Jew who had found himself at ease with a people that other Jews considered their eternal enemy. And when his Jamiat and NIFA escorts had come to learn he was a Jew—his greatest fear—it had endeared him to them even more. They had loved and respected him, even given him the same nickname as that of their greatest commander Massoud, the Lion of Panjshir. Shapiro was the "American Lion."

Carmen knew such ecumenical encounters had come to a halt that very first day of Shapiro's final trip with the soldiers of Gulbuddin

Hekmatyar, a man who had even then professed his hatred of everything born of the West. Did the Soviet paratroopers kill Shapiro and Lindelof as Abdul Malik had haltingly described to the American consulate in Islamabad? Or did the Hezb-i-Islami soldiers themselves kill them in a moment of religious rage? Or had they been caught in a cross fire between Hezb-i-Islami and one of the other tribal factions they despised? More likely, in my opinion, their escorts had sacrificed Shapiro and Lindelof for hard cash near Jalrez, a town known for its conspiracies.

The only thing we saw clearly now was that the struggle for Afghanistan had not been as pure as we had first thought. Our own journey from naïveté to knowledge and finally to awareness had taught us to look beneath the heroic surface of that struggle to the shadow world of outside interests. The courage and nobility of the Afghan warrior was no myth, the enduring strength of its women no fiction, the atrocities perpetrated upon them by the Soviets no exaggeration. And, to be sure, their yet-to-be-told story was no less dramatic or necessary to hear. Hitler, Stalin, and Pol Pot may all be dead and gone, but other such men always wait in those shadows for the chance to reach out and grab the helpless, the weary, the blind, and the lazy.

The Afghans had participated in their own demise. There is vulnerability in the Afghan that one cannot help but notice, hubris that most would agree was not apparent before the civil war. By 1998 the limp was becoming obvious. Was it a permanent injury? As Ahmed Rashid reminds us in *Taliban*, Afghan Islam had always been tolerant and sectarianism was rarely an issue; but perhaps the long list of tribe-against-tribe atrocities has had a terminal effect on Afghan culture. First there was the slaughter perpetrated by Hekmatyar and Dostum on Kabul in 1993; then by Sayyaf's and Massoud's forces upon the Hazaras in 1995; Commander Abdul Malik's massacre of the Taliban in Mazar-i-Sharif in 1997; the Taliban's reprisals on both Hazaras and Uzbeks in 1998; and then Dostum's container truck massacres in 2001. Taken together they have "perhaps . . . irreparably damaged the fabric of the country's national and religious soul." Soul—that's a big word.

In the sixties and early seventies, Afghanistan was the ultimate

"on the road" destination for Western beatniks, hippies, and would-be poets searching for new beliefs, new meaning, and, I might add, hashish. Afghanistan had it all and offered these people a rough-hewn comfort, courtesy, and security found in few other places along that road. But now in its place, we find a profound distrust of those who are not of one's own tribal affiliation, a paranoia that has quickened over the last two decades, a hatred of their Afghan brethren that never existed before the wars, a hatred born not of Islam but of the horrors of those wars. To be sure, the limited resources for life have always been held close to the vest, or hoarded, in this hard land. Now they are held at a sword's point.

# Pakistan, India, and the Bomb

**After returning to Peshawar, Carmen headed back** to New York while we continued our shoot for another few days, along the border and then tracking the Indus River in Pakistan. Since Pakistan had been so pivotal in the recent history of Afghanistan, we wanted to create a film portrait of it as well. We would do this by tracking the Indus River from the mountains to the sea. Pakistan, as we know, was created in 1947 upon the British retreat from India, but the Indus River civilization dates back to 2500 BC.

Ghandi wanted to keep India together after partition, but the country's Muslims, a sizeable population but still a minority, were concerned about a possible backlash against them. Indeed, when India was last an independent country in the eighteenth century, its rulers were Muslim Moghuls who were not always kind to their Hindu subjects. Ghandi understood this fear and suggested, as noted in chapter 7, that the Muslims control the first government of the new India. Even Muhammed Ali Jinnah, the eventual founder of Pakistan, might have gone along with this plan if Nehru had not been vehemently opposed to it. Consequently, at midnight on August 15, 1947, the greatest migration of people in recorded history began as 17 million Muslims and Hindus traded borders amid colossal violence.

Pakistan was established as a country comprised of two sections on either side of Hindu-dominated India, separated from each other by a thousand miles—West Pakistan, which included the capital of Islamabad, and East Pakistan (present-day Bangladesh). Most people today in India and Bangladesh and even some in Pakistan will agree

that history has proved this partitioning was a disastrous idea, especially for Pakistan. In spite of its democratic constitution inspired by Jinnah, its government has been reduced to military dictatorships for most of its brief existence. Besides, it lost its eastern half in a war of attrition in 1971 against the brethren Islamabad referred to as "Hinduized Muslims" and has fought three wars with India, losing each time. Well, what does a country of a hundred-plus million do when it cannot win a traditional-style war against a country with ten times its population as well as a nuclear capability? Build an atomic bomb, of course. And what does the big country do to protect itself from the little country with the bomb? Build a bigger bomb, of course. The nuke race was alive in South Asia. And it could only complicate Pakistan's relationship with Afghanistan.

At a traffic circle in the center of Peshawar stands a monument to Pakistan's defense, a dormant missile. Inscribed on the worn metallic surface in English graffiti is a message: "I want to go to India."

In 1998, Pakistan was still under the confused, though elected, government of Nawaz Sharif, a corrupt leader of such minimal skill and vision that another military coup seemed imminent just to keep the country functioning. The struggle between Sharif and former Prime Minister Benazir Bhutto's Peoples Party was heated, and "democracy" was taken to the streets of Karachi, where the disparate elements of society were still at each other's throats after decades of failed integration. Meanwhile, Abdul Qadeer Khan was hard at work on his uranium enrichment process, which he had pursued since President Zulfiqar Bhutto gave him the secret green light in the late seventies. Everyone in Pakistan knew Khan was working toward building a bomb of some sort, and so did India, which quickly went to work on its own.

I have traveled widely in Pakistan. The ill effects of poor government are obvious, but more disturbing is the rage among the people: Ahmadists against Deobandi Sunnis, all Sunnis against Shias, all of the above against the Sufis, and the indigenous Sindhi population, still at virtual war with the muhajirs, or the new arrivals, and their second- and third-generation offspring. On the streets of Sehwan Sharif, a small city on the Indus in the country's southern quadrant, we filmed as Shias marched down one street and Sunnis marched up another,

each protesting the other. Meanwhile, in the huge mosque sponsored by Benazir Bhutto, strange but benign Sufi rituals were taking place seemingly in defiance of the protesters on the streets. But it's important to note that even in this rather remote region in the spring of 1998, the people were not vilifying Americans. In fact, most people were friendly in an aloof way, and Sehwan Sharif's young chief of police even asked us to ride along with him in his cars to film all the action. But in spite of the welcome being offered Americans and other Westerners who had supported Afghanistan's struggle against the Soviet atheists and in spite of the great energy and determinations of its people, Pakistan as a nation presented a profoundly disturbing reality as a divided country with bad government and an atom bomb.

When we crossed back into Pakistan on May 28, there was a great buzz in the air. We learned Pakistan had just detonated its first atomic bomb in the Chagai Mountains of Baluchistan. People on the streets were wild with glee, and the newspapers boasted that Pakistan had become a nuclear power. It made our last few days of shooting difficult in southern Pakistan, where tempers are always heated. Of course, India had conducted its first tests back in 1974 and had already built up a nuclear armory. But Pakistan, even though everyone knew it had the capability, thanks to A. Q. Khan, had not yet conducted a test.

When we arrived at the airport in New Delhi, India, directly from Karachi, Pakistan, less than a week after the nuclear tests with twenty-one cases of film and sound equipment after a shoot in Islam's "Pure Land," we were not warmly received. As soon as we had passed through the Immigration and Customs areas of the airport, the police detained us, and we waited in a small room for several hours while various intelligence cadres seized and sifted through our equipment. Our life for the next two days would not be unlike what Tom Hanks endured in *The Terminal*. Denied entrance into India we were forced to nap on the floor and eat deplorable fast food, all the while watching an aged police assistant tie our cases one by one with coils of rope and sealing each with hot wax that he dripped slowly and meticulously from a candle. The entire waxing took about twelve hours over two days as the old man moved as though in a Sufi trance. Whenever we

became bored with life in the terminal, we could always sit on the floor and watch him melt wax. My eyes still cross at the memory.

The next morning after a hard night's sleep on the benches, I decided to call the facilitators who were supposed to have met us at customs. We had not heard from or seen them since we'd arrived, in spite of repeating their names and telephone numbers over and over to the Indian police. Searching for a public phone, I pushed my way through the crowds of travelers to the opposite end of the terminal, where I was suddenly caught in a river of humanity all moving in one direction. No matter how I struggled I could not escape the current. Then a gate sign loomed above me, and I can still remember it, gate 29. Pushed through the gate, the crowd carried me toward two large jets sitting on the runway. I struggled even harder, but to no avail, as I was carried up the mobile stairway toward one of the plane's doorways. There at last I found someone who would listen to me in English. I held onto the flight attendant and begged for assistance while the crowd jostled about me for seats. She told me I had boarded a flight for Mecca with several hundred Hajj pilgrims. My struggle back down the stairway required the assistance of several police.

The subcontinent is a vibrant and volatile part of the world. Its people speak other languages and move to other rhythms, but they have their fingers on buttons that could plunge the entire world into war with no help from the West. The struggle for control of Afghanistan meant a great deal to Pakistan; it meant another friendly Muslim neighbor in the region to harass India over the Kashmir problem. And not just any neighbor but one justifiably renowned for its fierce warriors. If Afghanistan slipped from its grasp and slid toward India (which it would do after the Taliban was defeated by U.S. forces in 2001 and early 2002), Pakistan would find itself more isolated. But then, after all, an atomic bomb would be a great equalizer no matter what happened. Whatever vengeance Osama bin Laden had promised to visit upon the West in Khost at the end of May 1998, Pakistan and India would still have to deal with each other.

# Routes of Coincidence

**Just when we think we've identified all those natural** laws that govern our lives in predictable ways and believe we have seen into the heart of universal matter, we encounter challenges to that perception. *Coincidence* is the word we use to describe events or thoughts that have a connection with other events or thoughts that cannot be explained by science. Not so long ago people would have considered these connected events "miraculous." Today we write them off as coincidental, with the word intended to remove any hint of otherworldly origin. I suppose coincidence could describe some of the parallel occurrences in our universe but certainly not all. When Arthur Koestler first published *Roots of Coincidence* in 1972, he was challenging a mindset that wished for simple, secular answers to life's questions, and he ran into considerable resistance to his theories. Science had replaced the concept of prime mover with "big bangs," and according to Karl Marx, Friedrich Engels, and V. I. Lenin, God was dead anyway. But how then, Koestler asked, do we address unconnected parallel events using the scientific method when the results might relegate the possibility of such accidents as one in billions.

Of course, my crew and I were unaware of bin Laden's presence down the road from us in Khost on May 27, 1998, until later, but the fact that his promise to wreak vengeance on the West occurred at the very moment Pakistan conducted its first nuclear tests can hardly be a coincidence. In fact, I would consider it additional evidence of the ISI's collusion with al-Qaeda. Bin Laden chose a spectacular way to send a message to the world's fanatic Muslims that the moment

had finally come to overthrow the infidels. Not only did they have the determination, says the message, but they now had the capability. It still astounds me that no news analyst (of which I'm aware) has blown the whistle on this obvious connection between al-Qaeda and Pakistan's secret police.

In August 1998, two months after our sortie into Afghanistan, I settled into other aspects of my work and left my Afghan crusade, as Hadi had accurately called it, on hold. It was time to make a living again. To that end, I created a TV series that would take me across the length and breadth of Africa as I recounted the adventures of both the first Western explorers to travel there and the great indigenous leaders they encountered: the Stanleys, Livingstones, and Spekes with the Chakas, Mzilikazes, and Kabaregas. The project is of no relevance here, but the coincidence that occurred while shooting it is.

When I set out with three crews to re-create this history in ten African countries, I carried few thoughts of bin Laden, al-Qaeda, or the Taliban. Why should I? We were in sub-Saharan Africa, a long way from South Central Asia. But just as Pacho Lane learned of Shapiro's and Lindelof's deaths as he boarded his plane for Moscow, so we would learn of the U.S. embassy bombings in Kenya and Tanzania as our crews landed in those two countries. They were our first stops in Africa. I had thought I was taking my sixteen-year-old son Ryan on a relatively safe trip to the land of safari, but the first photos he took and sent to his mom revealed the monstrous devastation on the very streets in Nairobi where our outfitters were located. They had been transformed into an area of smoking rubble the size of Ground Zero, where metal and concrete mixed with human flesh, and cranes whined as they struggled to move debris. When we arrived in Dar es Salaam a week later, the smoke and dust had cleared, but the picture was much the same.

Only two months before, I had unwittingly found myself a short ride from Khost while bin Laden was there, promising these strikes. And now here I was in Africa, again unwittingly in his wake. I could, of course, write these circumstances off as coincidences, but if Arthur Koestler were still around, he'd give me a good drubbing. If there was something more to these incidents, as I prefer not to believe, then what

was it all about? This stuff is spooky to consider, especially for some-one raised in a gothic form of Catholicism. Aside from my occasional readings of Jung and his not-quite-a-theory of synchronicity, I chose not to explore the phenomenon further. But years later these events in Khost and Africa still haunt me.

Never one to pass up a good coincidence or story, however, I set out as soon as we arrived in Africa to document events in and around this grim tale of two cities now so mysteriously connected to Khost. What we had learned, well before other journalists arrived on the scene, was that bin Laden had set this plan in motion back in 1994 and 1995 while he was living in Sudan. Many asked, why Africa? Why would he target two countries that were so far removed from Muslim revolutionary causes? We had a few ideas because we had done our homework on African history. From the early eighteenth to the mid-nineteenth centuries, the East African countries of Kenya and Tanzania actually formed the greater part of a large Omani Arab empire. At one point they even defeated the Portuguese to control the east coast of Africa from Somalia to Mozambique, as well as trading routes to the interior. The seat of that power centered in Zanzibar, the island fortress off the coast of Tanzania. From there the Omani sultans presided over a vast, lucrative trade in slaves and ivory that the West would soon covet. And to this day, though the people of East Africa's interior are mostly a mélange of Muslim, Christian, and animist, the coastal areas are solidly Muslim. Swahili, in fact, the language of most of East Africa and much of central Africa as well, is a blend of Bantu and Arabic.

One evening in Zanzibar during that stormy August, as the sun sank into the waters leading to the African mainland, we set up our cameras outside a freshly painted green-and-white mosque. As the faithful arrived for prayers, the men came on foot and bicycle and before entering the mosque, removed their sandals and piled them outside the entrance just as the men do in Pakistan, Afghanistan, and every Muslim land. Inside the mosque, which was illuminated by two lights that we'd brought in with the mullah's tentative agreement, the worshipers knelt at the first call of the muezzin from the nearby mina-ret. When we tried to take the next obvious step and enter the mosque with our cameras, the mullah shouted for us to leave the sacred space

and to film, if we must, through the windows. Then he began the prayers, at first echoing the muezzin but then continuing on long after the minaret call had stopped. Twenty minutes later, with the ablutions and prostrations completed, the mullah raised his eyes and spoke directly to the faithful. I asked, Nasrullah, our tall, black, London-educated translator, what the man was saying.

"Mullah says that if people wish to know the meaning of the bombs in Nairobi and Dar es Salaam they should not read the government newspapers or watch the television of the West, but only look into their own hearts."

I pondered his words a moment and then asked, "And what will they find there?"

"Mullah does not say," he replied.

"OK, but what do you think, Nasrullah? Forget the mullah."

"I am only a translator, sir. I cannot make the mullah say words that he does not say. He says only to look into the heart."

That was the only answer I received, but it was all I needed to understand the thrust of what was being said. The hearts of these people, from Mogadishu to Dar es Salaam, were still Muslim. Perhaps the mullah had not heard that along with the twelve American casualties in Nairobi, 279 Kenyans died and 5,000 were injured. Or perhaps he did know. I believe the important point is that the people of the East African coast are as Sunni Muslim today as they were several hundred years ago. The bombings in Kenya and Tanzania were not random events but purposeful. There were people who follow Shariah tradition there who could and would accept bin Laden's crusade, even if they did not wholly approve of the bombings. But then centuries ago these same folks might not have supported the concept of slavery that the Arabs had brought with them.

In a social, behavioral sense, Islam is the most demanding of all religions. In his everyday actions, a Muslim has no choice but to conform, outwardly, that is. It was meant to be a religion of laws, of behavior, to keep a harsh desert people in line. It does not necessarily encourage reflection, unless a Muslim chooses the Sufi path. Instead, in Sunni Islam a believer is judged by his or her actions and not by what goes on in his head. The Prophet was clear on this point. It was

no accident. The result is that Muslim "true believers" might be better termed "true doers."

After leaving the east coast of Africa, we headed for Uganda to film what remained of the footprints of those early Western explorers who had sought the source of the Nile. John Speke had felt in his gut that it was Lake Victoria while Burton disagreed violently, but Henry Stanley proved Speke right twenty years later. So as we revisited the great controversy of nineteenth-century Europe, on August 20 we stopped and watched the American response to the embassy bombings on a fuzzy television screen with a broken speaker, sipping hot Tusker beers in a restaurant by Lake Victoria. We sat on the outdoor patio along with about twenty silent locals and watched the results of the Cruise missiles that had killed twenty-one suspected "terrorists" in Khost. Khost yet again! Even when the TV had been turned off, none of us spoke. Neither did the locals who kept glancing suspiciously at us. We took our beer to our rooms and climbed under our mosquito nets but not to sleep.

In the heart of central Africa, Islam holds less sway than it does along the coasts, but its influence in certain cities along the old slave routes is still felt. Ujiji, Tanzania, is one of these. The next day as we filmed the remains of an Arab slave market in the city, I caught sight of a popular coffee shop on the main dirt drag. Dozens of customers had gathered around makeshift tables and three-legged chairs, undoubtedly discussing yesterday's events in bin Laden's adopted homeland. Two men were repainting the sign above the entranceway and giving it an inviting new look. They had rechristened it "The Scud Café."

# 32

# *Caravans to Kabul*

**It was 4:00 p.m. on November 20, 2001,** at the Spinghar Hotel in Jalalabad. The ABC crew—JM, Meredith, Fred, Josh, and Bill Roberts—had left four hours before in the motor caravan with twenty or more other journalists, all headed for Kabul. I had stayed behind, taken over the crew's room, and fallen into a deep, gloom-ridden sleep after being up for more than two days. Suddenly I woke up to a great ruckus outside the window from below. Vehicles screeched around the circular driveway, car doors slammed, people shouted in different languages. I leaped from the bed to the window to see what was going on. The caravan to Kabul had returned prematurely, and the journalists and their drivers were running back and forth in a panic. Something was very wrong. I wrestled my way into my shalwar, grabbed my camera, and headed downstairs.

Gazing through the camera's eyepiece, I saw one male journalist trying to comfort a female counterpart who was sobbing between high-pitched screams. I panned over to a panting Latino newsman who was dragging his heavy equipment cases up the concrete steps as if running from thieves. People rushed past on all sides. Outside, a guy was shouting and cursing into his satellite phone, trying to position the antenna at the same time. I remember few words being spoken, mostly just stunned, frightened faces. A French reporter was the first to tell me what happened, or what seemed to have happened.

Clearly no one knew exactly what had happened, but it seemed men with automatic weapons had stopped the lead vehicle of the caravan in a canyon. They were just off the Kabul River at the Silk Gorge

near a small village called Ushmen Tangi about seventy miles north of Jalalabad.

"The occupants were dragged from the car," said one journalist.

"No, they were forced at gunpoint," interrupted another, "and led off the road and into the rocks."

Someone else said he'd seen the men throw large stones at the victims while another said he'd heard shots. Still another thought he saw them being beaten with sticks or clubs.

"Did anyone see it clearly?"

"Yeah," one guy said, "it was the second car they hit. Or was it the third?"

"How many were taken by the marauders, four?"

"No, six."

"The attackers were Arabs," offered one American who'd been far back in the caravan. "I heard them shouting with Arab accents."

"What were they speaking? Farsi, Pashto, Urdu, English?"

"A mixture," he replied.

"A mixture? What were they wearing?"

"Camouflage clothes," said one.

"Shalwars," said another.

Only one thing for certain struck me at the moment: the attack might never have happened if the convoy had had a military escort.

As any journalist can tell you, panic can cause people to act out of character or perhaps very much in that hidden character some suppress or repress. Outgoing, outspoken people go silent. Quiet, reflective folks cannot stop talking, or even screaming, telling you exactly what happened over and over again. The reactions here were not particularly unusual, except this time the people who usually ask the questions and write the story were the victims and part of the story. As for myself, here in part to complete a film about two journalists who were murdered in Afghanistan fourteen years earlier, the confused facts and contradictory statements carried me back to earlier conflicts. A personal fear was creeping in, not of al-Qaeda killers, but of losing touch with the unintelligible reality around me. Though many of them appeared quite unseasoned, these people were journalists just as I was, but they had all lost the cool, almost arrogant confidence with which

they had carried themselves only a few hours before. Now they were terrified. Seeing my own kind in such a state messed with my head. My camera was on, my hands steady, and my framing good, but the images flickered before my eye the way I remember old, silent black-and-white movies did when I was a kid. I was watching everything as if through some kind of veil that removed me from any connection to these events and any control I could have over them. That was the bugbear—the issue of control, or should I say the illusion of control.

I saw Doug, the ABC coordinator, and tried to talk to him, but he didn't seem to see me. Neither did JM, the worldly-wise, savvy correspondent, who sat in a dark corner of the lobby and stared at a replay of his last night's standup news report. Meredith, the ABC producer, kept her wide, bloodshot eyes on the road to the north, as if expecting the attackers to appear at the Spinghar any second. Then I caught a glimpse of myself in one of the tall lobby mirrors, this white-bearded American dressed as Aladdin filming himself. The scene was shades of Jack Nicholson's character in *The Passenger*, deep in the Sahara trying to change his journalist's identity. While all the other journalists were wearing the same Western garb—jeans, T-shirts, Banana Republic–style vests, and even a few backward baseball caps—here I was, dressed as one of the locals or the attackers. Worse, I was the only one filming this scene, the only one who even thought to turn on his camera in such a vulnerable and candid moment. What exactly was I doing and why? Whose side was I on anyway? I glimpsed at the mirror again. Had I really lost touch? Had my media training become irrelevant? Had my instincts become all that unfashionable? Maybe my former soundman and buddy, Dan Devaney, who'd taken the first fifteen trips across the Afghan border with me but had refused to join me on this last one, had it right. I was getting too old for this shit!

After all, our Afghan footage still had no broadcaster. Yet broadcasters had cared enough about our other shows—when we'd snuck into Castro's Cuba on shrimp boats, when we'd shot the war in Nicaragua from both sides, when we'd filmed the effort to save the black rhino from poachers in Zimbabwe, when we'd told the stories of cannibals in New Guinea, headhunters in Peru, octogenarian expatriate artists in Paris—to run them at peak times. They had even liked the

strange one about the scientists who thought they may have found Noah's Ark. They'd even honored a few of these projects with nice awards. But no one in the broadcasting community had ever given spit for our footage of the gaunt guys wearing blankets and chitrali beanies, even though we had filmed them fighting our Cold War for us, and then, God help us, fighting each other. Maybe the networks were right. God protect America from such nuts! Maybe I had missed something?

I continued to film my colleagues and was rolling camera when two Land Cruisers arrived with mounted recoilless rifles and a dozen mujahedin bearing Kalashnikovs. As the commander got out to talk with a few of the convoy drivers, I recognized one of the soldiers from Haji Zaman's compound. I sidled up to his truck with a smile and a wordless request: Can I join you? Can I get in your car and go with you? He smiled, tapped the driver on the shoulder, and gestured for me to get in. I could feel all eyes upon me as I climbed into the back seat and chatted with the driver in bad Dari, not wanting to acknowledge the sudden silence.

Then two other guys jumped in beside me: Altaf, a friendly German reporter who had worked on *Behind the Veil,* the short documentary that stunned the West with its scene of the Taliban executing a woman in a soccer field; and Louis, a veteran French correspondent for the newspaper *Figaro.* Before long, a man in his mid-thirties with a neatly trimmed beard, white shirt, and crisp British accent poked his head in the window. He glared at the two other guys as though I was invisible and shouted at them in righteous rage. "Shame on you! Shame on you for taking seats from soldiers who might be able to help our colleagues. Shame! Shame! Shame!" At this the two Europeans looked at each other and started to get out. Not knowing why—perhaps not wanting to be alone in all that shame—I tugged at their vests. They turned to me, paused a moment, and sat back down. The driver gunned the engine, and the Land Cruiser peeled out in a cloud of dust. As I filmed the receding crowd through the side view mirror, I saw Meredith and Doug staring at us.

There were three vehicles in our caravan: one Land Cruiser with the three of us, the driver, and two mujahedin, and two Toyota

pickups, one fore and one aft, with about twelve soldiers altogether. A Japanese cameraman with the latest-model Sony digital camera bounced along in one of the open truck beds with the soldiers. I was relieved that the state-of-the-art Japanese video equipment came with a Japanese operator up to its challenge, but I was also a little jealous. I was stuck with only a three-chip Sony mini DV camera.

The road from Jalalabad to Kabul begins like any two-lane blacktop in rural America, but within twenty miles it disintegrates into dust and potholes. Probably the asphalt had been so obliterated the Taliban had gotten only as far as removing the remains of the last layer of road, the first step in highway rehabilitation here. Certainly it had not progressed as far as the segment between Torqam and Jalalabad.

The two journalists with me were a bit broad in the beam, so the three of us more or less sat on each other as we hit the bumps. The French reporter sat in the middle, and his head frequently hit the roof as he balanced his laptop on his knees and somehow managed to type. Impressed, I studied his technique, which required great patience. He punched one key at a time between potholes, actually having divined a rhythm in the chaos. The German fellow was an interesting and friendly type who was quite familiar with the region. With all the babble in German, French, English, rudimentary Dari, and the music on the driver's tape deck, we rarely understood each other and mostly just smiled and nodded.

The music was loud and appropriate, like Willie and Waylon if you were traveling across the Texas or Arizona wastelands. The singer was Yusuf Islam, formerly Cat Stevens of "Peace Train" fame, who had embraced the Muslim faith twenty-four years earlier and given up his Western music career. But even without musical instruments (a taboo for certain Muslim sects), the vocal melody and harmonies revealed the same talent that he had displayed with guitars, bass, and drums in the early seventies. Listening to the music carried me along in my time warp of "Hell-no-we-won't-go" songfests, Merle Haggard's "he [Nixon] lied to us all on TV," acid trips, Fonda's hips, Ali's quips, dead soldiers, dead presidents, dead students, dead journalists, and now dead journalists again. And I began to question why I was here again—this hard place where I had come of age—after all these years.

To find out more about Lee Shapiro? Yeah! To document the terrible legacy of the Soviet invasion and the Afghan civil war? Of course! To clear up the mystery of the Taliban's rise to power and learn more about the man who had brought down the Twin Towers? Of course again. OK, but is that all? No, I knew it wasn't as simple as a Hollywood plot anymore. I realized that while I had been privileged to observe each new chapter in Afghanistan as it happened and to observe it from ground level, I had not really understood it. I had ducked most of the shadows until they had shoved their opaque faces into mine. Now at last I was beginning to appreciate what I had experienced. There was yet hope that I might survive my innocence and face all the truths of this place.

Along with thousands of other men my age, I had managed to escape the Vietnam-era draft. No, I didn't grow facial hair that I never brushed or piss in pants that I slept in to escape induction. I had already had a couple of kids by then, and fatherhood together with poor eyesight gave me a draft deferment. I didn't believe in that war, but I was uncomfortable about avoiding it. I knew then that other choices were available, but I didn't dwell on them. Though I didn't realize it at the time, I came to see myself as Joseph Conrad's Lord Jim, who leaped from the gunwales of the ship *Patna* as it was supposedly sinking with hundreds of sleeping passengers on board. Unfortunately for Jim and the crewmen who bailed, the ship limped into port ahead of the crew's lifeboat! Conrad's Jim never received another vessel or an easy chance for redemption. I would be more fortunate. Other battlefields would await me so that I might regain what my unconscious mind insisted I'd lost. This might explain why I became hooked on Afghanistan in the first place, but it's not what has kept me coming back.

About an hour and a half later, I was jostled from my ruminations as the dirt road from Jalalabad began tracking the Kabul River. The sun was sinking low, and the stark landscape was taking on an ancient, Biblical hue. I wasn't sure if I was seeing actual things in the countryside or if they were heat mirages. Just as in John Huston's *The Bible*, when John the Baptist crosses the stone desert and dissolves into the shimmer, I could make out an occasional ragged tent strung on poles, a grazing camel or two, and ruins that resembled ancient Judea

except for the Soviet tank carcasses. We passed ragged kids shepherding goats, women in burqas running from the road but glancing back over their shoulders to check us out, and tall, thin men wearing blankets and pancake beanies who gave us the Afghan "evil eye." A stray bullet apperently kicked up dust in the road behind us and sent the guys in the rear truck off road briefly to search for phantom gunmen. The shadows are dangerous here in this land of fast-setting suns. The landscape was beginning to lose its blue periphery and was becoming as undefined in the purple haze as an impressionist painting.

One thing was clear: the groups of long beards sitting on the rooftops with their weapons in hand hadn't yet gotten word of the U.S. bombing of Taliban headquarters in Jalalabad. This area had been Taliban country a week ago, and it was still Taliban country now.

Our drivers stopped the few vehicles coming from the opposite direction to ask if they'd seen the journalists. No one had (or chose to say they had) until one cab driver we encountered in the last, dusty light said he'd seen them, about five miles up ahead in a canyon, lying beside the road. We asked him whether they were alive or dead. They weren't moving, he said.

A few miles farther, without warning, our drivers pulled off the road at a mud building where several larger, funky rigs were parked. The Ramadan sun had set, and our men wanted to break their fast as soon as possible, although our grim destination was just around the corner. Altaf, Louis, and I followed them into the café, where the Japanese cameraman was already filming. I was pissed at myself for not filming there alongside him, but I relaxed knowing he was considerably younger than I and quicker on his feet. Besides, he had an onboard camera light that would permit him a decent exposure in the dark place.

The crowd inside took notice of our presence, though no one stood to welcome us. We were shown a place on the floor beside a dozen other truckers who were seated cross-legged at the long kilim that served as the dinner table. Several gas lanterns hissed, producing harsh, white light where the beams hit and impenetrable shadows where they didn't. The black metal weapons stood out in silhouettes. One of the lanterns faced me directly and created a visual white noise to accompany the two transistor radios playing at speaker-cracking

volume, one in Urdu from Pakistan, the other in English from the BBC. Several dozen local men sat cross-legged, talking and laughing with each other as they sipped tea and watched us, their Kalashnikovs on the floor in front of them. Everyone seemed friendly enough—that is, they smiled—and in short order our naan and tea was delivered followed by plates of traditional mutton stew, which we scooped up with naan and fingers.

Suddenly, a local mujahedin commander burst into the café and, in an authoritative manner, sought out our commander. All eyes followed him, and the Japanese cameraman moved to cover the exchange, knowing something was afoot. I rose from the floor, searched out our driver, and had him unlock the truck so I could get my own camera. When I came back in, looking through the lens, I saw the mood in the place had changed. Altaf had joined the two commanders, and they were discussing the situation. His face had tightened, and his eyes darted nervously around the room, belying his smile. He turned to me and said in halting English, "This commander is from here, and says we must go back now and stop looking for the journalists. They are dead. The canyon is narrow and there are many men shooting down from up high." The local chief interrupted adding a final thought that the German quickly translated. "And he says there are men here in this café who will kill us too. He says we should go. The quicker the better!"

As I panned around the room, I saw many of the younger men and boys had pulled in close. One boy stood right in front of the lens and smiled, blocking my shot. Then another kid joined him and waved at me. "Photo me!" he shouted. "Photo me now!" It was more an order than a request. Others who had been eating dinner or drinking tea had come to their feet and gathered around us as well, weapons in hand. Everybody was getting very friendly, smiles all around. Our mujahedin driver tugged at my arm, winked, and headed for the door. With my eye to the camera, I turned and followed him. As I passed through the doorway, the lens collided with someone coming the other way, and I felt fingers inside my vest near my wallet. I lowered the camera and grabbed with my free hand for the stranger's hand. It withdrew into the dark chaos, leaving the wallet, but my confidence had been stolen along with—finally—my naïve, all encompassing belief in the honor

and integrity of the Afghan warrior. I tripped over several feet, stumbled out the door, and fell on my knees. A young man standing in front with a grenade launcher on his shoulder found it very funny. So did several black-turbaned men behind me. Within seconds I had followed our crew across the dirt parking lot and jumped into our Land Cruiser as it roared off from the café with the door still open.

When we arrived back at the hotel later that night, all the other journalists were anxious to hear what we'd found. Lights were on everywhere—lights for correspondent stand-uppers; lights on the big satellite uplink being built in the front garden; and lights to illuminate workspaces, repair decks, satellite phones, and the lighting process itself. Understandably the media army swarmed over us grasping at any new bit of information that might be useful in their pieces. Being made of shark cartilage ourselves, my two colleagues and I understood the feeding frenzy, its style, focus, and duration. The ABC crew of Meredith, Fred, Josh, Doug, Bill, and JM were there as well, though we avoided each other. I was relieved to see that their camera was at last out of its case and rolling.

Everyone was focused that night, all their antennae out, cigarettes, coffee, and scotch fueling the rush. Trash piled up in public places as did people, dozing on assorted blankets and seat cushions. And there was even less room at the inn than before for not only had the Kabul "death caravan" returned but another caravan, unaware of what had happened, had arrived from Peshawar with a large and confused British crew. There was even word that Geraldo Rivera had been on his way, but he had stopped to buy a brace of pistols. Journalists laid claim to certain sections of floor to define their workshops. The Spinghar was becoming a living entity, a refuge comparable to other media havens of the past: Hotel Nacional in Havana, the Managua Hilton, the Palestine Hotel in Baghdad. These lodgings were not just places to sleep and eat but bases in which to live your life.

I still had the key to the room that ABC had given up, and no hangdog look from that crew was going to coax me into giving it back. At last, Fred and Josh asked if I was using the other bed in the room. Of course I wasn't and wondered which of them would be my company that night. Neither, it turned out, as they carried the mattress

and box spring out into the hall to share with their mates. I began to feel isolated among my own kind. Maybe I should get my own Yankees cap and wear it backward.

Later in my room, I lay down on the bare mattress, pulled the moth-eaten blanket over my head, and wrestled with the idea of sleep. On the patio outside my window, someone had set up another satellite uplink, and news teams were buying their time on it for their nightly recaps. Their work lights were aimed in my direction. With more white light and white noise, I slipped in and out of consciousness for an hour or more while listening to JM do his piece. Correspondents, producers, and camera teams all love the "stand-upper," because they don't have to go wherever someone's been killed or, God forbid, look for the killers. Success depends on the credibility of the guy on the TV screen. They know they've done their job when the talent stands in front of the camera and tells the world what happened. It's especially effective when he is actually in the general region when he shoots the piece and can work in that over-the-shoulder glance at the identifiable landmark in the background. Even a misplaced clown such as Geraldo can turn this technique into high art. I finally went to sleep with the lights in my face and JM recounting for me what I'd seen and heard in his savvy, soothing way.

# 33

## *Tora Bora*

**The next morning I did my best to wash away** the events of
the day before with a cold shower. During the scrub, I noticed how
strangely the shower had been constructed and how the shower stream
hit the built-in wood cabinets head on, warping the doors. And the
rising water, blocked by a long-clogged drain, had eaten away the entire
lower part of the cabinet. The shower and the room were completely
out of synch with each other. Why, I wondered, would someone have
constructed something to malfunction? I figured this Afghan design
must have some deeper symbolism to it, perhaps for me personally,
but I chased it from my mind.

Downstairs, the hotel's lobby, hallways, and front steps were
filled with the same confused and frightened people. They wandered
around, looking more like refugees than journalists. Disturbing new
rumors alleged that al-Qaeda was going to target the Spinghar itself,
which would have been an obvious thing to do. I interviewed numer-
ous reporters and found out most were determined to find a way back
to Pakistan. A few were planning to hide out in their rooms until their
employers sent in helicopters to rescue them. The ABC team had made
up its mind to return to Peshawar in the next armed convoy. The bot-
tom line was no one was filming anything around Jalalabad, and most
of them just wanted to drink; however, they'd run out of their scotch
or bourbon and were now inquiring about the local hash.

But what about the missing journalists? Were they still lying
wounded and helpless alongside the road, or were they, as I thought,
dead? No one knew any more about the situation that morning, but
now they suspected the worst. The information void, the confusion,

and the panic became stifling. Leaving the hotel, everyone said, was suicide, but the place was becoming weird and claustrophobic so I had to chance it. I found Wakil's lieutenant, Ahmet, who introduced me to Lal, a tall, handsome, but formidable-looking guy in his mid-thirties with a permanent scowl tattooed across his face. Lal seemed as if he had just stepped out of a Taliban uniform, but Ahmet said he had recently been the principal of the Girls Academy in Peshawar.

Lal spoke great English. He asked, "How much are you prepared to pay me?" When I explained Wakil had been making all my arrangements, he hinted at a smile. "But, my friend," he said, "Wakil is in Peshawar and you are here." I liked his directness. "Where are the Arabs?"

"In Tora Bora," he replied. "Tora Bora, of course!"

He agreed to take me there but revealed to me that the local government considered it off-limits, so we'd have to stop at his village outside town and pick up a couple of mujahedin friends with Kalashnikovs. Unfortunately, we'd also have to sneak around on foot behind the military checkpoint at the edge of town while our Land Cruiser created a diversion in front of the checkpoint. Nevertheless, I should wrap myself head to toe in a blanket (in the hot sun) to be safe. We would all meet a few miles down the road at his village. It was standard Afghan operating procedure.

Back then, the name "Tora Bora" called to mind a South Sea paradise, which I knew it wasn't. I'd never heard of it, but Lal said it had plenty of caves and tunnels in which the Taliban and al-Qaeda were hiding, tunnels that the CIA and the Saudis had helped the mujahedin build back in the eighties during their war with the Soviets. When I asked him how we would get there and back with our heads he explained that we would pick up a commander who not only knew the region but had family in Tora Bora. But was I up for it? he asked. I wasn't sure, but I said yes.

Several hours later found us in two Land Cruisers, approaching some very harsh, barren mountains. We had gone as far as we could by car, and we would have to walk the rest of the way. I asked how far was it. Not very, said Lal. Two hours after we'd crossed through those first peaks we were still hiking. Stupidly, I had worn my local

ill-fitting sandals instead of my Nike sneakers, and my feet stumbled through the loose stones. We reached a stream that Lal and his friends crossed easily on a narrow log they'd slung across, but I was feeling so wobbly, I chose to walk through the water rather than risk falling off the log. It was embarrassing, but I figured what the heck. Lal saw my difficulty and offered to carry the camera bag. My pride rose in my throat but I swallowed it. These were tough Afghans, after all, and Lal was already referring to me as his "elder brother."

On my first trip here in 1986, I'd met an elderly journalist named Arthur Bonner. At sixty-eight years of age, he seemed quite old to me at the time, and I was very impressed by his habit of heading inside for weeks at a time with only his camera and his sleeping bag. His hair was white and he was beginning to stoop, and here I was catching up, at least with the hair. I didn't like to dwell on how much time had passed but I'd been on the trail here doing the same thing he'd been doing for quite a while. Arthur had told me the Afghans were great folks, as long as you kept away from their politics. I never understood what he had meant because I'd never met an Afghan from whom I could separate his politics. When I last spoke with Arthur in 1989, he tried to convince me to accompany him and film the final days of the thirty-year-old war in Eritrea against Ethiopia. The only hitch, he said, was that the Eritreans conducted their operations at night, and during the day they stayed underground in tunnels similar to those I was now hearing about in Tora Bora. Thirty years in tunnels! I found the idea of living underground even for a few weeks appalling, and I think Arthur wrote me off as a weekend warrior. Compared to him, I am. But at twenty-two years and counting, the Afghan conflict was approaching the Eritrean conflict in duration.

We passed through a small village that looked as ancient as anything I'd seen in the Middle East. The commander schmoozed with the people. When he asked if any Arabs were around, the villagers looked nervously at each other. There had been, they said, but they had left. Lal winked at me as he talked with them. I figured I knew what he meant, and when we were outside the village, I suggested that from then on we should say I was French. Lal laughed, "You are a

big tall American with blue eyes. Arabs are not stupid. They know you are not from France! Besides, al-Qaeda kills French people too!"

I began to question the wisdom of this Tora Bora jaunt. If I'd thought it was dumb for the journalists' caravan to head to Kabul without a military escort, then what was I doing? If I'd thought that Shapiro was dumb for rushing to judgment and going inside in May 1987 with such a proven scoundrel as Hekmatyar, then why was I walking into the lion's den? Life was a mixed bag, I guessed, and I was probably as dumb as anybody. But at least I had a few hired guns with me and a guy who knew the area. Besides, if the Arabs were hiding here, Lal had assured me, they had every intention of remaining hidden. Shooting a stray American and alerting the rest of the Western media to their hideout would not be smart. That's what I kept telling myself, and though there was truth in it, it wasn't working all that well in keeping me calm.

We reached the final approach to the mountaintop, where one of the al-Qaeda hideaways was supposedly located. I found my lungs giving out as much from fear as from fatigue. I had to sit and rest. Catching my breath, I asked Lal what might happen if there were Arabs at the hideaway.

He smiled wisely. "They will shoot you, of course, and then they will shoot the rest of us." He laughed and asked, "Are you ready to 'shoot' them first with your camera?"

The commander, whom I had not noticed had only one hand, suddenly shoved his stump in my face as though he were interviewing me. "Is your microphone ready?" he asked. The commander laughed. Lal laughed harder. His two mujahedin friends laughed as well. Finally I laughed. This kind of irreverence in the face of trouble is what some of us love about the Afghans. It gave me a jolt of crazy energy, and I climbed back to my feet.

We reached the crest of the ridge and found the remains of a mud building that housed a pile of used tires. What supervehicle, I wondered, could have negotiated these hills? In the center of the small plateau stood a traditional, Arab tent-pole structure, devoid of its canvas. When Lal saw it, his brow furrowed deeper. Nearby on the sides of the crest we found about ten shallow tunnels, all intact and filled with military supplies. Except for the wind it was silent. We were

high up here, maybe 8,000 feet, with a clear view of the world for miles around. Conversely, it offered a good view of us to whoever was out there.

I filmed the tunnels and their contents—boots, food tins, water jugs, jerry cans, and live ammo—from outside. I chose not to step inside, remembering too well those few close calls in Jalalabad years before. Especially memorable was the time I'd almost picked up a sparkling silver spoon that beckoned me, sticking straight up in the ground with its handle buried and attached to an explosive. Booby traps, by definition, are where people do not expect them and often where they do. But these tunnels had the definite look of being well-stocked and lived in.

Suddenly we heard a dog bark. Lal tracked the barking to an outcrop of rocks, where a nursing mother dog growled fiercely in protection of her no-more-than-days-old pups. What were domestic canines doing on this windswept mountaintop, where not a blade of grass grew? The message was clear: men had been living here until very recently.

"It's time to go," Lal declared abruptly. The one-handed commander nodded his agreement as he scanned the adjacent hills with a taut expression on his once jovial face. I was certainly ready.

"Walk in front of us down the hill," Lal instructed, "but not too far in front." With disturbing images of the back of my head in the crosshairs of telescopic sights, I was happy to be leaving Tora Bora. As we descended the mountain, Lal and the others pushed up the pace behind me. I could feel the tension in their silence. On the way up the hill they had been chatting nonstop, but now I could almost hear their thoughts. The sun was sinking low in the mountains far across the plain, and long shadows began stretching out across the parched, rocky earth. I wanted to break into a run, which, of course, would have been stupid. But I wanted to feel my legs moving in great, quick strides beneath me and the wind against my face the way it did when I was a child, running through fields and forests to escape imagined monsters.

As we made our way back across the hills in the fading light, I recalled when I was eight years old growing up in rural Maryland and my dad would take me on hikes into the forest behind the cornfields. Our destination was the Boy Scout camp where Dad said the

more advanced Scouts and their leaders came to overnight in a primitive environment. While they left lean-tos and tent poles standing for the next brave, young souls who would spend a sleepless night with hooting owls and screeching cats, it had little else of prearranged comfort. I loved visiting the Scout camp, wandering through the loblolly pine clearing and imagining myself one day as a Scout. I think Dad realized this camp was as close to a sacred place as there would ever be for me. I regarded it then as far holier than church, which, to be frank, scared the heck out of me with all the devil talk. Hell and damnation were real places and situations I had already internalized at that young age. I could see them quite clearly in my mind's eye and could even hear the gnashing of teeth.

On one of these treks in late spring of the late 1940s, Dad and I came across a huge snake's skin along the path just outside the camp. It stretched at least seven or eight feet long. Dad moved the snakeskin into the bushes with the hiking stick he always carried, and we kept going. Of course even at eight, I was aware of the serpent's significance in Catholic teachings. Was the snake not the devil itself in the Garden of Eden? Didn't all the statues of the Blessed Virgin Mary have her crushing the head of a serpent beneath her foot while she held baby Jesus in her arms? The snakeskin spooked me so much that I had recurring dreams about the snake returning to claim its outer layer. Snake devils, crow devils, and fly devils (all Beelzebub, of course) began to torture me while awake and asleep, so I made up my mind the snakeskin was not going to get me.

One summer sunset a few months later I looked out across the hazy cornfields to the dark forest and made my decision. I waited a few more minutes, until the twilight had arrived and the sounds of the Chesapeake night had settled in. Then I took off at full throttle down the path that led to the Scout camp a mile away in a race with my terror. Through the cornfields, past the Halloween Tree where the crows waited (but not looking up at them), and leaping from stone to stone across the stream, I could hear the frogs now. Pretty soon I'd hear the owls, and that would be really scary. Three-quarters of a mile into the race and not tiring I could see the last bend in the path before the camp. Would the snakeskin have returned, or worse, would I

encounter the snake itself? I jumped across the very spot where the skin had lain months before and continued into the camp. There I turned on a dime and tore off back toward home. I remember running so fast I felt as if I were flying, almost as though I'd been joined by some magical wind that was lifting me just off the ground. When I got home, wheezing and coughing, it was quite dark but I had outrun the snakeskin, for a while at least.

The long shadows stretching slowly out across the arid, flat landscape below Tora Bora reminded me of snakes, and I began leaping across them as I would have leaped across the snakeskin. It's curious how adult fears can often take the form of childhood goblins in our minds. In a sense, the al-Qaeda operatives behaved for me as poisonous serpents, hiding in the grass or among the rocks waiting for the moment to strike a lethal blow at the unwary. Later evidence showed that about 3,000 al-Qaeda were in the area of Tora Bora at the moment I was there, and we would have stood little chance had they decided to attack us. Though the United States had sporadically bombed Tora Bora in the weeks before Lal and I had ventured to the region, there had as yet been no concerted U.S. military effort there against al-Qaeda. According to several mujahedin commanders who had been keeping their eyes on the mountains, some of the Arab forces from other points had not yet gathered there for the final battle. By the first week in December, however, new rumor had it that al-Qaeda forces had swollen to over 5,000 and would make their last stand at Tora Bora. That battle between the tough Arab fighters and the half-hearted mujahedin under Hazrat Ali and Haji Zaman would begin in earnest on December 7, 2001, while for whatever reason the U.S. forces would mostly just observe. When the dust cleared, most of the surviving al-Qaeda forces had slipped across the porous border with Pakistan.

Is there any hard proof that bin Laden had been at Tora Bora with the Arabs? Intelligence sources alleged they had intercepted his voice on radios and satellite phones directing the operation. Using such a phone bin Laden had reportedly orchestrated the attacks on the Twin Towers and the Pentagon from 12,000 miles away.

But I'm getting ahead of the story that would soon be played out in Jalalabad.

# Kill the Messengers

**When we arrived back at the Spinghar from Tora Bora** late that night, the al-Qaeda rumors had taken on more immediacy. Bin Laden, they said, was now offering $100,000 for the head of any Western journalist. The panic had escalated.

"Maybe he'll bomb the hotel," one reporter moaned.

"Maybe he'll pick us off one by one with snipers," said another.

When I asked where they had heard about the reward money, someone said, "On television." I was confused. Weren't we the television here?

Two women moved through the lobby, spreading word of an emergency meeting. About thirty journalists gathered around the long table in the hotel's conference room to discuss the situation. People wondered what to do about their fallen comrades, about whom there was still no definitive news. Then they wondered what they should do to help themselves. I looked around and saw only one camera rolling, and it was in the hands of that Japanese guy (whose name I still don't know). I found a seat that commanded a good view and began shooting, trying like hell to be discreet. I wanted no more "shame" heaped upon my head by the tall, tweedy Brit, who sat at the other end of the table. The group talked, exchanged information, and shared their fears. It was good, supportive kind of stuff folks might say at an Alcoholics Anonymous meeting, but no one made any decisions.

I remember being bothered by one young American journalist with a gold ring in his ear and short hair fashionably laced with gel to give it that cornstalk-in-August look. He had his Dodgers baseball cap

on the table in front of him. He pronounced Kabul as "Kabool," Peshawar as "Pesha-*war*," and mujahedin as "mujadin," leaving out an entire syllable, and used all three in the same sentence! This guy was not going to inspire confidence in the local Afghan community and get at the facts. Without any information beyond what our foray to Ushmen Tangi the day before had furnished, the general consensus was that the four colleagues were dead and it was time to leave town.

After the meeting Lal insisted on taking me for a short walk from the hotel so he could show me something. Behaving almost secretively, he wouldn't say what it was, only that it was important. We walked past some bomb ruins onto a debris-ridden field, where about ten young boys in rags were playing soccer.

"There," he said pointing at the kids, "what do you see?"

After pausing to see if my eyes had missed anything, I replied, "I see children playing in the ruins."

"Do they look happy and healthy?"

I wasn't sure about the healthy part but I agreed on the happy.

"There," he said, "is the hope of our country—children who can still have joy, even in the horror, building goal nets out of broken metal and thorn wire. Why don't you take pictures of things like this instead of just bombs and dead people?"

I stood looking at these poor kids, playing with all the heart and soul of kids anywhere. If I'd had my camera with me, I would, of course, have filmed them. Then from the corner of my eye I noticed several men busy on the other side of the field. Two Afghans were digging a hole and piling up the dirt in a ridge in front of it. Then a correspondent, whom I recognized immediately but who was oblivious to my presence since I was dressed in local garb, waved off the diggers and directed the man holding the video camera to get down into the hole. Then he gestured impatiently for the other two men to leave the scene while he walked some distance away from the hole and waited for a signal. When the cameraman raised his hand, the correspondent ran back to the excavation and threw himself over the ridge. After a moment, he turned to peek back over the dirt and then ducked back down as though bullets were flying. The cameraman gave him a big thumbs up.

Lal had been watching the scene as well. "Isn't he one of your newspeople? Haven't I seen him on television?"

I nodded and turned away in embarrassment. Though the public may not care to hear it, reenactments are not uncommon in the news media. Usually they have to do with actual scenes or shots the cameraman may have missed the first time, and a second take is needed to make sense of the moment. But this total battleground fabrication in a soccer field where children were playing turned my insides. If I'd had my camera with me, I might have become a rich man.

Back at the hotel, Lal got word that Haji Zaman's troops had found the journalists, indeed dead, and they were returning with the bodies to the Jalalabad hospital. Without drawing the attention of the others, we left the hotel grounds and hailed a rickshaw on the main road. At the hospital, Lal managed to talk our way into the morgue. An ambulance and several trucks pulled up a few minutes later, and the corpses in heavy wooden boxes were unloaded and carried through the emergency room doors and down the long dark corridor to the refrigeration chamber.

In the cold, white room, an attendant opened one of the caskets, perhaps to verify the contents. I wished he hadn't. Though her white, silent face was bruised and cut and a small hole revealed where the bullet entered her forehead to explode the back of her skull, I could see that Maria Cutuli (*Corriere della Sera,* Milan) had been a nice-looking woman. I stepped back awkwardly as the attendants slid the heavy coffins into separate vaults. After the attendants left the room, I stay-ed to film in the icy silence the closed doors of the great white freezer, the water on the concrete floor now mixed with blood, a boot lying in a puddle.

Here were three Western journalists—Harry Burton, Julio Fuentes, and Ms. Cutuli—and one Afghan-born photographer, Azizullah Haidari. These three men and one woman had all been brutally beaten and then shot repeatedly in the head and chest. They had died just as so many other journalists had in this land during the Soviet war, though often without the benefit of coffins or ID tags attached to their remains. These latest unfortunates were symbols of things gone terribly wrong—gone wrong not only in Afghanistan, New York, and Washington, but in network news and perhaps journalism in general. While the world

was just beginning to recognize the new ferment and focus within Islam, I was witnessing the exact opposite in the way the media was covering and reporting world events. Were these four folks too brave? Were they not seasoned enough to know that journalists always traveled with armed escorts in Afghanistan? Were they left to their own devices by an unconcerned U.S. military? Were they disconnected from political and cultural realities? Were they improperly trained by the latest corporate news culture in what every journalist had once known was a soul-searching, dangerous job for which each had to be prepared?

And what about Lee Shapiro? His material on Afghanistan received no notice from the networks in 1986 and 1987. Critics could say with twenty-twenty hindsight that Shapiro and his soundman, Lindelof, were busy shooting stuff the networks would never have commissioned and, worse, would never have bought or broadcast anyway. They wouldn't air it today, either, not even as a "history piece" because it's "dated." They'll tell you that was yesterday's war! Then by definition it should be considered history, but broadcasters will say it's still too new, too murky. Never mind it had once been "today's war," at that time they considered Afghanistan irrelevant in the grand scheme of world affairs.

This circular thinking is maddening. So in 2001 what was it that made Iraq and Afghanistan all of a sudden so relevant that the networks would send journalists into harm's way? Was it simply that thousands of Americans and others died in New York, Pennsylvania, and Virginia? Only then did Kabul and Baghdad become top news stories.

Think about it. Among others, the CIA once backed the mujahedin to fight the Soviets during the Cold War. It worked hand in hand with bin Laden throughout the eighties to help the mujahedin, even giving him money and helping his soldiers build tunnels in which to hide weapons and men. And later the Taliban would turn around and use these weapons, soldiers, funds, and tunnels in future battles against U.S. and coalition forces.

Once we had a real press corps to sift out the truth from such convoluted stories and real news pros on the ground in war zones committed to getting the facts out to the American public. Unfortunately, the real news pros, the likes of yesteryear's journalists, are long gone.

Anyone who remembers Ernie Pyle in World War II, Edward R. Murrow during the fifties, Eric Sevareid in the sixties and seventies, or Peter Arnett during the Vietnam War knows journalistic standards have changed a great deal since then. Dan Rather in 1979 donned the local clothing and crossed the Khyber into Afghanistan, blending in-to the landscape to report on the early stages of the war with the Soviets. That moment may well have been the last hurrah for a kind of journalism we Americans thought would never die. Images of "shock and awe" may rivet our retinas, but they do not count as journalism. Real news journalists ask nasty questions and dig for answers where it hurts. Real documentary journalists try to connect the morass of dots to make sense of the bigger picture. They are not always liked for it.

So what had gone wrong with the coverage in Afghanistan in November 2001? Was it simply, as some claimed, that the U.S. government had ordered a blackout on access to the high-tech business of war on the grounds of protecting national security? That was part of the answer but not all. In Afghanistan during the fall of 2001, the majority went too willingly back to their hotels where they may have prayed for the redemption, which would be granted a year later in Iraq. It would be the media's dumb luck when some politico would devise that clever "embedded" concept. After messing up in Afghanistan, even Geraldo would get another chance in Iraq (and he would blow that too). But then, how much would a reporter really see of the big picture from an embedded berth protected by people who must channel and likely censor his or her view of the landscape. Better than nothing for sure. And then U.S. soldiers themselves began jumping into the journalistic void with their own footage and blogs. They became a new inspiration.

Back at the Spinghar that evening, a note from Wakil was waiting for me. Another commander had hand-carried it from Peshawar. In it, Wakil alerted me to another convoy on its way to Jalalabad and then to Kabul that was carrying an MSNBC crew. Always looking out for my interests, he had asked the crew to take me with them to Kabul, should I still want to go. My contact was Dave Arthur, head of the MSNBC team. When they arrived in their convoy that evening, though, I found myself fielding yet another nasty grounder. Lal and his friends, including Governor Haji Qadir, had taken one look at the MSNBC

guides and personally advised me against going with them to Kabul. They referred to the two men as "notorious thieves and bandits" and insisted every commander in Jalalabad knew them as such. They told me it was my duty to alert the MSNBC crew.

I approached Arthur in his room that evening with the touchy information. In accord with my other recent network encounters, I should have expected trouble, but I'm ever the optimist. Arthur, however, outdid all his predecessors. He was irate, or at least he chose to appear so in front of his two younger, inexperienced associates. Who was I to tell him that the men he'd chosen to work with were dishonorable? Being the senior producer who knew the region as well as the back of his hand, he asked me to keep my nose out of his goddamn affairs. Normally such arrogance would have found me slapping the nasty curl right off his lips, but at this point I sought only escape.

I was getting nowhere with my new TV colleagues, even after repeated efforts. It was also approaching midnight on November 21, and I didn't relish sleeping at the Spinghar again, especially with the al-Qaeda reward money rumors then up to $150,000 per journalist's head. It was time for me to sever my ties with Hotel Taliban. Bonding efforts aside, I didn't seem to be on the same wavelength with most of the other folks there. My fifteen years' experience in Afghanistan didn't seem to matter to my peers, and the isolation was beginning to hurt. I kept asking myself what I was doing differently from the way I'd handled so many other assignments.

Lal and I hitched a final ride with the ABC bus on its way out of Jalalabad back to Peshawar, and I moved in with Wakil's commander, Ahmed Wahob, into a room just outside Jalalabad, where I stayed for another week. Contrary to media opinion, Jalalabad and Nangarhar Province were at the center of the action then, and I was amazed everyone was so determined to overlook them. Perhaps they were just anxious to settle back into the luxurious Peshawar Grand Hyatt or one of those comfy four-star hotels in Kabul with rocket-holed ventilation and occasional cold running water. During the next few days, most of the journalists I'd met at the Spinghar had returned to the safety of Pakistan while a few had opted for Kabul, this time with armed escorts. Consequently, the critical events that were about to happen in the Jalalabad region never made it to network news.

# 35

# *Prisoners of Tor*

**The next morning, Lal took me to a number of sites** in and around Jalalabad where the United States had bombed the Taliban. The scenes were startling not only for the intensity of the destruction but for its containment. At the Taliban's military headquarters, the ruin within a six-block area was awesome, but the periphery was sharply defined. The bombing had not bled much, if any, into nearby residential areas. The mosque within the compound had suffered considerable damage, but I saw no way that could have been avoided. What astounded me most were the rows upon rows of big artillery pieces that had been rendered junk metal. This compound was the home of the Taliban's principal artillery division, which had hundreds of pieces that had been captured from or left behind by the retreating Soviets and had been augmented later by Saudi prince Turki al-Faisal, bin Laden, and CIA imports from Saddam Hussein's defeated ranks in the first Gulf War. These armaments had been of no value whatsoever to the Taliban in a war dominated by the new age of smart bombs and laser-directed technology in the hands of 200 Green Berets on the ground who could direct the fire from U.S. missiles and planes. Not that long ago this artillery would have been de rigueur. Now it belonged in museums with suits of armor and the crossbow.

In the wreckage of the Taliban Command Center building, I panned my camera from the senior officer's leather chair across reams of scattered paper, twisted electric lines, and a few carpets mixed among concrete fragments to a piece of multicolored fabric lying crumpled among aluminum map holders. I put the camera in Lal's hands and stepped through the debris to untangle the solid black cloth

sewn with gold lettering. There was dried blood on it. "It was the commander's flag," Lal said. I glanced around to see if anyone else was watching. "Should I take it?" I asked Lal.

"Go on," he said, "there may not be many others left in the country." The people were apparently burning them in joyous effigy. I cut the flag loose from its staff with my Swiss Army knife and crumbled it up. "Put it in your pocket," Lal cautioned, "and don't show it to anyone."

The following year this piece of worn fabric would take on a life of its own as the centerpiece of the permanent History of the American Flag exhibit at San Francisco's Presidio. Knowing bin Laden had been a frequent guest at the Taliban Command Center, U.S. government specialists would express interest in analyzing it for DNA "hitchhiker" samples of those who had touched the flag.

When Lal and I left the headquarters, we visited another smaller Taliban military location on the other side of Jalalabad. Here the U.S. bomb delivery had been just as accurate and as devastating as at the command center. The military targets had been completely taken out and adjacent civilian areas left unscathed. From what I could see, the American military had redefined the term *surgical strike.* The only error I came across was in the tiny village of Baloch, about two hour's drive from Jalalabad. Here a number of casualties had resulted not from mis-delivery but from targeting bombs at caves higher up the mountainside adjacent to the village. Though the caves were known to have dated from the Ghandaran Buddhist period, U.S. forces had no way of knowing if al-Qaeda had requisitioned them as they had elsewhere. The bombing had created a rock slide that fell on the houses below and killed seven people. But in spite of the tragedy, anything done to destroy the Taliban seemed worth the sacrifice to Baloch residents, who warmly greeted the first American they'd encountered since the bombing. Clearly, the decision that the majority of Afghans had made back in 1996 to go along with the Taliban's temporary rule to bring peace had worn very thin.

The more I saw of the U.S. offensive, the more I felt a need to learn about the Taliban–al-Qaeda point of view. I asked Lal to arrange interviews with prisoners whom the local commanders had captured. I knew arranging these interviews would not be an easy job for a

number of reasons. To begin with, the territory didn't have any functioning prisons or jails, so prisoners were kept under guard in their jailers' outhouses and basements. Thus no central authority governed the whereabouts or treatment of these men. In many cases, Lal explained, the commanders considered the prisoners their property whom they could treat and bargain with as they chose. With the intense rage Afghans openly expressed about Pakistan's manipulation of Afghanistan since 1979, I feared for the Pakistani prisoners' safety. It was no longer a secret to the average Afghan that the Taliban had been first and foremost a Pakistani ISI creation, and I could detect little forgiveness for the Pakistanis' orchestrations.

When Lal returned from Commander Tor's compound for the third time, he was livid. "Yes," he said, "Commander Tor will let you interview his prisoners but for 500 American dollars. They are selling humans now. The commanders will never change. 'Commanderism' is the downfall of this nation."

When I offered to pay a portion of the sum demanded for the interviews, Lal was suddenly concerned for my own soul. I was, I hope, able to explain this bartering on my part in terms of protective aspects that might follow disclosure to American TV audiences of the prisoners' dire situation. In the end, we returned to Tor's compound, where three prisoners were brought in one at a time. They did not come willingly. Lal translated my questions. It was a bit startling to realize that the language of these men was a complete mystery to the Afghan soldiers around us. Urdu is that different from Dari and Pashto. Their nations might border each other and their inhabitants may pray to the same God, but they definitely do not speak the same language.

The first prisoner held his hand in front of his face so that only his eyes were visible to the camera. It created a strange effect and I chose to go with it rather than hassle him to uncover his face.

"Why were you fighting with al-Qaeda?" Lal asked.

"I was not with al-Qaeda," replied the young man. "I was with the Taliban, but there were always Arab officers around to make sure that no one slacked in his duty."

"What duty was that?" I asked.

"To fight the American invasion," he said.

"And why," I asked him, "had there been an American invasion?"

"To protect Israel, of course—always to help Israelis while good Muslims died everywhere."

"And what," I asked, "do you think of the destruction of the Twin Towers in New York that had killed 3,000 Americans?"

"That was after the U.S. had invaded Afghanistan," he said without hesitation. "It was a just response to the American invasion."

I was taken back. "But the Twin Towers came first," I said.

"No," he insisted, "the American invasion came first."

The second prisoner said much the same thing, though he did not try to hide his face. I thanked them both. Lal translated our appreciation, and the men were led out of the compound at gunpoint.

"What will the commander do with them now?" I asked.

"First he will wash their brains, and then he will send them home if somebody pays for them."

"What if no one pays?"

Lal shrugged. It was a dumb question.

The third interview was with a former Taliban soldier who spoke Pashto. His story was peculiarly specific. He talked about the pressures on him to join the Taliban's army because of threats to his family. His service had been mostly in Jalalabad, where, he claimed, he frequently stood guard at bin Laden's compound. He spoke of the Saudi Arab's cell phone, which "he carried with him twenty-four hours which no one was permitted to touch."

"Did you see any computer equipment?" I asked.

"No, only the cell phone."

"Who did he talk to on the cell phone?"

"Many people," the soldier replied, "and sometimes he spoke in English."

"In English?"

"He spoke in English much of the time," he said, "especially when he would walk and talk with people in his gardens."

"What people in his gardens?"

"I don't know who they were, but they were Americans."

"When was this?"

"Just before the bombing."

"How did you know they were Americans?"

"Because bin Laden's translators said they were."

On November 27, I bid good-bye to Lal and my new friends in Jalalabad and returned to Peshawar, where I linked up with Wakil. I was not happy to hear that ABC and JM had created an enormous headache for him on their way back from Jalalabad after the four journalists' murders by arriving at the Torqam gate with only a single-entry Pakistani visa. Wakil spent the better part of a day solving their problem for which he had not received as much as a thank you. And for Wakil, it became much worse, but I'll leave it at that. Who wants to be sued by ABC? In any case, I guess the ABC crew figured it could burn these bridges.

Wakil's houseboy Rabbani woke me for breakfast on November 29 at the traditional 4:00 a.m. Ramadan call. In Jalalabad I had been getting used to this early meal consisting only of chai, but Wakil offered a four-course breakfast with eggs, chicken, bread, cheese, rice, veggies, yogurt, and tea. I couldn't handle such a meal at that early hour, but to refuse Wakil's or any Afghan's hospitality is not an option. So I drank a great deal of tea first to prepare for my attack on the food.

Wakil said he'd just gotten word the gate at Torqam had been mysteriously raised two and a half hours earlier, allowing six new, high-end SUVs with their lights off to cross the border into Pakistan. No one had approached the vehicles from the guard post, where the lights were also off, and no one had stepped out of the SUVs. Wakil's sources had then tracked the vehicles for some distance through the Khyber, where they eventually disappeared onto separate camel paths. Whoever they were had left Afghanistan through the front door with the full cooperation of the Pakistani military and the ISI.

This information was available to anyone with sharp contacts in the region, and even that old, reliable, journalistic warhorse, the *Christian Science Monitor,* finally hinted at the story many weeks later. No one else did. The event's importance was confirmed later through a mutual friend of a grand old gentlemen who was once a big player in U.S. Special Forces. So it's not a big stretch for me to consider that this may have been the moment when bin Laden, Mullah Omar, or

both escaped. The rugged border region of Torqam, extending to Tora Bora, is extremely porous and would, of course, become the exit point for those Taliban soldiers who would choose to fight their last pitched battle in the region a week later. When they left, they slipped across that same border into Pakistan on a trail that was negotiable for men on foot and maybe donkeys but not SUVs.

It was undoubtedly a high-level crowd that left through the front door that early morning, and the implications are extraordinary. An agreement of some sort would seem likely between persons or entities who either had an ongoing interest in bin Laden's survival or had considered the possible consequences if bin Laden were caught and the ensuing rage that the bloodied head of the Arab "martyr" would incite among extremist Muslims (especially in Saudi Arabia, the dissident's home).

Perhaps it was just the wrong moment to take out the Arab leader. November 2001 would most definitely have been the wrong time for Pakistan's President Pervez Musharraf to disturb the extremists in his own country. If so, when would be the right time? High-level Afghan sources agree bin Laden and his sergeant at arms, Egyptian Ayman al-Zawahiri, have been hiding out in remote western Pakistan, Waziristan, with occasional trips to Pakistani Kashmir. I have visited both and can attest to the myriad of places to hide. Waziristan is a vast, rugged area that could only be taken after a major military campaign, one on a considerably larger scale than that used to take Afghanistan in 2001 and 2002. Meanwhile, bin Laden's own men and the local Pashtun tribal peoples have rallied around the Saudi en masse, with tens of thousands of soldiers who consider him more than a saint.

In Waziristan bin Laden and the al-Qaeda network have had the time—years, in fact—to heal their wounds, reorganize, and plan future attacks. Meanwhile, the United States and its coalition partners have fought a deadly war in Iraq, one that has inspired extremist Muslims from around the world to join the opposition's cause. Algerians, Bosnians, Chechens, Indonesians, Malaysians, Pakistanis, Palestinians, and, of course, disaffected Saudis, to name a few, have crossed and will continue to cross the equally porous borders between Syria, Kuwait, Iran, and Iraq to fight in Baghdad. These aliens might be only

7 percent of the insurgency's force in Iraq, as some reports have suggested, but then 7 percent of a hypothetical million or so insurgents would be 70,000 men, or half the U.S. force.

So why didn't the United States go after bin Laden instead of avenging the Gulf War? A little shock and awe in Pashtunistan might have changed the course of recent history, yes? But that's a dumb question, isn't it, with a curious and equally dumb answer.

# 36

## *9/11 Revisited*

**The two weeks I had spent in Afghanistan** in November 2001 was my sixteenth trip in fifteen years. Up to this point we had covered the Soviet conflict, the war against the regime, the refugees' return, the civil war, the early maneuverings of bin Laden, the Taliban's birth, the al-Qaeda hijacking of the country, and now the U.S. invasion. Not only had Shapiro and Lindelof died in this faraway place but so had many other journalists. And how many Afghans? Somewhere between 1 and 1.5 million people had died in the fighting over the last twenty-six years, with another estimated 2 million wounded and maimed. What a tale not told. If my first shoots here had been difficult and frustrating, this last experience was the hardest to handle. By December 2001, I had been on this ever-changing story for nearly a third of my life, and the more I learned about it the more I tried to break through the roadblocks to tell the story any way I could. And the more I traveled down the path the more frustrated I became that no one had yet addressed the entire, bloody epic. When I'd followed Wakil to Peshawar in November 2001, I was confident that the moment had finally arrived. I was wrong again.

From Peshawar on December 2, 2001, I called Suzanne, who again had been handling negotiations with the networks in the States. She said no one was interested in a serious story on Afghanistan. I was stunned. Moreover, from what she could gather, none of the networks had anything of the kind or any plans to do an in-depth piece on the causes and implications of this war. It seemed as though they just didn't care—or had been told not to care by corporate heads—about the facts. They didn't want hard-hitting news questions asked: Who were the

Taliban? Where did they come from? How did al-Qaeda fit into the mix? Who made up the Northern Alliance? Who were the Pashtuns? Who was Massoud and why was he killed two days before 9/11? What part did Pakistan play? What was Saudi Arabia's role? Who were the Wahhabis? Where did trans-Afghan pipelines fit in? What was the Great Game, and what was this New Great Game? Instead, the networks seemed to care only about pictures or footage of Osama bin Laden and the new scapegoat John Walker Lindh.

Of course, I wasn't about to go soft on the project after all this time and effort, but the frustration was getting to me, and I was tired and out of cash. I wasn't prepared to go back inside at this point. I just wanted to find an aisle seat on the plane, stretch my legs, and lick my wounds on the long flight back to Los Angeles. Indeed, no one had sent me on this assignment, but I still believed I was returning with footage the networks would want once they saw it. After all, nobody else had it. They'd better want it too, or we'd be hurting. Having headed back across the Jalalabad plains from the war with only thirty-two dollars in my pocket, I felt a little as if I were James Woods in the eighties' classic *Salvador*, driving south in that beat-up Chrysler with equally empty pockets and high hopes. The exception was I was returning from, not going to, a war zone, and—I sincerely hoped—I was not nearly as crazy as Woods's character was. Along with good footage on the Afghans' situation in general, I had the update on our long search for Lee Shapiro. Of course, it hadn't happened as I would have imagined, but sadly, the "dead messengers" angle was stronger than ever.

At 3:00 a.m. on the road from Peshawar to Islamabad and my flight to Los Angeles scheduled to leave four hours later, I flashed to an earlier time. In January 1987, Carmen had made the same early morning drive, probably to catch the same PIA flight, only to discover at the airport that her footage had been stolen. This time Wakil had taken precautions and sent me with an armed escort. His other nephew, Majid, a tall man with the build of an Olympic weightlifter and little love for Pakistanis, was driving me to the airport in his SUV. I didn't have much to worry about with him around, and it didn't surprise me at the first checkpoint to watch him drive straight past the Pakistani Army guards without even making eye contact. Afghans are bold, for

sure, and this guy was as imposing as the wrestler/actor Rock. I figured that's why they'd let him pass, or maybe the guard knew him or his truck. But then the same thing happened at the next checkpoint. This time I noticed his index finger moved slightly up and down on the steering wheel.

"That a signal of some kind," I asked him after we'd cleared the stop, "or you're just exercising?"

"Yeah," he said, laughing, "it's the big signal. The finger stands for the 'I' in ISI. I learned it from a trucker friend of mine, and it always works like a charm!"

Say what? I thought about all the times I'd made the journey along this road and back across the tribal areas in the Khyber, hidden under blankets and sacks of grain, unable to move for hours, and holding my breath when guards searched the car. I had to chuckle. "So here you are, passing through these checkpoints as if they didn't exist."

"That's because they don't exist for the ISI," Majid said.

I had known for many years that this territory was big drug country and the right number of dollars and the correct connections could get anyone across any border or any checkpoint, but I'd never seen it done with such clarity and with only one finger.

To say the least, folks in the United States had not been clear for the last couple of months. Just as so many others, I had watched the television screen as the second plane appeared from the standing tower's right and disappeared behind it. The orange flame burst from the building's left side while Peter Jennings was still talking about the fate of the first plane. Then the second tower melted down while Jennings kept referring to it as though it were still standing. Was I confused, or was he?

We all were confused and with good reason. And in the following months, the confusion deepened as somewhere beneath the superficial ads for Viagra, face-lifts, and hair restoration we searched for glimpses of the rock-hard American substrata that still had to be in our cultural fabric. Life was unpredictable again, dangerous, perhaps even exciting in a nervous sort of way. And in this latest storm we looked for anything to keep afloat above the murk that barely hid all the incomprehensible rage in the Muslim world. We leaned against

those who appeared firm—firemen and policemen who stood straight and officials who had boasted they'd find the perpetrators. They sounded just as the Duke had when he promised in Shapiro's favorite film, *The Searchers,* to "find 'em sure as the turnin' of the earth." Even having witnessed a few of the world's conflicts firsthand during the last twenty years, after 9/11 I was confused and disconnected too. It was the same way I'd felt after the California earthquake of 1994, when the Great Hand reached up, grabbed my home, and shook out everything in it. Trouble that visits you on your own turf is more disturbing than the kind you choose to visit.

Reflections such as these have rarely entered my filmmaking equation. When I'm on a job, I think something more disciplined, or dumb, takes over—and that's fortunate. But as Majid flashed that same finger and drove past that last checkpoint into the airport, I felt disconnected again, disconnected not only from my American roots but from all the resentment, mistrust, intrigue, and conspiracy in this part of the world that I should have seen. I had to admit we journalists and documentary makers who had been working the Muslim beat should have seen 9/11 coming. So should have the CIA and the State Department. But I especially should have foreseen it. After all, I'd been on a sortie into Taliban-land at the very moment bin Laden had promised this kind of vengeance, and then two months later I had been in Nairobi and Dar es Salaam when he proved how serious he was. I had nodded off along with everyone else.

Within a couple of weeks of 9/11, the world had identified the culprit. Perhaps he was the same tall Arab who'd stepped out from behind the dirty, cracked windshield of the pickup truck ferrying wounded Arabs on the road from Jalalabad in 1989. Hey, what's going on? I remember asking myself then. We're the good guys, aren't we? We're all on the same side, aren't we? That menacing move had made no sense to me at the time, and later, when Wakil had told me whom we'd likely encountered, it still made no sense. The Soviets and the Regime were the enemy, right? Not two Americans who were trying to tell the Afghan story? But now twelve years later, U.S. forces had turned around and bombed Afghanistan as the Soviets had. Our military handled the job more humanely than the Soviets had, but that incredible fact remained.

As the PIA plane took off that morning into the back-lit, early morning smog that engulfed Islamabad, I recalled trying to land in Kabul during the civil war, when the airport had sent up enough flares to draw off Hekmatyar's heat-seeking missiles. Most American TV viewers were unaware of that war, because, as Hadi Raza Ali had once said, "Afghanistan is not a 'designated' news topic." The people were simply too strange and Americans couldn't relate to them. They couldn't get behind their dress code let alone their chaotic tribal politics.

"Americans need heroes with ten-gallon hats," he said, not joking this time, "heroes who look like cinema stars."

Of course, I'd said, "but I think the Afghans fit the part."

Hadi laughed, "You're out of touch. Besides they're Muslims, and Americans have made up their minds—all Muslims are the same, Sunnis, Shiites, Sufis, Ahmadists, Deobandis, and Wahhabis. You can't support Israel, as you've done exclusively since they took the land and think anything else, can you? It's simple politics and math, like one plus one equals two!"

That assessment was disturbing stuff to hear in 1989, especially when I was carrying a shopping bag full of footage of the latest pogrom. I knew it couldn't be true.

And here I was again on a plane with more shopping bags of film and tape and still determined to tell a story that was now as old as good Limburger cheese and smelled just as rotten. Soviet land mines were ripening in the soil, one for every three surviving Afghans, and now U.S. forces were sowing their own live ordnance as well. In 1989 when the Soviets crawled away, America left as well and never looked back. Neither George H. W. Bush nor Bill Clinton offered assistance to Afghanistan, and George W. ("W") Bush didn't pay attention either, until he had to. A number of CIA agents and researchers tried to blow the whistle about al-Qaeda and bin Laden. Called the "Manson Family," they worked under Michael Scheuer, who had headed up the Bin Laden Issue Station from 1996 to 1999. Their "heresies" and those of Scheuer were silenced (until under the pseudonym of Anonymous in 2002 he came out with his shadow-shaking book, *Through Our Enemies' Eyes*). And here we were in December 2001, on bin Laden's trail but about to be distracted yet again by Saddam Hussein and Iraq just as W's dad had been in 1990.

# 37

# *For the Record*

**It's time for a quick take on Osama bin Laden's** amazing success story. He arrived in Afghanistan during the war with the Soviets in the early eighties, and it took him nearly a decade to purchase the glories of jihad with his petrodollars. It wasn't easy, but he stuck with it and reaped the rewards. Unfortunately, you've got to give him credit. Remember, most Afghans did not like the Wahhabi Arabs because their brand of Islam was different from the mainstream Sunni and Sufi Islam practiced throughout the land, except, that is, in deep Pashtun country along the Pakistani border. After the Soviets left, bin Laden returned to Saudi Arabia to run his father's construction business in 1990 while his al-Qaeda representatives stayed in Afghanistan. As the United States and NGOs pulled out, bin Laden's money funded new roads, hospitals, and wells and completed other public works that he'd begun in the late eighties. When the Saudi royal family pulled his citizenship in 1994 because of his explosive reaction to U.S. troops on his homeland's sacred soil, bin Laden and his team left for the Sudan. From there, with U.S. intelligence hot on his trail, he decided to return to the alternate homeland he'd fought and paid for with the help of other Wahhabis. In 1995 when the Taliban's prospects for success showed greater promise than did Gulbuddin Hekmatyar's chances, bin Laden switched allegiances. With offers of financial and military aid, he then set about cleverly purchasing Mullah Omar's entire movement, Talib by Talib, in the name of his own vision of Islam, for it was not all that different from the young Mullah's extremist, Deobandi perspective. It is rumored that in 1997 he even married one of Mullah Omar's daughters to seal the deal. I sometimes wonder if the uneducated Omar ever saw the tall Arab coming.

Of course, the synchronicity of surrounding sentiment worked in his favor. Consider Pakistan's undercover efforts—in particular, those of Interior Minister Naseerullah Babar during Benazir Bhutto's second term to control the unstable and troubling neighbors to the north. He did not want Afghans hovering around his borders, getting wired on lots of tea, and making trouble. He wanted them deep inside their own country but still on friendly terms, controlled from the top by a government receptive to Pakistan's interests and perhaps a pipeline or two. Even before it had a name, the Taliban movement appealed to a number of Pakistanis but not all. In the early nineties, the ISI was still committed to Hekmatyar. However, by the time the Taliban had taken Kabul in September 1996, the Pakistani government was rumored to have been paying $140 million a month to keep it going.

Even though it had been born on Pakistani soil in the desperate and overpopulated refugee camps ministered by extremist Muslim clerics and, unknown to Benazir Bhutto, funded secretly by her interior minister, that movement could not have survived without Saudi money. Former president Zia-ul-Haq and the ISI channeled the funds to their chosen fundamentalist few, principally, Hekmatyar (who has been implicated in the deaths of hundreds), Abdul Rasul Sayyaf, and Younis Khalis. Eventually, when the Afghans had had enough of Hekmatyar's ravages during the civil war, along came the young, charismatic, but uneducated Mullah Omar, who had earned a reputation for bringing raping and murdering commanders to harsh justice (not in the defense of women, we now see, but in the defense of men who were no longer to be seduced by the sirens). It didn't matter that Ahmed Massoud thought Taliban philosophy was all bull, everyone south of the Tajik's control either joined the Taliban movement or, as Wakil and the entire NIFA organization did, headed back to exile in Peshawar.

During the early years of bin Laden's effort in Afghanistan, my team and I were following our instincts on different stories. That some of those fighting the great Soviet Satan were gearing up for another war with the great American Satan completely eluded us until the pickup truck incident outside of Jalalabad in 1989. So that part of our story that presumed to focus on presenting the untold tale of what was really going on in Afghanistan missed much of the point. The

other part that we did know something about had to do with the negative drift in U.S. journalism and centered to some extent around the stories of Shapiro, Lindelof, and Carmen.

As we know, Shapiro was a Jew from middle America who had moved to New York, and Carmen was a half-Jew from Guatemala. But their Jewish ancestry didn't bring them together. They both shared a belief in the underlying similarities of the great religions of the world. Today, when you read an e-mail from a Hindu friend in Bali or a Muslim colleague in Turkey, it's not hard to see that people around the world think much the same way about most things, but in 1986 such ecumenism was on the cusp. It's hard to believe that only a few decades ago people lived without the benefits of computers, and Americans then still resisted the concept that the third world had anything in common with them. The CIAs, the ISIs, and the Istakhbarats (Saudi secret police) of the world had based their raisons d'être on maintaining a political hierarchy. Who was the average American or Pakistani to think any differently then?

Before my post-9/11 trip, I had asked Wakil to fly down from San Francisco and help me put together a proposal package for the various news bureaus. For the past year, he had shifted between Peshawar and Fremont, California, where his wife Alya and their three young children were living with relatives while Alya awaited the birth of their youngest child. Rumors flew that in Peshawar he was working with other commanders on plans for a full-scale offensive against the Taliban set for the spring of 2002. When the Twin Towers were attacked, Wakil had been visiting his nephews in Connecticut and thought he was watching "a promo for some new 007-like series." I tracked him down when he returned to Fremont, and he made immediate plans to fly to Los Angeles.

On the night of September 13 at 4:00 a.m., three drunken young men, swearing vengeance for the events in New York, attacked and beat up my son, a third-year student at the University of California at Santa Barbara, outside his student apartment. I couldn't understand why they had targeted Ryan, whose ethnic origin is as obvious as his name. Perhaps because one of his roommates and several of his friends were Asian, irrational rage had been released.

When I picked up Wakil at the airport early on the fourteenth, Ryan had been admitted to the local hospital in a suburb of Santa Barbara with four facial fractures and was awaiting emergency surgery. Wakil insisted we put the upcoming war on hold and drive north. It was unforgettable, watching this powerful man hold my son's hand for hours and try to comfort him while his own family members and friends 10,000 miles away were at grave risk. But then, the terms *family* and *friendship* have another meaning in that land, where hardship is a lifelong companion. When another friend at the hospital asked Wakil how this kind of attack might have been dealt with in Afghanistan, he replied simply that the situation would have been handled before the police arrived. This code of justice, at the heart of the matter and stated so clearly, is both the blessing and the curse of the Afghan way.

The following week, Wakil and I arranged to make pitches to Los Angeles– and New York–based network news bureaus for financing to cover the impending war in Afghanistan. Not only did we have access to key areas and key leaders in the Afghan regions under fire, but over the last fifteen years we'd gathered more than a 150 hours of material for numerous NGOs, and other organizations, and we controlled the rights. Our offer, as independents, had been that we'd gather footage that I thought (correctly, it turned out) the networks would have trouble getting on their own. There was no question, at least in our minds, that we were the horse to ride.

When I spoke to Barry Silverman at *20/20*, however, his only interest was bin Laden: "I don't care about the story—just give us any pictures you've got of this dude."

In an e-mail Suzanne received from one of Peter Jennings's right-hand men, he reminded her "ABC has spent many millions . . . on war coverage, and while we would all like to believe they do it for the public good, that is not even remotely true. This is a business for them." What had happened to ABC after I'd worked there in the eighties, back when Pam Hill ran the *Closeup* unit? No one messed with the facts while she had anything to say about it.

At Andrew Heyward's office at CBS, his assistant kept saying he'd get back to us. We'd broken the Mariel Cuban boatlift story with CBS, but I guess that had been too long ago, because Heyward never

called us back. The NBC folks in Los Angeles were enthusiastic about what we could deliver, but editorial chief Marc Rosenwasser in New York thought the one camera he already had on the ground with the Northern Alliance commanders Abdullah Abdullah, Mohammed Fahim, and Rashid Dostum was enough. He thought the war would be over quickly, and besides, he'd already spent his budget on pieces about the 9/11 firemen who had died just down the street. Who could fault this thinking? By late October, it appeared we would yet again be self-financing another shoot across the Khyber.

Later, when I returned to the States in December 2001, the record kept skipping. Jennifer Siebens, bureau chief for CBS News in Los Angeles, watched our footage with interest and asked if we had "more dead bodies." She thought she might be able to make a piece out of the prisoner footage and the Tora Bora stuff, since I'd gotten there first, but it didn't have "a sensational look to it." But, I pointed out, that was the way it was before the United States had begun the heavy bombing in hopes of getting bin Laden. Citing tight budgets, she offered us a grand for the whole ball of wax. We walked. And in New York, CBS News head honcho Betsy West told Suzanne that CBS never bought anything from outside any more. As for finding a place down the pike for our special on "dead journalists" or the Afghan story by any other name, "CBS wouldn't think of it." Her advice was straightforward: "Find a rich angel!"

Even before Christiane Amanpour's fall 2002 blast at CNN's coverage in Afghanistan, the executive vice president and general manager of CNN International, Rena Golden, laid out her version. The censorship, she explained at a conference, "wasn't a matter of government pressure, but a reluctance to criticize anything in a war that was obviously supported by the vast majority of the people." Well, I would ask Ms. Golden three questions: Who specifically was reluctant? Why were all those journalists who had been sent to Kandahar to cover the final battle there forced under U.S. military duress to stay locked in a hotel with no access even though they were just a few miles outside the city? And why, as Kurt Nimmo writes, after a stray bomb hit U.S. troops north of Kandahar on December 6, did Marines lock up the journalists

who had been released from the hotel in a warehouse to ensure they wouldn't take pictures of wounded American soldiers?

What's a documentary filmmaker supposed to do with a film that hints at a U.S. credibility crisis, that doesn't feature Morgan Freeman and Clint Eastwood, and that no one will broadcast? Well, as an old cowboy politician once said, if everybody's so darn against what you have to say, it just might be true. So I would write this book and finally find a way to complete the feature documentary *Shadow of Afghanistan*.

# 38

# *Kabul in the Wake*

**In June 2002, I had been in touch with Jack Hanna** (of *Jack Hanna's Animal Adventures* and the Columbus Zoo) to do a piece on the Kabul Zoo. I had never visited the zoo, but I had heard sad things about the state of its animals. Jack was ready to go, as he's always ready to go to the wall in support of wildlife anywhere, but the company boss couldn't see any money in such a downer episode. So based on a brief conversation with Animal Planet about a project we thought would pay our way, Carmen and I decided to go on our own to film the surviving beasts. Of course, we had other plans in Kabul, which was about to host Afghanistan's first loya jirga in twenty-five years.

At the time, Wakil was living in Kabul. He picked us up at the airport and took us to his family compound not far from the American Embassy. He showed us around the old *Zhivago*-like structure that, unlike many others, had survived the Soviets, the civil war, and the Taliban. I had heard some amazing accounts of the Taliban's ignorance during the past five years, but the one Wakil was about to tell me was beyond the pale. As he escorted me to the bathroom, he explained, that he'd been relieved to find it still intact. The Taliban, he said, felt that toilets were sinful since they mixed feces with water, and water was near sacred in desert-born Islam. Consequently, the vice and virtue police ordered that all flush toilets in Kabul be filled with concrete and that bathtubs be filled with sand. Thus, they afforded everyone an age-old, desert dweller's approach to relieving themselves.

Carmen and I heard many more Taliban stories and anecdotes. A few were funny, most not. The Kabul Zoo's tale belonged to the latter category. When Carmen and I showed up at the gate of the ravaged

building, we couldn't believe creatures were still living inside. We were met by a gentle, smiling man who introduced himself through our translator as the zookeeper, though he had not been paid in more than a year. He was there only because of his love for the animals. He led us through several buildings that had been bombed and where animals had been killed. Then we went to the outside pens, where we found rabbits, peacocks, and a few small deer living in wire-wrapped rubble. The animals stared at us as if they were prisoners of war. Many cages were empty. When I asked the zookeeper what had happened to the former inhabitants, he pantomimed firing an automatic weapon.

He escorted us to a central area where a fence surrounded a large, concrete watering hole. From a cavelike structure to the side came limping toward us a large, brown animal, the only surviving celebrity of the zoo. The translator had to tell me that it was a bear, for the scars, wounds, and open sores all over its body made it difficult to identify. I was stunned. Even Carmen, a medical doctor who had seen countless injuries, was taken back.

The poor animal struggled toward us as if we were long lost friends. It probably hadn't had many visitors of late. The zookeeper reached through the mangled fence to rub its head. Up close the sight of the bear's wounds became too difficult to linger on, especially an empty eye socket where it had been gouged out. The zookeeper seemed near tears as he relayed the bear's plight under Taliban rule. They came several times a week to beat it with clubs, he said, and sometimes they even used it for target practice, trying to hit it in the foot or leg. But often they missed and hit the bear in more critical areas. When I asked him why they had done such a hideous thing, he laughed as a few tears made their way down his cheek. Perhaps the bear wasn't religious enough, he said. I stared at the zookeeper, not knowing if he was serious. Who would punish an animal for not bending toward Mecca five times each day? Or was it that the bear, as in Russian bear, symbolized the atheistic monster that needed to be taught still more brutal lessons?

Later that day, Wakil, Carmen, and I climbed the endless stairs to Razul Amin's new apartment in Kabul. Since Hamid Karzai appointed him minister of education and then relieved him of the position a week later, Razul Amin had been forced by economics from his

first-floor flat to the top floor of this ugly, eight-story dinosaur built during the Soviet years. It was "something of an exile," he said half jokingly. Carmen knew him well, having stayed at his home in exile in Peshawar during her 1987 visit after Shapiro's death.

We had literally run into Razul Amin two days before. Carmen and I had crashed the gate at Bagram Air Base and collided with the celebrated scholar, almost knocking him down. Wakil had arranged for us to film an event at Bagram, which he explained only a few minutes before we arrived at the airport gate. I had no idea what the event was, but coming a week after the first loya jirga, I knew it had to be something symbolic. With Wakil's imprimatur, I burst past the guards, camera in hand, and managed without much trouble to find a place among the crowd to film the ceremony. After a few minutes I realized I was standing with the dashing President Karzai on my right and the starched Dr. Abdullah Abdullah (of Northern Alliance fame) on my left. Before the prayers began, I smiled, introduced myself, and repositioned my camera across from the two men to get a head-on shot.

I soon learned through the eulogies that followed that these men had convened to bid farewell to an old friend who had fought the good fight and had died in exile far from his homeland. His body had been brought back to be buried in one of the provinces to the west and his old colleagues had come to pay their respects. Mohammad Rahim el-Ham was recognized as one of Afghanistan's great poets.

Once former president Sibghatullah Mojaddedi, that aging icon of moderation, had completed the prayers and the casket had been carried onto a helicopter for the local flight, all the men present who had fought for twenty-two years to reestablish an independent Afghanistan mingled with each other. It was a privileged moment of white beards, hugs, and tears all around. These men had struggled in turn against the Soviets, Najibullah, Hekmatyar, the Taliban, and al-Qaeda and were now hoping to work with the Americans. Some of these men had not seen each other in decades. They embraced each other and cried. The scene went far beyond politics.

But politics, prowling close by, waited for the moment to bite. I never saw the gnashing of teeth at the ceremony, but Vice President Haji Qadir, who had attended as well and in whose Jalalabad home I

had sipped tea after 9/11, would be executed gangland style the day after we left Kabul.

After the ceremony, I encountered Razul Amin again in the crowd. The man had a good word for all and a twinkle in his eye, especially for Carmen. He agreed to meet with us the next evening for dinner with an on-camera interview clearly on the menu. The next evening came and then the next, but we received no response from Professor Amin. Wakil called him repeatedly to no avail. Finally an answer did come and with it an invitation for a meeting at Amin's new digs, without elevator. His son, an affable, well-spoken young man in his twenties, welcomed us. He escorted us to the kitchen, where Razul leaped from his seat from behind an ancient Royal typewriter. He embraced Carmen and shook my hand vigorously. Carmen and Razul went back a long way but apparently not long enough, for Razul had decided not to give us an interview—no on-camera commentary, that is. Our discussion at his kitchen table over green tea, however, was as clever and candid as any I'd experienced.

We asked Razul why he had lost his appointment of minister of education after only one week. The professor was not in the least hesitant to explain. He told us the Americans—not the military but the government people from Washington—had changed Karzai's mind. Razul Amin's public position against the warlords had cost him U.S. support, Karzai had told him at their last meeting. Karzai had gone on to say that the United States felt it needed the warlords, and alienating them was a dumb move on Razul Amin's part. Karzai, as events would bear out, knew what he was doing and how to deal with Washington. He realized that the Bush administration was determined to keep its options open with the warlords to ensure the troublesome country remained decentralized. But as a former Unocal employee, Karzai also knew well the myopic U.S. perspective. Long-term vision was unlikely. We asked Razul if he was disappointed in Karzai, and he gave us his assessment of the interim president: Unlike his outspoken self, Karzai was a diplomat who knew how to get things done with people who didn't like each other. His style was accommodating, but he was the same man who had sworn vengeance after al-Qaeda thugs had gunned down his father in the streets of Quetta.

"What will you do now?" Carmen asked her old friend.

The professor smiled again, but this time he betrayed an anger deep within. "Return to academia, of course, and live out my days among ideas and words that have concrete meaning. No more politics for me! Hamid can have that."

Razul Amin's words disturbed me, as did the empty presidium I filmed the next day where the loya jirga had just been held. The desks, tables, chairs, and nametags of each of the 1,600 participants had been piled gracelessly one on top of the other as though waiting for the junkman. The delegates and the country got little of what they'd hoped for at that first big meeting. They'd only developed a list of twenty-nine new ministers who were either warlords themselves or had intimate ties to the warlords but without any knowledge whatsoever of the particular ministries to which they'd been appointed. Was this plan to appease the warlords? Or was it Karzai's way of forcing the warlords out of their traditional comfort zones and into Kabul? As for Karzai himself, there was never a question that he should be the interim president. But as three women schoolteachers who had weathered the Taliban years shared with me, the Karzai they knew seemed to be a different man after the loya jirga. He was no less charming, but somehow he was different. Perhaps the realities of what he had hoped to do and what the United States was prepared to let him do had been made clear.

Carmen and I had returned to Afghanistan to share in the celebration of the country's liberation and to appease our own needs for closure. But closure, we saw up close, was not yet at hand. "How many more years can we keep coming back?" I asked Carmen.

She only looked at me and continued down the concrete stairway from Razul Amin's apartment. At the bottom, she turned to me with a question on her lips, then thought better of it, and turned away with a wistful look. "If Lee had known how long this would go on...," she said. "He died so early on . . . so young . . . so—" And then she choked up.

After a pause I asked her, "If Lee had known what we know now, do you think he would have kept going?"

Carmen turned back to me with tears in her eyes. "What do you think?"

# 39

# *Pul-i-Charki*

**As Afghanistan in July 2002 was slouching slowly** toward some form of democratic government woven from its own jirga and shura traditions, one didn't need to dig too deeply to uncover more dangerous new flaws in the national fabric. Ever since the Soviet Union began manipulating Afghan affairs in the early 1970s, imprisonment, torture, and assassination became the political way of life. No one was safe, not even members of the two branches of the Communist Party, who were always at each other's throats. And whenever imprisoning the opposition became the solution, there was only one five-star residence.

Pul-i-Charki Prison might be the grimmest place I have visited in my years of filming. Its vibrations are so strong that just gazing upon its monolithic expanse across the flat plains outside Kabul is disturbing. It is the Auschwitz of Afghanistan. Of course, it cannot be compared in any way to that slaughterhouse with regard to the numbers of inmates murdered, but in terms of the sheer horror and creative manipulation of the tortures served up, it does. Pul-i-Charki Prison could hold a few thousand prisoners at a time. It became a place of ghoulish happenings for those unfortunate enough to have been targeted by the Soviet-backed Khadamat-e Etela'at-e Dawlati (KHAD), Afghanistan's secret police after the Soviet invasion. It still produces nightmares for those whose family members and friends were taken there to be tortured and killed for information that most never possessed. Wakil told me friends who had lived in a small village two miles from the prison would hear screams and gunfire every night as inmates were brutalized and dispatched.

Afghanistan's beast from 1986 to 1992 was Mohammad Naji-bullah, who served as the KHAD's director (1980–86) before he assumed the "presidency" under the Soviets in September 1987. The Soviets brought on board numerous Gestapo types in their orchestrated takeover—including Hafizullah Amin, Nur Muhammad Taraki, and Babrak Karmal—but the Ox maintained control during the last brutal years of the war. The horror stories from his years as head of the KHAD almost legitimized his monstrous fate at the Taliban's hands in September 1996.

Through all the years I had worked with Wakil, I had never seen him flinch in the line of fire, but Pul-i-Charki Prison was different. He did not want to go there and told me it was completely off-limits. I suspected he too had a story from this place he was unwilling to share. As we pulled up to the huge iron gate wrapped in chains and with brightly colored lettering announcing the prison, he was quick to suggest it was locked and that we should leave. At that moment, a disheveled young man carrying his Kalashnikov at half mast appeared from behind a huge pile of rusted bedsprings. Wakil knew he was trapped and turned off the engine to explain our presence. Several other men joined the guard. They explained in Dari the Karzai government had stationed them there six months before to keep out intruders, but, they laughed, no one ever came to this place. They maintained nothing was there but unmarked graves of mangled corpses and miscellaneous body parts.

With Wakil and Carmen occupying the soldiers' attention, I stepped from the Land Cruiser and presented my small video camera for their inspection. Wakil explained I was hoping to take a few shots of the exterior. The head man seemed to nod that this was OK. I made my way slowly toward the gate, grabbing a few shots of the exterior of the building as I went. Then I unraveled the chain, which had no lock, and made a point of shooting my own passage through the gate as I pushed the heavy metal frame with my free hand. After I shot the scene, I withdrew quickly to perform the same routine again. I did this several times pretending to get it right, but when I noticed Wakil had lured the men behind the pile of bedsprings, I grabbed the moment. I entered for real and raced across the broad inner courtyard

that was overseen by the remains of a mounted machine gun sitting on top of a bullet-ridden tower swarming with crows. Strewn all about on the hot, sandy surface were rusted wreckage, strands of barbed wire, decaying matter of some sort, and rats. I nearly stepped on one of the rats as I reached the main compound and chose one of the many iron doors to push open. The old metal screamed at my intrusion as if determined to keep the deadly silence of this place.

Inside more rats nibbled on unidentifiable items. Light from the tiny barred windows shined in shafts from the dust I'd kicked up. The only sounds were of my own echoing footsteps, a few rodent squeaks, and the usually inaudible mechanics of the video camera. Then I stumbled onto more debris: a broken chair, a strand of rope, a pile of recent scat from some animal larger than a rat, the skeleton of a dead bird, rotting canvas, rotting clothing, and then several large bones and part of a rib cage. It might have come from a donkey or dog or perhaps something else. I didn't stop to study it.

Then I heard angry admonitions in Dari behind me. I had expected the voice to eventually come after me when I'd first heard it outside the gate, the snarling voice of the disheveled young guard. He stepped into the cell behind me, and his heavy boots echoed on the concrete. His voice with its harsh inflection reverberated too. When I lowered my camera and turned to him, I knew I had to stop shooting.

Wakil's voice bellowed with urgency from outside the gate. "It's time to leave! Definitely time to go!"

As the guard led me across the yard, he said things I could not understand, and I could smell the odor of alcohol. He walked sloppily, and the weapon slung over his shoulder swayed from side to side. I knew he was swearing in Dari under his breath. Then he pointed at the crows that were now swarming around another tower. He slipped the Kalashnikov from his shoulder and fired a burst at the birds. They took flight. I realized the crows were not crows at all, but vultures.

Back outside the gate, the young guard conferred with his colleagues about me and my camera. Their expressions were changing. We bid them a quick thanks and piled into the car. Wakil put the pedal down hard, and we were gone. I could see the guards glaring at us through the dust in the side view mirror. Leaving the prison grounds,

we passed more piles of rusted bedsprings. They became living enti-
ties to me, as had the hundreds of chairs piled up in the loya jirga hall
that we had seen the day before. Wreckage and ruin were still accu-
mulating in Afghanistan, even with Karzai's best-intentioned efforts.
I wondered how long ago those last bones had been sown in Pul-i-
Charki. Were they as recent as those at Qala-i-Jangi and Sheberghan
prisons, where the brute Rashid Dostum had herded hundreds of
Taliban prisoners inside unventilated metal freight containers in the
scorching desert sun and let them suffocate and burn? Probably not,
but I knew grim practices here had not ended with the Soviets, as the
histories would have us believe. Although there had been many
changes of hands in Kabul, most of them were dipped in blood that
even best efforts have not succeeded to wash off. After all, you can't
waste such a good prison as Pul-i-Charki (as the United States, using
it in 2007, has proved).

Back on the main road Wakil remained somber. I asked if any of
his family had ever been detained at Pul-i-Charki. After a long pause
he told me about another nephew, a boy who worked down the street
from me at the "Ameci" pizza parlor in Woodland Hills, California,
who had lost both of his parents there.

# 40

# *Signs of Life*

**It was September 2004, and the grand old man** of the Afghan struggle had had enough bickering. This time his compatriots were arguing about the national languages to be written into the new constitution. The loya jirga representatives had agreed on Dari (Farsi) and Pashto, but they were not prepared to bend on Uzbek. Dostum's Uzbeks, however, were not going to ratify a new constitution without their language being included on an equal basis. For days, everything hinged on this final decision. Sibghatullah Mojaddedi, who chaired the proceedings, did his best to find a middle ground on the issue, but neither side would budge. The mullah looked at the representatives before him and shook his head.

In 1970, Mojaddedi, this slight, bespectacled Sufi, led the first major opposition against the Afghan Communist Party and Soviet influence in the Kabul government and was forced to seek asylum in Denmark. In May 1979 he had witnessed the murders in prison of ninety-six family members under the last days of Taraki's Khalq (People's Democratic Party) regime. In 1980, he established the National Liberation Front of Afghanistan and commanded its forces during the war against the Soviets. He was elected as the first Afghan Interim Government president in February 1989 and then the first president in the rotating presidency of Kabul in 1992.

Mojaddedi had fought too long and too hard to see Afghanistan's new government fall apart now. On the very cusp of success, he refused to participate in its self-destruction. He stood up from the podium, bowed, and left the hall, heading for his home. The parliament sat for minutes in shocked silence. A half hour later, a determined

Foreign Minister Abdullah Abdullah and several other high-ranking officials drove to Mojaddedi's home and tried to persuade him to return. The conversation continued for several hours. Before he would consider going back to the hall, Mojaddedi demanded from all parties blood promises of complete cooperation on the language issue. On his return, the parliament was prepared to deal. Sibghatullah Mojaddedi, the venerable Sufi moderate, had shamed them into action. While no national language was written into the constitution, they gave Pashto and Dari premiere positions while Uzbek and Turkmen received official classification in the regions where the languages were predominant.

They had drafted a new constitution. A year later Hamid Karzai would be elected in a somewhat contested election as president of the republic, and former king Zahir Shah would receive the title Father of the Nation.

What does this framework mean? Has the concept of compromise finally returned to this fragmented nation? Has the tolerance of tribal and religious differences, which the civil war had destroyed, reappeared? Is it possible that the fabric of Afghanistan has not been irreparably torn?

And will those countries and corporations with an interest in this land support this tiny bud of hope? Will Pakistan keep up its Machiavellian moves to control Kabul, or will it finally bow out? Will Russia support new trade initiatives from Turkmenistan, Uzbekistan, and the other "'stans" north of the Oxus across Afghanistan to Pakistan and India? Will the United States continue with its mega Azerbaijan-to-Turkey pipeline if Russia and the People's Republic of China decide they've had enough of U.S. troops hanging around their backyards? Has Unocal picked up again with its Afghanistan pipelines, with Karzai's blessing? Will the United States, in light of President George W. Bush's 2003 State of the Union declaration of "friendship" with Afghanistan, continue to honor its commitment to help rebuild the country even with such an enormous price tag attached to the Iraq War? And how much longer will bin Laden, al-Zawahiri, and the resurgent Taliban be allowed to plan and prepare new terrors across the border in Pakistan?

The ways of conspiracy in Afghanistan always take the unexpected course, a path less traveled by the West. Afghanistan is not a place for naive NGOs or CEOs who believe love or money is all one needs to make a difference or for Western politicians who fail or refuse to grasp the ways of the Islamic East. And clearly it's not a good destination for untrained and inexperienced journalists.

Afghanistan's landscape is unforgiving. Along with vast deserts, great mountain ranges, unmapped canyons, and deep caves, there is incredible heat and subarctic cold. Visions twist and meander in this land, climb rugged peaks, and suddenly dip into arroyos to disappear in shimmering heat waves. They become warped by the sun's furnace during the day and then grow lethal with the night. Paths and footprints vanish. If the U.S. and coalition forces are having a terrible time fighting the insurgency in Iraq, battling a united Afghanistan would be a nightmare. Just ask the Russians and the British before them.

Iraq, in the meantime, has become a guerrilla quagmire, sopping up American and Iraqi lives as if it were a sponge. The U.S. invasion of Iraq in 2003 was a dream come true for bin Laden and al-Qaeda. Now they had the opportunity to fight Americans not only in a Muslim land but on actual Arab soil. This was the chance they'd been praying for, to prove the mettle of their born-again Islam.

Many analysts believe that a U.S.–al-Qaeda confrontation would sooner or later have taken place in Afghanistan if the perfect scenario in Iraq had not come along when it did. But if the present confrontation is focused on Iraq, Afghanistan is still a near-failing state on the edge of big trouble. Its people have risen to the call for some form of representative government, and Afghans have participated in three elections over the past few years and demonstrated their desire for a better way. But the Taliban thrives only a couple hundred miles from Kabul in Kandahar, Zarbol, and the rugged mountains along the border with Pakistan. It's been estimated that of the original 50,000-strong Taliban military as of September 2001, only 20 percent, or 10,000 men, have been accounted for as casualties or prisoners. That leaves 40,000 of the original force alive, probably well, and no doubt reinforced during the last four-and-a-half years by Pashtun warriors who believe in Shariah and the Deobandi-Wahhabi way. Afghanistan is comprised

roughly of 40 percent Tajik and Hazara peoples and 60 percent Pashtun.
The majority of Afghanistan's Pashtuns does not follow the Taliban
way, but the war button need only be pushed anew in Pakistan's tra-
ditionally xenophobic Pashtunistan for pressure to build on their
strong-minded brethren across the border to drive out the alien Ameri-
cans and the Karzai government

Afghanistan is populated with warrior people who, when mo-
tivated to organize, have an historically proven ability to raise total
hell in the entire region. And now, thanks to modern technology and
terror tactics worked out by others on their very terrain, they have the
potential to take their own version of the show on the road. Never
confuse the Taliban with a united Afghanistan, for the war with the
Soviets brought together all the tribes in an organized, single-purpose
military jihad. Consider that in the al-Qaeda attacks in Dhahran and
Riyadh, Saudi Arabia; on the embassies in Africa; on the USS *Cole* in
Yemen; and then the coordinated 9/11 attacks in 2001, no Afghans
participated. Muslims were the perpetrators, of course, but not Af-
ghan Muslims. This will not be the case if any new round of hostilities
erupts in the region.

So putting aside the Afghan people's enduring, noble qualities
that have so inspired me and others who have had the privilege of
spending time with them through the years, it appears America's long-
term interests are not served by continually engaging Iraq and other
nations and allowing people such as these to continue in a near-failing
state. And as in the post-Soviet period, when the bulk of promised aid
from the United States, Japan, and other Western nations failed to ma-
terialize, the Taliban has seized the opportunity to proselytize yet again.

If Afghanistan explodes, will the U.S. administration's answer
be to send in more super troops? Are the solutions put forth by mili-
tary advocates the best and only way to deal with long-term prob-
lems? In a July 2002 interview we conducted with Fatima Gailani, the
director of the Red Crescent (the Red Cross in Muslim countries) in
Afghanistan and the daughter of NIFA's Pir Gailani, she had this ob-
servation to share:

> It's not just the U.S., if it's a powerful government involved
> here, . . . they like to see that things are instant—instant

coffee, instant juice, and lots of instant. Most of the misery we see today in Afghanistan is because of that instant politics.

So what is the long-term view of Afghanistan? Beyond the perception in Kabul that extremist elements and greedy warlords can be controlled, the waters are murky and the winds are kicking up whitecaps in the south and in the east where the likes of Hekmatyar as well as al-Qaeda and the Taliban are digging in for the long haul. How will we Americans, dependent on our new definition of mass media, even know what's really going on in Afghanistan or any other hot spot before it's once again too late? After all, as ABC told us in October 2001, "that they do it for the public good . . . is not even remotely true."

In the last quarter century, when the U.S. government has been confronted with armed conflict overseas and it has had a choice of either arming a civilized faction friendly to U.S. ideals or the hard-core killers, it has tended to opt for the goons. Why? Various administrations have done so because they have been able to rely on the latter to wreak havoc by day and to do brutish things by night. They can and will do things more civilized and progressive folk will not condone. The only problem with this strategy is that at the end of the day, the goons have all our weapons and technology and none of our ideology.

Look at the rogue's gallery the United States has supported, financed, and armed in the Middle East and South Asia in the last twenty-five years. Look at Hekmatyar. Look at the Taliban. Look at bin Laden. Look at Rashid Dostum. Look at the Saudi royal family. Look at Saddam Hussein. Look at all the other known butchers in the region who have, at one time or another, been recipients of American aid. In the past, we've financed and armed them all.

# 41

# *Roots of Terror*

**"The war on terror" has become a household phrase.** We still have to remove our shoes and dispose of liquids at airport checkpoints, and bin Laden and al-Zawahiri still make occasional TV appearances to reinforce these new rites of passage. The U.S. military is still in a holding pattern in Iraq, with thousands dead and counting, while the Taliban has resurfaced in Afghanistan. Not far across the border in Pakistan, Quetta has become the new al-Qaeda headquarters for all South Asia. In New York, "Ground Zero" is still at ground level, and the price of gasoline keeps rising as oil company profits skyrocket. In the November 2006 U.S. midterm elections, the Democrats took a bare margin in the Senate and the House and then demanded new policies in Iraq, while the Iraq Study Group suggested revisiting nearly every aspect of the U.S. effort there. Saddam Hussein, one-third of the "axis of evil," is dead, but his departure doesn't seem to have effected the changes in Iraq that had been promised.

So, in plain terms, what is this war on terror all about? What's the focus? Who is winning, but more to the point, how do we gauge success? Do we, the American people, still think Saddam Hussein was bedding Osama bin Laden? If so, then we must be winning the war, since he lies moldering in the grave alongside his two sons. But my suspicion is we've finally recognized the "global war on terror" for the red herring it's always been. The larger question remains: is our world any safer today than it was after September 11, 2001?

To answer that question, we must look first to Pakistan, a complex reality both the Bush administration and the media continue to ignore. But why do they overlook these obvious truths: after six years

bin Laden hasn't been eliminated, al-Zawahiri hasn't been captured, and there's been no concerted U.S. effort since the battle of Tora Bora in December 2001 to pursue these two dudes in Pakistan. Further, the Pakistani military always arrives too late to catch the villains before they make their way through tunnels to the Afghan side of the border. So why do Presidents Bush and Musharraf continue their congenial fireside chats? A part of the answer is simple. The Pakistani general has his finger on the atomic button, and if he is assassinated or removed by some other means, then another general's digit—perhaps one more rigid—will replace his. But let me pause for a moment to examine more closely the complex reality of the nation of Pakistan.

In 1947, when Pakistan was created, certain areas refused to buy into the arrangement. The most important of these is the territory of the Pashtun people, through which I have traveled often since 1986. This rugged land of rugged, individualistic, private peoples wanted no part of Pakistan. The Pashtuns may have prayed to the same God as the newcomers from India, but they lived by different traditions, spoke a different language, and wanted their own separate nation. Pakistan tried hard to include them as part of the new nation but never really succeeded. Instead a compromise was drawn. Pakistan could claim the region, designated as its Northwest Frontier Province (NWFP), on paper, but Pakistan police and military would keep their noses out of Pashtun affairs. More than a half century later little has changed. The NWFP is its own boss; Pakistan has little direct control over what goes on there. Musharraf faces the same obstacles as every Pakistani president before him, of antagonizing these people.

Consequently, Bush fears the consequences of jeopardizing Musharraf's shaky balancing act between the extremists and the moderates in Pakistan and the new generation of homegrown Taliban fanatics of Pashtunistan. Understandably, Musharraf faces a major problem. But why do the U.S. government and its allies persist in behaving as the proverbial ostrich? Sooner or later they must confront the Pakistani-Pashtun connection that has nurtured the roots of the problem since the beginning. They need no more scapegoats, such as Iraq or Iran or Syria, to distract them from this critical problem.

Let me make it clear once again: the Pakistanis are not bad people, but their country is a near-failed state. Perhaps it does not meet the exact definition of a failed state because it still has an economy and a quasi-functioning government, but the concepts on which it has failed, and failed miserably, are those embodied in its original constitution. When Muhammed Ali Jinnah and others founded the country, it was intended to be a safe haven for all people regardless of ethnicity or creed:

> You are free, free to go to your temples, free to go to your mosques or any other place of worship in the state of Pakistan. You may belong to any religion or caste or creed—that has nothing to do with the business of state. . . . We are starting with this fundamental principle, that we are all citizens, and equal citizens, of one state. (Muhammed Ali Jinnah, August 11, 1947)

Hadi Raza Ali continued to hold onto this dream into the early nineties, and so have so many other Pakistanis, many of them good friends of mine. In reading Ahmed Rashid's bold writing, his commitment to these ideals, even in the face of great danger, is still apparent. But many successive leaders of Pakistan have severely damaged, if not totally destroyed, this founding concept. Yahya Khan, Zia-ul-Haq, and Nawaz Sharif were perhaps the worst, and under Zia all remnants of Jinnah's dream were erased. He imposed Shariah law and zero tolerance for all but the extremist Sunni creed, and under his watch, Abdul Qadeer Khan began exporting his atomic warehouse. And as I mentioned earlier, there are ongoing clashes in Pakistan between Muslims of various sects and regions, along with hatred for Sikhs, Christians, and Jews. Sunnis hate Shias and Sufis, and vice versa; Barelvi Sunnis hate Deobandi Sunnis; Sindhis hate the Mujahirs; the Pashtuns hate the Punjabis; and the Punjabis hate everybody outside of Punjab, where the feeling is mutual. An outspoken Hindu, Christian, or Jew would have a hard time surviving anywhere in Pakistan outside of certain sections of the capital city of Islamabad.

And yet Pakistan has a broad history extending to the earliest cultures on the planet; great resources, including one of the best irrigation systems in the world; amazing landscapes; and a marvelous and colorful mix of cultures. It's an exciting place to visit. Unfortunately it is now also dangerous. This is the legacy of military coups and a complete violation of Jinnah's dream of the Land of the Pure. So the world now faces a near-failed state that has nuclear capability, a general as president, a people with no tolerance for each other, a long-gone framework for creating true democracy, and the world's most wanted man.

Pakistanis and others are proposing solutions for the resolution, or at least containment, of this problem within Pakistan and for broad policies to counter the extremist Muslims' outreach to other parts of the world. Michael Scheuer suggests the United States and its allies are not facing a war on terror but a war against a worldwide Muslim insurgency under the al-Qaeda banner. These frightening words come from one who has been in a position to know. Do we listen when he also suggests bin Laden and al-Qaeda are not so much out to destroy America as they are trying to stop what they perceive as the West's intention of destroying the Muslim world through political favoritism, manipulation of its economies, and its irreverent behavior, in collusion with the Saudi royal family, toward the seat of Islam in Saudi Arabia? Could there be some truth in such an un-jingoistic statement? When we examine the record, we see bin Laden (but not al-Zawahiri) usually brings up the same old saws: U.S. troops stationed on sacred Muslim soil, blanket U.S. support of Israel over Palestine, and U.S. attempts to undermine particular Muslim economies.

There are 1.5 billion Muslims in the world today. If we're going to avert another global crusade, perhaps we should take a second look at the vast majority of Muslims throughout the world—still moderate—who simply want what they feel is a fair shake for themselves and their brethren. Ours is not just a military job.

# 42

# *The Other Pakistan*

**Every December in Bangladesh a great number** of Muslim people assemble near Dhaka, the capital of that "other" Pakistan, which, just as Afghanistan was, was once a victim of Islamabad's Machiavellian schemes. The gathering, called the *Ijtema,* is the creation of the Tubliqs, a sect of Sunni Islam based in New Delhi, India. This group preaches Islam's basic tenets, and its missionaries deliver the Muslim word from door to door in much the ways as other missionaries—namely, the Mormons, Jehovah's Witnesses, and the original Franciscan Friars—have done. While performing their proselytizing duties, they are forbidden to accept anything more than a meal or a cup of tea from their hosts before moving on to the next household. They must live by their own means.

The Ijtema traditionally attracts from 4 to 5 million devotees every year, or about a million to 1.5 million more than the Hajj in Mecca hosts. It is the largest Muslim gathering in the world. Thousands of tents are put up for people to sleep, and sanitary stations are erected every few hundred feet. Here the people gather for three days to eat, sleep, pray, and listen to the Tubliq mullahs and scholars who quote from the Qur'an and related books in an effort to set the pilgrims on the straight path. In fact, as one Tubliq told me, the Ijtema's purpose is to cleanse the teachings of lies and fictions that creep into the faith if left unattended.

And what kinds of lies were to be dealt with this year? I asked the mullah.

He leaned forward and spoke in a gentle voice, "The lies of killing innocents and of killing oneself for Allah."

"But doesn't the Qur'an say that jihad must be waged against unbelievers?"

"Jihad must first be waged against oneself," he said. "It is an internal striving, a struggle of the soul with the mind and the body."

"But then why is the term *jihad* used to mean 'war'?"

"That is not the translation. It means to strive for God, with prayer, fasting, good deeds, and, yes, war, if war becomes necessary after you have struggled without war. But jihad is not war."

"And suicide bombers?" I asked

"The Qur'an is very clear: to kill oneself is to take God's right upon oneself. Hell awaits him who takes that right from God."

I wondered, in spite of the Mullah's clear interpretation, if the Pakistani people might translate these concepts differently. With Saudi assistance, extremist Islam has taken even firmer root in Pakistan since the Bangladesh (then East Pakistan) genocide of 1970 and 1971. Despite their now friendly relations, these two Muslim nations have never had a meeting of the heart or mind.

Getting permission from the Bangladesh Ministry of Foreign Affairs to attend the Ijtema proved a bit complicated. During the previous week in the northern part of the country, while filming a large demonstration against India's proposed mega dam project—that is, the Inter-River Linking Project, which could spell extinction for Bangladesh after diverting its rivers—I had been asked to speak a few encouraging words to the crowd of 30,000. Thus, for a brief moment, I was a known quantity on Bangladesh TV News, and the Foreign Ministry granted my initial request for permission to film the Ijtema. It had even been suggested that I go with then-president Khaleda Zia's cabinet, but the more the minister of foreign affairs deliberated on this idea, the weirder he thought it would seem to have an American at the Bangladesh cabinet's side during a solemn Muslim convocation. Mind you, there was no interdiction, as in Mecca, against non-Muslims attending. Apparently, no one had ever asked to attend. So it was decided I would have to work out logistics on my own.

I drove out to the location three days before the Ijtema and filmed as people set up tents and great canvas tarps to shield the pilgrims from the blistering sun. I could see the convocation would cover a

vast area. And as far as ritual ablution was concerned, people would have access to a river that literally flowed through the Ijtema grounds. I lined up a few locations to film atop nearby buildings for wide camera angles of the gathering and grabbed a few preliminary shots.

On the first day of the three-day convocation, people arrived by train, bus, truck, rickshaw, bicycle, horse, and carriage and on foot. Perhaps 3 million people were already in place under the tents, but witnessing the arrival that morning of the last 1.5 million was amazing. I was surprised to see the great diversity of people: rich and poor, well dressed and scraggly, dark skinned and light, children and elders, men and women. A small percentage of the women wore black burqas while about half wore head scarves. An equal number were bareheaded. Most men wore the traditional fez cap.

We returned to film on the second day, but our real focus was the third and final day, when prayers for the world would be offered. To cover this event, we decided to send camera teams into the crowd itself, while I remained in our preplanned position on a rooftop. Using both handheld digital and 35 mm film cameras, one of the local cameramen, Mahmud, was already moving among the crowds while I shot from a tripod that afforded me a panoramic view. When Mahmud returned and gave me a thumbs up signal, I made my decision: I wanted to join the crowd myself. When I declared my intention to my partner Salik, he thought it was crazy. After all, it was a post-9/11 world, and no matter the smiles and handshakes we'd received on the way to our stations, some extremist out there might be offended by an obvious American presence. No matter the assurances from the Tubliq mullah, the foreign minister, and others, Salik worried there might be a few Taliban and al-Qaeda types among the millions.

But as risky as it seemed to Salik, I felt it was a once-in-a-lifetime opportunity to probe the true feelings of rank-and-file religious Muslims. If this ostensibly peaceful gathering was unfriendly to all things Western and American, I needed to know. One of the boys who could translate went with me and together we joined the crowd below. First we had to make our way across a narrow footbridge over a stream. Hundreds of people were on the bridge, but they smiled and moved aside to let us pass. At the other end of the bridge, a middle-aged man

and his young son ran to greet me and shake my hand. Once off the bridge, another family insisted on giving me a cup of tea. While I drank it another man offered me a large piece of naan. A few feet further a distinguished-looking man around my age insisted on carrying my over-the-shoulder bag and clearing the way for me through the crowd.

And so it continued for another hour as we made our way to the river that divided the Ijtema. Here a grizzled boatman pulled up to the shore and offered us a ride to the other side. He helped me on board and provided nonstop commentary in Bangla as he paddled the craft to the far shore. There more hands offered to help us off the boat. The lectures and prayers of the mullahs and scholars bellowed over the entire scene, reaching the 4.5 million from large speakers. Though I do not understand Bangla, clearly the mullahs were not preaching military jihad against all things Western. Otherwise my experience would have been quite different.

So what do I make of this tiny moment in this new age where radical talk of Islamic terrorism and crusader imagery becomes more and more common? Was Osama bin Laden, as some have asserted, establishing himself in the seat of a new Muslim caliphate that had been left vacant since the collapse of the Ottoman Empire nearly a century ago? Has he become, in essence, the new leader of the Muslim world?

There is in my mind no doubt that bin Laden is the current Muslim sensation. You can't walk through the bazaars of even a benign and gentle country as Bangladesh, where bin Laden T-shirts are on sale everywhere, and not understand his popularity. After all, outside of the late Saddam Hussein, he's probably the only other global Muslim figure. And not to downplay the effectiveness and determination of such new Muslim leaders as Mahmoud Abbas of Palestine and Karzai of Afghanistan, no other Muslim enjoys international star status.

Here I would cautiously venture an opinion: Osama bin Laden is not yet the new leader of all the world's Islamic people. But, perhaps, the word *yet* is the key. He definitely inspires those radical fundamentalists determined to return the world at any cost to seventh-century Arabia. And his popularity grows as we fiddle to the fire in Iraq. Bin Laden and his gang are alive and well in that remote region

of Pakistan, busy working out new strategies for maximizing the West's blunders in the Muslim world.

Michael Scheuer feels the die has been cast by these blunders and by the U.S. administration's determination to cast bin Laden as the Antichrist. Through our ignorance, he believes, we Americans refuse to acknowledge our role in the new terrorism. He believes, in fact, that the West at this point is already dealing with no mere terrorist threat but, as I have mentioned, with a global Muslim insurgency, and that as far as Afghanistan is concerned, "America's Afghan war is still in its infancy." If Scheuer proves correct on this last point, then I'd say we in the West may already be looking at history in this shrinking world that only awaits a spark to touch off the nuclear furnace.

Given my experience at the Ijtema in Bangladesh, I'd prefer to believe we still have enough room to maneuver and enough time to reach out to the moderate Muslim majority around the globe. We can prove our sincerity through our actions and provide them with the assistance they need, to stand up to those in their midst who would coerce them—against the teachings of the Prophet—to join the suicide brigades.

Sadly, since I wrote the first rough draft of this chapter over a year and a half ago, in 2006, al-Qaeda has already begun the terrorization process in Bangladesh. In August 2005, more than a hundred bombs were detonated in synch across the country, and on November 29, 2005, suicide bombers blew away the checkpoints outside two national court buildings, killing eight people and injuring more than fifty.

"Yet" may be disappearing quicker than I had imagined.

# 43

# *Return to Ushmen Tangi*

**The main road from Kabul to Jalalabad had been paved** recently and was actually functional. I knew that would change as we headed south for Sorobi through the Silk Gorge and to Ushmen Tangi about eighty miles away. I was right. Another twenty minutes later, the road took a dip into oblivion and eventually disappeared altogether as a paved entity. It had been quite a while since I had come that way from Jalalabad in search of the four dead journalists. Having come so close then to the spot where they'd been killed, I wanted to see it now, to study the surroundings, catch a faint breeze, and perhaps a vibe of what had happened.

My driver, Hamid Gul, stopped at a small village he knew well and hired a pickup truck and six armed men for the journey. The drive south was rough but uneventful. The heat rose from the rocks as we entered a desert landscape that was the furthest thing from romantic sand dunes imaginable. Three hours later we passed through the legendary gorge with its sheer rock walls rising up more than a thousand feet. Many an invader had lost his life here. Somehow when we'd entered the rugged terrain that tracks the Kabul River, we'd missed the clues that we'd been told marked the spot where the journalists had been killed, and I found myself once again at the truck stop where I had ended my search the night of November 19, 2001. Afghan music blasted from the same cracked radio speakers inside while parked outside were three of those crazily painted Pakistani trucks, the ones that Wakil's little boy called "happy cakes." The mood was far from ominous this time, but the sun was beginning to set on the heat-warped

horizon. With nighttime approaching, I knew moods could change abruptly.

Hamid turned our two-vehicle convoy around in the parking lot and headed back into the canyon, where the light had already failed. He drove faster, not wanting to be here when night fell. The deep shadows from the canyon wall darkened the road while occasional patches of sun broke through the rocks and overwhelmed our eyes. Hamid conferred with his friend Amir, who studied a handwritten map and pointed to some high rocks. Suddenly he stopped the truck in the middle of the road and turned off the engine. Amir leaped out and scanned the ridge up ahead with binoculars as the soldiers in the truck behind us searched with their bare eyes. Then Hamid started the engine again, and we continued up the road into the canyon. We wound around sharp curves for several minutes when Amir suddenly pointed. I saw a grouping of rocks that looked to me like any other, but then I was no longer studying the landscape; rather I was recalling an earlier time.

The mujahedin leaped from their pickup and fanned out through the rocks on both sides of the road. When they thought it safe enough, Hamid stepped from the Land Cruiser and I followed. The unseen sun was sinking faster, and we could make out very little clearly. Hamid joined the soldiers, leaving me alone at the side of the road where the journalists were found. I didn't see any bloodstains, of course, or blunt instruments or spent shells. I gazed up at the canyon wall and then at the road that snaked off in endless curves, a perfect place for an ambush. The convoy had had to slow down here, and it was a simple matter for the gunmen to step from behind nearby rocks. Other gunmen on the ridge above could have held off a moderate to large force approaching from below. But the convoy had no force, just a contingent of sightseeing journalists.

I thought again of Maria Cutuli, the woman in the coffin in the refrigerated vault, and of the bullet hole in her head and the deep cuts and bruises that were obviously inflicted first. She never had the chance to report what had happened here, and this place wasn't talking. But we knew the parameters of her death and those of her three colleagues. And we knew, of course, what had happened to Daniel Pearl, not just because the authorities found all the pieces of his mutilated corpse,

but because the conscientious folks at al-Qaeda had videotaped his death in dripping color.

No one, however, ever saw Lee Shapiro's body or even pictures of it. We don't know how many bullet holes riddled his and Lindelof's corpses or whether they too had been beaten or tortured. No one knew but the guide, Abdul Malik, and he wasn't talking. Shapiro and Lindelof were murdered in 1987, and we were still trying to determine what really happened.

After all these years, I've learned that answers come hard in Afghanistan and in war in general. They come hard and at a price. Even when the armies of Islam began their efforts to convert the region in the eighth century, they too faced tremendous opposition, and it took two centuries to complete the job. Why should we in the West think that our "instant" approach to issues can do things here any faster?

In 1986, Lee Shapiro wanted to find out, as he said in his diary, "what the hell is really going on." Down deep he must have been concerned that his great secret—he was a Jew in a Muslim world—might put him in jeopardy. Maybe his heritage did contribute in some small way to his ultimate demise, but if so, we still don't know for certain. We do know he had lost patience and went to the wrong place with the wrong people. Impatience and a belief in journalism's protective shield are not assets in a war zone. And I could say perhaps the same for the journalists who died here on the road to Kabul. Maybe Daniel Pearl suffered from such eagerness and naïveté as well, bless his courage, rushing off to Karachi with only a clue and no support and leaving no trail for anyone to follow. And perhaps I was just plain lucky in Tora Bora.

If you're a journalist or documentary filmmaker, you'd better have a streak of arrogance and enough irreverence toward the powers that be to enable you to speak or write your mind without fear of losing short-term favor. If these latter elements rule your house to the exclusion of all else, you'd better find another line of work. Journalism requires research and respect before action, and humility before ego-gratification. It also requires accepting that no matter what compassion you feel for a foreign people or how extensive your experience has been with them, you will always be a visitor in their land.

Today we see a rekindling of the old spirit among a group of journalists covering the war in Iraq. In spite of the embedding process, they are stepping out from the protection of U.S. guns and choosing the hard road again, willing to take the same risks that their forbears did, asking questions that are uncomfortable, unpopular, or downright unsafe. Yes, they are at risk. Lee Shapiro was one of these and very different from the majority of bridge-burning, upwardly mobile, baseball-capped corporate recruits who have gone by the same name in recent years. The wars in Afghanistan and Iraq and the global war on terrorism have been great American tragedies, but the compromise of our fourth estate has been a tragedy as well. If passion for the truth can no longer be found in the heart of the American journalist or that of his or her superiors, or if that fire that has fueled the determination of reporters from Twain and Orwell to Sontag, Steinbeck, Mailer, and Didion is allowed to die, then we as a people will surely suffer the fate of the blinded. Such journalists are not known for being easy and they're not a particularly sane, solvent, or even sanitary bunch. They'll do crazy and often dangerous things to get at the truth. For the real journalist, this quest is a kind of love affair. I'm reminded of the last poem written by Rahim el-Ham, the Afghan writer-warrior whose posthumous return I had filmed at the Bagram Air Base in 2002. He knew about truth and passion.

### The Will
*The day my soul departs my flesh*
*Make my shroud of flowers fresh*
*Wash me with the tears of love*
*And lay me with the rose above*
*So that nightingales may sing*

*If rain and wind should wither my grave*
*None should try to repair it*
*Let my fragments be scattered abroad*
*In whatever form they would have it*
*To be carried away by the air*

*On the open plains and the mountain tops*
*The dust of my heart shall fall*
*That in the early spring and from my dust*
*A tulip may grow tall*
*For the bosom of my love*

*Save for madmen, none should come*
*To visit my resting place*
*If a sober one should approach somehow*
*Tell him to quicken his pace*
*For the sane know nothing of love*
*The sane know nothing of love*

I guess Lee Shapiro was a madman. He and el-Ham would have had much to discuss.

# Suggested Reading

**As you will see, I have included several novels** in this bibliography. I have found that unlike names, events, locations, and histories, the sight, sound, taste, smell, and feel of a land and its peoples are sometimes rendered more completely through the pen or word processor of a novelist.

Aburish, Said K. *The Rise, Corruption and Coming Fall of the House of Saud*. New York: St. Martin's Press, 1994.

Ahmad, Hazrat Mirza Tahir. *Murder in the Name of Allah*. Cambridge, UK: Lutterworth Press, 1990.

Anonymous. *Imperial Hubris: Why the West Is Losing the War on Terror*. Washington, DC: Brassey's, Inc., 2004.

———. *Through Our Enemies' Eyes*. Washington, DC: Brassey's, Inc., 2002.

Aslan, Reza. *No God but God*. New York: Random House, 2005.

Bergen, Peter L. *The Osama bin Laden I Know*. New York: Free Press, 2006.

Brisard, Jean-Charles, and Guillaume Dasquie. *Forbidden Truth: U.S.-Taliban Secret Oil Diplomacy and the Failed Hunt for bin Laden*. New York: Thunder's Mouth Press/Nation Books, 2002.

Coll, Steve. *Ghost Wars: The Secret History of the CIA, Afghanistan, and bin Laden, From the Soviet Invasion to September 10, 2001*. New York: Penguin Press, 2004.

Constable, Pamela. *Fragments of Grace: My Search for Meaning in the Strife of South Asia*. Washington, DC: Brassey's, Inc., 2004.

Crile, George. *Charlie Wilson's War: The Extraordinary Story of the Largest Covert Operation in History*. New York: Atlantic Monthly Press, 2003.

Dupree, Louis. *Afghanistan.* Princeton: Princeton University Press, 1973.

Elliot, Jason. *An Unexpected Light: Travels in Afghanistan.* New York: Picador USA, 1999.

Goodwin, Jan. *Caught in the Crossfire.* New York: E. P. Dutton, 1987.

Griffin, Michael. *Reaping the Whirlwind: The Taliban Movement in Afghanistan.* London: Pluto Press, 2001.

Gurdjieff, George I. *Meetings with Remarkable Men.* New York: Penguin, 1991.

Hopkirk, Peter. *The Great Game: The Struggle for Empire in Central Asia.* Oxford, UK: Oxford University Press, 1991.

———. *Quest for Kim: In Search of Kipling's Great Game.* Ann Arbor: University of Michigan Press, 1999.

Hosseini, Khaled. *The Kite Runner.* New York: Riverhead Books, 2003.

Jones, Owen Bennett. *Pakistan: Eye of the Storm.* New Haven, CT: Yale University Press, 2002.

Junger, Sebastian. *Fire.* New York: Perennial Press, 2002.

Kipling, Rudyard. *Kim.* Oxford, UK: Oxford University Press, 1901.

Klass, Rosanne. *Afghanistan: The Great Game Revisited.* New York: Freedom House Press, 1987.

Lamb, Christina. *The Sewing Circles of Herat: A Personal Voyage Through Afghanistan.* New York: Perennial Press, 2002.

Lewis, Bernard. *The Crisis of Islam: Holy War and Unholy Terror.* New York: Modern Library, 2003.

Magnus, Ralph, and Eden Naby. *Afghanistan: Mullah, Marx, and Mujahid.* Boulder, CO: Westview Press, 2002.

Matinuddin, Kamal. *The Taliban Phenomenon.* Karachi: Oxford University Press, 1999.

Michener, James. *Caravans.* New York: Random House, 1963.

Rashid, Ahmed. *Taliban: Militant Islam, Oil, and Fundamentalism in Central Asia.* New Haven, CT: Yale University Press, 2001.

Rubin, Barnett. *The Fragmentation of Afghanistan: State Formation and Collapse in the International System.* New Haven, CT: Yale University Press, 2002.

Schultheis, Robert. *Night Letters: Inside Wartime Afghanistan.* Guilford, CT: Lyons Press, 1992.

Smucker, Philip. *Al-Qaeda's Great Escape: The Military and the Media on Terror's Trail*. Washington, DC: Brassey's, Inc., 2004.

Weaver, Mary Anne. *A Portrait of Egypt: A Journey Through the World of Militant Islam*. New York: Farrar, Straus and Giroux, 1999.

Wolpert, Stanley. *Jinnah of Pakistan*. New York: Oxford University Press, 1984.

———. *Nehru: A Tryst with Destiny*. New York: Oxford University Press, 1996.

# Index